GARY COCKERILL was born and raised in the village of Armthorpe, South Yorkshire. After working as a miner in the local colliery to earn enough money to move to London, he established himself as one of the UK's top make-up artists, without the help of formal training or contacts. Over the past 20 years, Gary has accumulated a vast collection of celebrity clients and his work regularly features in magazines, music videos, TV shows and advertising campaigns. He is also in demand as an expert in front of the camera, appearing on numerous programmes, including *10 Years Younger*, *Make Me A Supermodel*, *This Morning* and *What Katie Did Next*. In 2011 he presented Sky Living's new flagship show *Promzillas* and he is currently working on his own make-up range. Gary lives in central London with his husband Phill Turner and their dogs Dolly Parton, Scarlett O'Hara and Lola Ferrari.

From the reviews of *From Coal Dust to Stardust*:

'Gary's my best friend and also my make-up genius. I would be lost without him. And now everyone can read why he's so important to me'
KATIE PRICE

'Gary gave me one of the best make-ups I've ever had in my life. It felt so fabulous'
MELANIE GRIFFITH

'I've got so many tips from Gary. He made me feel so confident with make-up. I surrendered to him completely'
LORRAINE KELLY

'Gary means the world to me and makes me look a million dollars'
BARBARA WINDSOR

GARY COCKERILL

From Coal Dust to Stardust

HarperCollins*Publishers*

HarperCollins*Publishers*
77–85 Fulham Palace Road
Hammersmith
London W6 8JB

This HarperCollins paperback edition published 2011

1

First published in Great Britain by HarperCollins Publishers in 2010

A catalogue record for this book is
available from the British Library

ISBN 978-0-00-737148-8

Set in Minion by
G&M Designs Limited,
Raunds, Northamptonshire

Plate sections designed by seagulls.net

Printed and bound in Great Britain by
Clays Ltd, St Ives plc

Mixed Sources
Product group from well-managed
forests and other controlled sources
www.fsc.org Cert no. SW-COC-001806
© 1996 Forest Stewardship Council

FSC

FSC is a non-profit international organisation established to promote the
responsible management of the world's forests. Products carrying the FSC
label are independently certified to assure customers that they come
from forests that are managed to meet the social, economic and
ecological needs of present and future generations.

Find out more about HarperCollins and the environment at
www.harpercollins.co.uk/green

*To my mum, dad and sister Lynne, all the strong,
inspirational women who I have been lucky
enough to work with over the years and to Phill,
my husband and the love of my life*

CONTENTS

ONE

Doncaster Dynasty

I never forget a frock. This one was pumpkin-orange with a pattern of tiny yellow flowers, smocking across the bodice and a flourish of gypsy ruffles. It must have been the height of fashion in early Seventies Yorkshire. It was also far too big for me, and clashed with the frosted pink lipstick that was now smeared across my five-year-old face. My big sister Lynne took a step back and – head cocked to one side – appraised her handiwork.

'Go on then, Gary, give us a twirl.'

I obliged happily, giggling as I tripped over the flounced hem. Now *this* was more fun than football …

My sister was three years older than me, a gorgeous, doll-like little girl with the sweetest of natures. I worshipped her – I still do to this day. For her part, Lynne had always wanted a little sister and when she was presented with a rosy-cheeked baby boy she obviously decided that she would just have to make the best of the situation, which is why I grew up with zero interest in cars or soldiers and an obsession with dressing up and dolls.

Beauty Pageant was one of our favourite childhood games. I'd make the badges with the contestants' numbers on them out of old toilet rolls and Lynne and I would take it in turns to be the show's host.

'... And here's the lovely Miss Scunthorpe wearing a very pretty red pinafore dress. Her hobbies are dancing to Abba and watching *Rentaghost* ...'

We'd rope in our cousins on Mum's side (Lorraine, Julie, Cheryl, Mandy, Kelly – there was one boy cousin, Greg, but for obvious reasons he usually did his own thing) and we'd spend hours putting on concerts and plays and musicals in the garage, a magical place which doubled as Dad's workshop when it wasn't playing host to the all-singing, all-dancing Von Trapp children or being transformed into a ghost train complete with sheet-shrouded ghouls.

At the weekend Lynne, me and our girl cousins would troop off to the Saturday morning club at the local cinema together where I'd sit spellbound in front of the latest Hollywood blockbuster. Fairytales were a particular favourite of mine, with a film based on the story of Cinderella called *The Slipper and the Rose* becoming something of an obsession. I must have seen it at least ten times. Even when Lynne wasn't around to play with, I would sneak into her room to steal her shoes and dressing-up clothes and then dance round the room wearing this big black wig that Mum kept for best, pretending to be Shirley Bassey.

* * *

At the age of six, I begged my parents to get me a Girls World, one of those slightly creepy-looking plastic heads on which budding make-up artists can practise their skills.

'Are you sure you don't want a Scalextric set?' my father asked hopefully, as he did every Christmas. My poor dad. He tried his best to do the right thing by his only son, bless him. He would take me

outside and then lift the bonnet on our green Vauxhall Viva as if he was about to share some incredible secret.

'Right, son,' he'd say, crouching down by the car, all excited. 'Now listen closely, I'm going to help you find your way round an engine …'

If it wasn't cars, it was DIY. Dad treated his toolbox like it was buried treasure, the spanners and screwdrivers as precious as any diamonds or rubies. I hadn't the heart to tell him I'd rather be lifting the lid of my sister's jewellery box and watching the little ballerina spin round. He'd drag me along to watch Doncaster Rovers, even though I made no attempt to hide the fact that I was more interested in the half-time bag of crisps and pop, and occasionally he'd even rig up a net in the back garden to teach me some skills.

'Come on, Gary, let's go and have a kickabout!'

On one of the few times he actually got me in front of that net I was so scared of being hit by the ball that when he kicked it towards me I dodged out of the way and it went straight through the picture window at the back of our house, showering my mum and sister with glass as they sat watching *Jim'll Fix It*.

I never did get the Girls World. However, my long-suffering parents did buy me the other presents on my Christmas wish list: a little toy Hoover and a pair of ruby red shoes for me to live out my obsession with Dorothy from *The Wizard of Oz*.

'Wouldn't you rather be the Tin Man or the Lion?' Dad would ask, an edge of desperation creeping into his voice. But no – I was convinced that one day I would go over the rainbow. There weren't that many boy-sized sparkly red slippers in Armthorpe though, so Dad ended up spray-painting my trainers and covering them with red glitter.

Without a Girls World to practise my make-up skills, I started to steal my sister's dolls instead. I would stockpile them in secret hiding places around the garden and when Lynne eventually found them stashed behind the hedge or round the back of the shed she would

go mad because I'd have felt-tipped on red lipstick and blue eye shadow and tied their hair into plaits.

If I couldn't get hold of the dolls, I would find other outlets for my creativity. I would get up early in the morning, long before anyone else in the house was awake, and trace women's faces complete with pouty lips and one spider-lashed eye (I was too lazy to do a matching pair) into the condensation on the large window at the back of the house, sending my houseproud mother ballistic when she came in to make breakfast and saw all these smeary, drippy faces defacing her nice clean windows. I completely destroyed the covers of Dad's treasured record collection by biro-ing eyeliner, lipstick and false lashes on the already heavily made-up faces of the ladies of Abba and The Three Degrees.

And when I ran out of pop stars to beautify, I started on the Page 3 girls in my parents' copy of the *Sun*. I would define Jilly Johnson's brows or make her lips slightly bigger, and once I'd finished with the faces I would draw bras on them. In my mind I was just making them look prettier, but – as you can imagine – my dad wasn't best pleased, especially if I got my hands on the paper before he'd had a chance to see it. I would even draw muscles on the men, a skill that would stand me in good stead many years later when I would end up using make-up to shade pecs and abs on a certain singer who would later become one of my clients …

But I'm getting ahead of myself. My story really begins in the very early hours of 30 September 1969 at 67 Burton Avenue in Balby, a suburb of Doncaster, South Yorkshire. This was my parents' first home, a typical two-up, two-down terraced house in an average Coronation Street-style street.

At the moment there are three people in this little house: Ann and Brian Cockerill and their three-year-old daughter Lynne, soon (far sooner indeed than anyone actually realises) to be joined by me. Ann and Brian are childhood sweethearts who met at the age of 16 at the Gaumont cinema in Doncaster. Brian – devilishly handsome,

the spitting image of Tony Curtis – was mucking about with his mates throwing popcorn down the top of the curly-haired, big-boobed brunette in the row in front until Ann – beautiful, ballsy, typical Scorpio – turned round to give him an earful, having apparently already given him an eyeful.

The rest, as they say, is history.

Having both come from solid, working-class families with the same family-orientated values, the couple married at 21 after a traditional courtship and my sister was born two years later. By the time I came along, Dad had a secure job working at the Doncaster Royal Infirmary as a painter and decorator and my mum handled the paperwork in a clerk's office. My earliest memories of her are in a neat pinstripe pencil skirt and a little ruffled blouse, her wild hair shaped into a bubble of curls – a cross between *EastEnders'* Angie and Jill Gascoigne from *The Gentle Touch*.

Mum never did make it to hospital that morning. I made my appearance into the world at 6 a.m. in the chintzy comfort of my parents' bedroom with Dad panicking outside the door and one of the neighbours roped in to help poor Mum. It was the last time in my life that I was ever to be early for anything.

My parents didn't have a very good track record with baby names – my sister was called Tinkerbell until she was a good few months old – and similarly Gary wasn't the first choice of name for their son. For the first few weeks of my life, I was called something completely different. In fact, if it hadn't been for Dad putting his foot down, the name on the front of this book would read 'Ivor Cockerill'.

My attention-grabbing arrival into the world was to prove typical of my need to be in the spotlight at all times. Although I was quite small at birth, about 6 lbs, I would take as much milk and affection as I could get and quickly blossomed into a chubby, red-cheeked little cherub. And so, for the first few days of his life, Ivor-turned-Gary and his folks lived in the same blissful, chaotic, exhausting bubble as any other young family with a new baby. But then, just

three weeks later, my family's lives were turned upside down, inside out and very nearly destroyed.

It was a Wednesday and Mum was getting us both up and dressed when she started to get terrible pains in her arms and chest and then suddenly, without any warning, my slim, active and outwardly completely healthy 26-year-old mother suffered a devastating heart attack and collapsed. When it became clear after a few minutes that Mummy wasn't going to wake up – even with her new baby brother screaming the place down – Lynne (who, remember, was just three at the time) managed to get out into the garden, climb over the fence and knock on a neighbour's door to tell them that Mummy was poorly. The ambulance arrived just in time.

The attack had been caused by a massive blood clot, which was eventually linked to her being on the Pill. She was one of the first women to try this revolutionary birth control drug – almost a guinea pig. The damage to Mum's heart was so extensive that the doctors at the hospital in Sheffield where she lay in intensive care warned that her life was hanging in the balance; even after she made it through the first few days they gave her five years, max. With a job to hold down, two very small children to look after and no idea whether his young wife would ever make it out of hospital, my distraught dad moved us all in with Mum's parents, Grandpa Joe and Grandma Jean.

Just five months later, Mum – with typical bloody-mindedness – proved all the doctors wrong by being well enough to leave hospital, but the attack had left her seriously weakened and she was warned that the slightest physical exertion could kill her. Even today she gets out of breath very easily and has to have regular check-ups. I don't actually think the doctors really understand why she's still alive. So throughout my entire childhood my mum's poorly heart was at the back of my mind. Whatever we were doing, from swimming on family holidays to going on the swings at the park, I was aware that we had to watch out for Mum – well, some-

one had to because she certainly didn't seem that bothered about herself.

Far from taking things easy, she became obsessed with TV-AM fitness queen Mad Lizzie, putting on her tracksuit every morning before work to do star jumps in front of the telly. But it was because of Mum's heart that a few months after her return from hospital my parents sold our two-storey house on that steep street in Balby and bought a new-build bungalow on a private estate in the nearby mining village of Armthorpe, where they still live to this day.

To me, that three-bedroom semi-detached bungalow with its neat front and back garden will always be home. My memories of growing up there are coloured with love, laughter and food; my parents might not have had much money, but they always made absolutely sure we had the best of everything.

Sundays were a particularly happy time in the Cockerill household. Dad would cook a huge breakfast of eggs, bacon and sausage to keep us going until one o'clock, when Mum would serve a traditional roast with all the trimmings. Our modest dining-room table would be crowded with guests. There would be all the cousins, my aunts and of course Granddad Joe (former ICI factory foreman who loved a flutter on the horses) and Grandma Jean (golden-blonde bingo queen).

My grandparents argued non-stop; an outsider would have probably found it upsetting, but to us kids it was better than a sitcom, like Victor Meldrew and his wife.

As soon as Mum had cleared away the lunch things she would tie on a pinny and start baking, so at teatime we would have fluffy sponge cakes fresh from the oven and rounds of perfectly trimmed sandwiches. My sister and I would listen to the Top 40 countdown on Radio One in our pyjamas and then straight after the Number One our mother would swoop.

'Right, you two, off to bed now.'

She ran a tight ship, did Mum.

Every summer we would have two weeks at the seaside, somewhere like Whitby, Scarborough or Bridlington. Almost as exciting to me as the beach and its many attractions was the prospect of going to see a show. One year we caught legendary drag star Danny La Rue in summer season and I was completely knocked out by this man who was dressed as a fabulously glamorous woman.

Another time we were staying in a boarding house in Scarborough and Barbara Windsor – then a huge *Carry On* star – was staying in the room next door. I remember walking out on the landing and bumping into this tiny, curvy blonde, probably barely taller than I was back then.

'Ello, darlin', you alright?' she said in that instantly recognisable voice:

Funny to think that she's now one of my closest friends …

Our summer holidays also provided an opportunity for Dad to indulge in his favourite hobby – painting landscapes. He is an amazingly talented artist and I know he would have loved to pursue it as a career, but he put his family first and stuck to the safer, steadier option of being a decorator. In a way I suppose you could say I'm now living his dreams for him, except that I paint on faces rather than canvas.

I grew up surrounded by Dad's pictures on our walls at home and he influenced me profoundly. We might have failed to bond over Doncaster Rovers and DIY, but we shared a real love of art and he did everything to encourage my passion, buying me an easel, paints and art books. I would sit for hours alone in my bedroom with my sketchbook, usually drawing women's faces – whoever was famous and fabulous at the time, be it Joan Collins as Alexis in *Dynasty*, Lady Di, Barbra Streisand or Madonna.

At the age of eight I won a *Blue Peter* competition with one of these paintings, and Dad was bursting with pride when I had to go on the show to collect my badge from Peter Purves. (This wasn't my first taste of TV fame. That was on *Calendar News*, our local teatime

bulletin. The Queen had come up to Doncaster for the Silver Jubilee and as the camera panned over the crowd it stopped on a group of little kids waving flags and there was me in the middle, grinning like an idiot. I remember everyone making a fuss – 'Ooh, our Gary's on telly!' – and I remember how good it felt …)

To this day, Dad is a massive inspiration to me. He's a real Mr Nice Guy: sensitive, kind and very laidback. He rarely loses his temper or raises his voice. Without a doubt, it's Mum who rules the roost. She's a calm, quiet, almost shy person most of the time, but boy can she lose her temper quickly – and God help you when she does. Although discipline was usually of the verbal variety in the Cockerill household, I remember her grabbing a tea towel and giving my bum a good slap on more than a few occasions when I was growing up.

I once brought our class stick insects home from school and hid them in my bedroom, as I knew Mum wouldn't be keen on having a tank full of creepy-crawlies in her pristine house. Well, I can't have secured the lid properly and while I was at school they escaped all over the house and got busy breeding in the comfort of our soft furnishings. We were still picking stick insects out of the curtains weeks later; I don't think I've ever recovered from the ear-bashing I got from Mum for that particular little episode.

If I get my artistic talent from Dad, I get my determination and strength from Mum – and also my addictive personality. She smoked like a trooper when I was little – despite the heart attack – eventually quitting when I was in primary school. But she quickly found something else to replace her nicotine addiction …

When I was nine, my family went on our first holiday abroad: two blissful, sun-soaked weeks in the South of France. We stayed in a campsite just outside Antibes and went on a coach trip to Monte Carlo for the day, visiting the famous casinos and drinking ice-cold citron pressé with little jugs of sugar syrup in the lobby of the famous Hôtel de Paris.

'One day I'm going to come back and stay here,' I told my parents. For a little boy fascinated with glitz, glamour and fairytale it was heaven on earth.

Mum, too, was very taken with the French lifestyle – especially their love of wine. At this time in the late Seventies us Brits hadn't yet taken to vino in the same way as our Gallic neighbours, and the French habit of sharing a bottle over the evening meal proved a revelation for Mum and was one she kept up with enthusiasm long after our holiday tans had faded. She started making her own wine with kits from Argos and very soon was polishing off a couple of bottles of Château de Cockerill every single night.

After the first glass she'd be nicely merry, but as the evening wore on and the bottle emptied, her personality would suddenly change. I know she would be horrified at the suggestion that she had a drink problem; after all, she never drank during the day, she didn't touch hard spirits and she never went boozing down the pub. But even today, Mum can't leave a bottle unfinished. So whereas most kids grow up thinking of alcohol as something exciting and glamorous, to me it was the stuff that turned my mother into a totally different person – someone who I didn't want to be around. As a result of her drinking, I've been a lightweight all my life.

Mum never used to wear much make-up. Just a touch of lipstick, a bit of rouge and that would be it; not even any mascara. Her two sisters, however, were a very different story. While Mum was the academic one, my Auntie Maureen – or Mo – and Auntie Janice were beauty queens in their youth and even today, Janice treats every day like it's the grand finals of Miss Doncaster. They wouldn't be seen dead without full-on make-up and perfectly styled hair and were always disappearing off to the plastic surgeon for sneaky nips and tucks. The pair of them were having Botox before anyone else had even heard of it. I thought they were impossibly glamorous. Auntie Janice wouldn't think twice about spending a fortune on a designer outfit, whereas Auntie Mo might wear a six-quid outfit from down

Doncaster market but, honest to God, she would work it like it was Chanel couture.

Mo was known as The Big Red because of her shock of dyed scarlet hair, fiery temperament and huge boobs. Her signature look was orange-toned lipstick and a slick of eye shadow in iridescent blue or purple, but somehow it all worked. Her sister Janice – the much doted-on baby of the family – had platinum blonde hair and a deep perma-tan that she set off with frilly white dresses, pink frosted lipstick and long nails that were always painted glossy red. When *Dynasty* first appeared on TV in the Eighties I was instantly smitten, immediately recognising Alexis Colby and Crystal Carrington as a slightly more polished version of Mo and Janice.

But it wasn't just their flamboyant appearance that made such an impression on me. They were both truly strong women, real survivors who suffered a lot of tragedy and ended up carrying the men in their lives but never losing their fighting spirit.

'Whatever you want in life, Gary, you go get it,' Mo would tell me, eyes blazing.

Both Janice and Mo were pub landladies, a real couple of Bet Gilroys, each running a succession of establishments in the Yorkshire area. Their lives seemed full of drama and mystery – especially compared to my humdrum upbringing in Armthorpe.

I actually think one of the reasons my cousins, especially Lorraine and Julie, spent so much time at our house was because it gave them a bit of normality after the craziness of their own lives, but for me hanging out at Janice and Mo's pubs gave me my first taste of the world of showbiz. Okay, so the Bluebell in Gringley-on-Hill probably wasn't the most glamorous place on earth, but once I was through those doors it might as well have been Las Vegas.

My aunties would never come down to the bar at the start of the evening. Like the stars of the show they truly were, they timed their entrance for maximum impact – which was when the pub was full and they'd had enough time to make themselves look fabulous. At

around 8.30 they would suddenly appear behind the bar, all sequins, big hair and even bigger cleavage, smiling and waving at the punters like they were strutting on stage at the London Palladium.

Once on the floor they'd pull the odd pint, but mostly it was just lots of chit-chat with the regulars, a bit of flirty banter here and there, and then, after just a couple of hours of razzle-dazzle, they'd disappear upstairs again. Although I was obviously too young to be drinking in the bar, during the evening I would always sneak downstairs to get a bag of crisps so I could have a peek at everyone and bask in my aunties' reflected glory.

Even at that age I gravitated towards the limelight. 'I'm on this side of the bar with my glamorous Auntie Janice and you lot are stuck on the other side,' I would think, feeling special and, yes, probably more than a little bit smug. It was the same feeling I got years later the first time I was ushered into the VIP section at some fabulous celebrity party or other.

Sadly Mo passed away a few years ago, although she was so larger than life I still find it hard to accept that she's gone, but Janice is still with us and just as glamorous as ever, bleaching her hair and dressing half her age (and carrying it off) despite being well into her late sixties. Janice and Mo taught me the power of make-up to transform and seduce – and instilled in me a lifelong love of strong, glamorous women.

TWO

Drama Queen

All children have their little quirks. Some carry a security blanket, others suck their thumb – I, on the other hand, used to flap. Whenever I got excited I would start waving my hands in front of my face as if I was rubbing chalk off an imaginary blackboard, then I'd run round and round on my tiptoes, frantically flapping all the while. This would sometimes happen several times a day, frequently in public.

'Gary!' Mum would hiss under her breath as I tore round a shop. 'For God's sake will you stop that flapping!'

If a child behaved like this nowadays he would probably be diagnosed with Attention Deficit Hyperactivity Disorder and promptly put on a course of Ritalin; in Seventies Yorkshire, however, the solution was tap-dancing.

Looking back, I was always destined to be a stage school kid. The endless shows and musicals our little gang put on in Dad's garage had left their mark: my cousin Julie had blossomed into a talented performer (later becoming a dancer on cruise ships) and cousin

Mandy was attending the Italia Conti stage school in London. But it was my Auntie Ann who inspired me to take my love of the spotlight to a whole new level.

By the time I was eight or nine, my days as my sister's best friend, dress-up doll and number one playmate were almost numbered. Lynn was hitting puberty, blossoming into a stunning young woman, boys were sniffing around her and I suspect that having an effeminate little brother hanging about was seriously cramping her style.

My girl cousins, who were all older, were outgrowing me too, and I had few school friends of my own age to play with. Unlike most boys of my age I hated sports, so didn't even have the excuse of a kick-about to get me out of the house. Instead, I would spend the weekend with my Auntie Ann and Uncle Michael who lived in nearby Halifax with their son Craig.

For a kid with an overactive imagination and a taste for the dramatic it couldn't have been a better place to visit. Auntie Ann was a girl-guide leader and Uncle Michael (my dad's younger brother) worked in a sweet factory. He would sometimes take us to visit and I would watch entranced as rainbow-coloured delights danced past on conveyor belts, breathing in the heady hot-sugar vapours and imagining I was Charlie let loose in Willy Wonka's Chocolate Factory. Almost as magical to me were the family's trips to church. My parents were atheists, but Ann and Michael were regular worshippers and so every Sunday morning we would put on our best and go just down the road to St Martin's.

I loved everything about those mornings in church: the singing, the stained-glass windows, the gang-like chumminess of Sunday school and the theatre and mystery of the service itself. It wasn't the religion, it was the drama of the place that really moved me (although a few years later I would appear in a local production of *Jesus Christ Superstar* and I would cry every single night when the actor playing Jesus was crucified). To me, going to church was almost like putting

on a show – which brings me neatly on to Auntie Ann's other great love: Rodgers and Hammerstein.

Ann adored classic Hollywood musicals with a passion I soon grew to share and the house echoed with the soundtracks to *Carousel*, *Oklahoma!* and *Singin' in the Rain*. It is she who is also to blame for my Streisand obsession: I remember her putting on the *Funny Girl* album and just being mesmerised by this incredible voice belting out 'Don't Rain on My Parade'. Pretty soon Auntie Ann's kitchen replaced Dad's garage as my own personal theatre, and I would rope in cousin Craig to star in productions alongside me. Poor Craig, I thought he enjoyed himself as much as I did but my auntie told me just the other day that he always dreaded my visits:

'Please, Mum, can't I stay with Grandma when Gary comes to stay? He always makes me dress up as a girl …'

And so, at the age of nine, thanks to a heady blend of Rodgers and Hammerstein and the Holy Trinity, my future suddenly and magically became clear: I would go on the stage. I would be a child star. And, for a while, I suppose that's exactly the way it turned out.

* * *

The Lynn Selby and Phil Winston School of Dance and Drama was located in Doncaster town centre, about five miles from our home in Armthorpe. It was an offshoot of the prestigious Sylvia Young school in London, offering classes in drama, mime, tap, ballet, modern jazz and singing to 6–16 year olds, and had a great track record in getting local kids into the entertainment industry.

I spotted an advert for the school in the paper and after weeks of begging my resolutely untheatrical parents to let me attend, I started going to classes every Thursday after school and on Saturday mornings, although pretty soon I'd be making excuses to be there as much as possible.

The school was run by a professional couple in their late twenties, actress Lynn Selby and Phil Winston, a dancer and choreographer.

It was Lynn I really looked up to. She was successful and sexy, all black hair, voluptuous curves and violet eyes – for a time I thought she actually *was* Elizabeth Taylor.

Inspired by Lynn, I quickly became a regular on the local speech and drama festival circuit, blossoming from a shy little boy into a regular Laurence Olivier. The Barnsley Music Festival, Worksop and Pontefract Speech and Drama Festival – there wasn't a competition in the greater Doncaster area where nine-year-old Gary Cockerill didn't turn up to dazzle 'em with a poetry reading or mime solo and leave clutching a medal.

My festival crowd-pleasers included a poem called 'Colonel Fazackerley Butterworth-Toast' by Charles Causley:

> 'Colonel Fazackerley Butterworth-Toast
> Bought an old castle complete with a ghost
> But someone or other forgot to declare
> To Colonel Fazak that the spectre was there.'

and a reading from *My Family and Other Animals* by Gerald Durrell. I also did well with a group mime called 'Fickle-Hearted Sally' with my best friend at drama school, Gavin Morley – a stocky little bruiser with an angelic face and a halo of golden hair – and his girl-friend Nicola Simpson. But it was my performance of 'I've Got an Apple Ready' by John Walsh at the Barnsley Festival that really caused a stir and is possibly still talked about to this day. At this particular festival there was a choice of two poems for the age group I was in, and the one that I set my heart on started like this:

> 'My hair is tightly plaited, I've a bright blue bow.
> I don't want my breakfast and now I must go.
> My satchel's on my shoulder, nothing's out of place,
> And I've got an apple ready just in case.'

It's basically about how a little girl gives this bully her apple to stop him chucking her beret up in a tree on her way to school.

When I told Lynn Selby I wanted to do this particular poem for the festival she said gently, 'Gary, you realise that this poem is actually meant for a little girl …?'

My parents were even more tactful: 'Are you sure you don't want to try the other poem, love? You might find it a little bit … easier.'

But I was determined. I knew I could ace 'I've Got an Apple Ready' and I didn't care what anyone else thought.

I clearly remember the festival adjudicator's expression as I climbed up on to the stage and announced which poem I would be performing. I can still see the other parents in the audience looking embarrassed and shaking their heads at this strange little boy as the other kids sniggered at me. But I didn't care. I *was* that coy little girl with the blue bow and beret, goddammit! I'd show them. Ninety-eight points and a gold medal later and my cockiness levels had shot through the roof.

* * *

When I started at Lynn Selby's, I absolutely idolised two of the eldest students. Carl Gumsley and Gracinda Southernby were good-looking, bubbly, confident – your archetypical stage school kids. He was as dark and handsome as she was blonde and pretty. The pair of them were more than just an inspiration to me, I wanted to be them – well, more Gracinda if I'm honest. Even her name was fantastic. So when I turned on the telly one night and saw Gracinda pop up in an episode of top police show *Juliet Bravo* my mind was made up. Cleaning up at the local speech and drama festivals had been fun for a while, but I fancied getting my face on the telly.

I'd been going to stage school for a year when I had my first professional audition – a TV ad campaign for English Apples. Lynn took a group of eight of us from the school down to London on the train. The tickets weren't cheap, and I remember my parents had to

dip into their savings to pay for them, but they knew how badly I wanted to go. It was my first visit to London and by the time the train finally pulled into Kings Cross I was buzzing (and quite possibly flapping) with excitement.

The auditions were being held at an advertising agency on Charlotte Street where our little group queued up behind a line of dozens of kids that was already stretching up the stairs. As I waited, I thought again about my audition piece. In the circumstances, what else could it really be but 'I've Got an Apple Ready'? I was bursting with confidence.

Then suddenly it was my turn and I was ushered into a small room. There was a man standing in the corner behind a camera and another couple with clipboards and a box of apples.

'Right, Gary,' said one of the clipboard carriers. 'What we need you to do is stand over there' – I was directed to a cross on the floor – 'take a bite out of this apple, chew and then turn and give a really big smile into the camera, like it's the most delicious thing you've ever eaten. Okay?'

'Um, don't you want me to say anything?' I asked, my heart sinking. 'I've prepared a poem. It's about apples.'

'No, just the bite and then the smile, thanks. Right – let's go, give it all you've got!'

It was a green apple, sour and a bit woolly, but I did as they asked and was then shown to a large meeting room filled with a group of other kids.

Over the next few hours, I would go back into that little room and do the whole bite-turn-smile thing several more times until Lynn appeared, gave me a big hug and said, 'Gary, you got the job!'

On the way back to the station, my head spinning with dreams of TV fame and fortune, I popped into one of the tourist shops on Oxford Street to buy Mum a thank-you present. For some reason I ignored the London-branded trinkets and picked out a decorative plate covered with spriggy little flowers and the words 'Give us this

day our daily bread'. The only money I had on me was the emergency couple of quid Mum had given me in case I got lost, but I figured I could pay her back out of my advert earnings. The plate is still hanging on our kitchen wall to this day, a slightly kitsch monument to my first ever pay cheque.

Well, after that there was no stopping me. Blond, cute and cocky, I became a regular fixture in the nation's TV ad breaks. I was the voice of the Batchelors Mushy Peas commercial ('Who's the champion mushy peas? Batch-batch-batch-batch-batchelor! Champion mushy peas that please, Batch-batch-batch-batch-batchelor!') and one of the sailor-suited kids in a Birds Eye Fish Fingers ad. I popped up in kids TV shows like *Emu's World* and *Mini Pops*, the cult series in which pre-teens dressed up as famous pop acts to belt out their latest hits. I was in Showaddywaddy – or Showeenyweeny as we were known – and had to sing 'Under the Moon of Love' with a fake guitar, shiny purple suit and crepe-soled shoes.

I had been bitten by the fame bug and wanted more. I wanted to be Gracinda starring in *Juliet Bravo*. But even more than that, I wanted to be Andrew Summers. Ah, Andrew Summers: my nine-year-old nemesis. Andrew was a child star who found fame as the little boy alongside his granddad in a cult tomato soup advert of the late Seventies and at one time was virtually a household name. He was about the same age as me. 'Ooh, that Andrew Summers is a really cracking little actor …' people would say. I can remember being incredibly jealous of his success.

He's not that special, I'd sulk silently to myself, *he just gets all the adverts because he lives in London.*

It was a desperately sore point for me that I missed out on castings because I lived up North. My parents were amazing, but there was no way they could pay for me to travel down to London for auditions every week – even with the help of the money that I earned.

By this time, I was turning into quite the little performer. As well as acting, I was really getting into my tap-dancing (although I would never quite get to grips with ballet) and I had always had a strong singing voice. Before my voice broke I could belt out a Barbra Streisand or Julie Andrews number and sound exactly like my idols.

A few years ago I went to New York with Barbara Windsor to help get her ready for some personal appearances and one night we went along to hear the famous jazz singer Diahann Carroll in cabaret. During 'The Age of Aquarius' she handed the microphone around for a bit of audience participation and when I started singing I can remember Barbara turning to me, open-mouthed, and muttering, 'Where the bleedin' hell did that voice come from?'

With a few adverts under my belt, at the age of ten I appeared in the chorus of a stage show called *The Marti Caine Christmas Cracker* at Sheffield City Hall. It was a proper old-fashioned variety show – lots of big musical numbers, comedy skits, a bit of audience participation – fronted by the comedienne and singer Marti Caine, who had shot to fame winning the TV talent show *New Faces* a few years earlier. Marti was this incredibly thin woman with a tumbling mass of deep red, almost purple, curls and a broad Sheffield accent. She wore slinky jewel-hued gowns that emphasised her pipe-cleaner figure.

Ever the sucker for ballsy, glamorous women, I worshipped her. She was so lovely and warm, plus she had a mouth on her like you wouldn't believe which made me love her even more. My parents never swore in front of us when we were growing up, so to hear someone so famous and fabulous effing and blinding just added to Marti's exotic glamour. (The one and only time I swore at my mum in my life – telling her to 'fuck off' in a rare moment of early teenage rebellion – she grabbed me by the hair, dragged me to the bathroom and literally washed my mouth out with soap. I never did it again.)

* * *

Occasionally Sylvia Young would come up to our stage school in Doncaster to scout for talent, and it was on one of these visits that she put me forward for an audition for another stage show. *Once in a Lifetime* was billed as 'The brightest musical evening in the country' and was to be a vehicle for the talents of singer, dancer and all-round small-screen superstar Lionel Blair, who at this time was wowing TV audiences on the hugely popular charades gameshow *Give Us a Clue*, alongside fellow team captain (and star of *Worzel Gummidge*) Una Stubbs. This magnificent stage spectacular was set to go on a nationwide tour, from Bournemouth to Sheffield and everywhere in between, and they were looking for 20 talented youngsters – 'The Kids' – to star alongside Lionel.

For my audition I performed a song and tap-dance routine from *42nd Street* and did my Noah (of Bible fame) solo dramatic piece, which always used to go down well at the speech and drama festivals. Well, I tapped my little heart out and I got the gig, along with three girls – including my mate Gavin's girlfriend Nicola Simpson and my first-ever girlfriend, Kerry Geddes – and one other boy from Lynn's school. It was all over the Doncaster papers that these local stage school pupils were to be in Lionel Blair's new show, even making it into the *Yorkshire Post*. Move over Andrew Summers, Gary Cockerill had hit the big-time.

Rehearsals started in earnest just before the school summer holidays. The show was to open with 'The Kids' belting out the Anthony Newley number 'Once in A Lifetime' and as we launched into the final chorus a beaming Lionel would make his entrance through our carefully choreographed ranks, wiry arms flung wide, to rapturous applause. Then it was onto a Fred and Ginger number, something from *Cats*, a routine from *Bugsy Malone*: in short, an evening of back-to-back crowd-pleasers. Or, as the show's programme described it: 'a rollicking, rumbustious night, Gay Nineties style'. (I should probably point out that 'Gay Nineties' is a nostalgic term that refers to America in the 1890s, a period known for its decadence,

rather than anything to do with Lionel's passion for tap-dancing and improvisation.)

There were other acts too, including a pair of incredibly beautiful Italian acrobats called Angelo and Erica. Every night I would watch mesmerised from the wings as they ran through their routine, with the lovely blonde Erica balancing on the Adonis-bodied Angelo's upstretched hand, always thinking that this would be the night when he dropped her – although he never did. At the time I assumed they were married, but looking back, it's now obvious to me that no straight man has eyebrows that perfectly groomed …

It was during rehearsals for 'Once in a Lifetime' that a chink started to appear in my otherwise armour-like confidence. One of the song and dance numbers we were doing was 'Matchstick Men', in which we were dressed in caps and braces like the little stick figures from the famous L. S. Lowry paintings. For some reason, I just couldn't get the hang of this one dance move. It wasn't even particularly difficult. Thumbs hooked in braces, I had to kick up my left heel behind me to touch the right heel of the girl next to me, but I always ended up kicking the wrong foot, which meant I ended up standing out like a sore thumb amongst the ranks of perfectly drilled little stick figures.

On the day of the final dress rehearsal we were running through the number with the choreographer on stage, while Lionel and the producers sat watching in the auditorium. It came to the chorus – 'And he painted matchstick men and matchstick cats and dogs …' – and, regular as clockwork, I kicked up to the wrong side. Suddenly there was a yelp from the auditorium, the orchestra stopped playing and then Lionel was bounding up on stage, this incredibly wiry streak of energy. I remember being very much in awe of him because he was on television every week. I also remember him having the most terrible breath. I have no idea whether it was garlic or cigarettes, but these are the sorts of things that stick with you when

you're a kid. (I should say that I've met Lionel a few times since and his breath has been absolutely fine.)

All the kids waited nervously as he strode along our ranks before coming to a halt in front of me. He was almost always smiling, which made it all the more terrifying now that he had a face like thunder. He pointed straight at me.

'This boy' – he said to the choreographer – 'is getting the step wrong every time. You'll have to move him to the back of the chorus.'

'Of course, Lionel.' The choreographer turned to me, furious that this little brat was making him look bad in front of the talent. 'You, Gary – swap with Mark.'

And with that I was shuffled to the back, my cheeks burning with shame at my public humiliation.

'Right, everyone' – Lionel clapped his hands theatrically, then swept off the stage – 'From the top. A five, six, seven, eight …!'

As the music started again I went through the motions, but my mind was elsewhere. A thought had suddenly wormed its way into my head. *There are people here who are better than me at this.* And that thought terrified me.

The Once in a Lifetime tour was to prove a bittersweet time for me. On one hand I was appearing in a major production and lapping up the nightly applause and attention. We were treated like celebrities – staying in the best hotels, accompanied by chaperones and even getting asked for autographs at the stage door. (I would always sign mine with a big swirly 'Gary'; I never put my surname as I found it a bit embarrassing.)

I had a laugh with the other kids and, of course, my little girl-friend Kerry, although it was all very innocent – some kissing, a bit of hand-holding and one night a slightly awkward 'I'll show you mine if you show me yours' session in a deserted dressing room. On the other hand, however, appearing in the show marked the end of my friendship with Gavin Morley, who had become my best – and up until then only – male friend. When he didn't get a part in Once

in a Lifetime with me, Nicola and Kerry, he left Lynn's stage school and, as he lived in another village ten miles away, we drifted apart.

I needed all the friends I could get, as I had very few of them at school. When I was younger I'd always preferred to play with my sister and cousins, and then stage school became such a huge part of my life that I missed out on all the usual socialising kids do, the playing-out after school and the sleepovers. But it wasn't just that; I had this strong feeling that I was different from my classmates – special even. After all, I often missed school for some audition or performance, I was occasionally on the telly, I even spoke differently from the other kids after all the 'Red lorry, yellow lorry' elocution exercises at Lynn Selby's softened my accent. I hate to admit it, but I almost felt I was better than them – and, of course, that didn't go unnoticed by my peers.

The bullying started harmlessly enough.

'Oi, Gary, can I have your autograph?' some kid would shout after I'd popped up in another advert or the local papers. Being a mouthy little sod at the time, I would never just ignore it.

'Yeah, course you can!' I'd shoot back, cocky as ever. 'Bet you're jealous, aren't you?'

When I was ten my teacher contacted my parents to tell them I was getting a bit of hassle from the other kids, so my dad started taking me to karate lessons to help me take care of myself if any trouble kicked off. I loved the karate; it was just like another dance class for me, plus it was really lovely spending time with Dad. As I was to painfully discover, however, the whole self-defence aspect of karate – which had, of course, been the aim of the exercise – was pretty much lost on me.

I was on the school playing fields one day with Joanne, one of the few friends I had at the time. Joanne was a really lovely girl: funny, sweet natured, always smiling. She was also a quadriplegic, with neither arms nor legs, and confined to a wheelchair. It was one of the things that drew me to her, I suppose: in my eyes we were both

different from everyone else, both outsiders. So on this particular day I was pushing Joanne and we were chatting when a group of three lads from my class came over and started making the usual cracks about me being in the local paper.

'You think you're so much better than everyone else, Cockerill … Nancy boy … Pansy …'

I gave them a mouthful back and kept on walking, but today it didn't stop at verbal insults. Suddenly I felt an almighty shove and was knocked to the ground. Before I could move – or remember any of my months of karate training – I was roughly pulled up and held between two of the lads. I was vaguely aware of Joanne screaming, 'No, leave him alone!' Then an agonising explosion of white-hot pain as this kid kicked me in the balls with all his strength.

I lay on the floor, sobbing, winded, dizzily nauseous. I was still in agony when I got home that afternoon, but I didn't tell my parents what had happened. Instead I pretended I'd fallen off my Raleigh racer. I suppose I was embarrassed what Dad would say if he found out I hadn't stood up for myself.

* * *

13 February 1983. I still remember the exact date to this day. It was 10 a.m. and I was at London's Olympia for the biggest audition of my life. Just me and 10,000 other kids going for 46 parts in the debut West End production of *Bugsy Malone*. Every corner of the cavernous space was filled with wannabe Bugsys, Fat Sams and Tallulahs. It was exactly the sort of scenes you see at the audition stage of *The X Factor*, except with shrill-voiced pre-teens and pushy parents.

By the end of the day I was covered with a mass of the little coloured stickers they gave you when you successfully completed each round of auditions. I was recalled again the next day, and the following day I found out that I had got one of the parts. It was like finding one of Wonka's golden tickets. A role in a West End musical!

I was ecstatic, telling anyone who would listen that I was going to London to be a star.

When you're 13 you think the world revolves around you – well, I know that I did. But while I was busy dreaming about seeing my name up in lights on Broadway, the rest of my family were falling apart.

My sister, by then 17 and working for a local knitwear manufacturer, had been seeing a boy called Simon whose parents ran our village off-licence. He was a bit of a lad and my parents were adamant that he wasn't good enough; they wanted a doctor or a lawyer for their cherished only daughter. So when the relationship started to get more serious, Mum put her foot down and gave Lynne an ultimatum: either you stop seeing this boy or you leave home.

We'd always been really good kids and had never rebelled, so it must have been a huge shock to my mum when Lynne suddenly turned around and snapped: 'Fine – I'll move out.' And the next day she was gone. Without much money to find a decent place to live, she ended up in Hyde Park, the red light area of Doncaster, sharing a shabby bedsit with a prostitute and a scarily butch lesbian.

Devastated that her daughter had gone, but too stubborn to change her mind about Simon, Mum stuck her head in the sand. Lynne wasn't coping well either; each time I went to visit her she looked thinner, paler and more miserable. In the end she moved back home after four months, but although she gradually rebuilt her relationship with Mum, my sister stuck to her guns and refused to stop seeing Simon. And now, after more than 20 years of marriage and two beautiful sons, my parents realise that Lynne couldn't have made a better choice for a husband.

This emotional chaos was all going on when I landed the role in *Bugsy Malone*, so you can imagine that when my parents found out I would have to move to London for the show they weren't entirely enthusiastic. A few days after I'd heard I had got the part, Mum came

into my bedroom and sat me down on the bed. It was immediately obvious we were going to be having A Serious Chat.

'Gary, your dad and I have been having a talk.' From her expression I knew this was going to be bad. 'I'm sorry, love, but I'm afraid we both feel that it isn't a good idea for you to do *Bugsy Malone*.'

She went on to explain that they were worried about me having to live so far away in London on my own and missing so much school. She told me that she knew how important the show was to me, but that my education was ultimately the most important thing and I would understand this in the future. I think she even said something about the fact that I would miss my friends. But I'd stopped listening at the point when my world had collapsed on hearing: 'It isn't a good idea for you to do *Bugsy Malone*.'

As you can imagine I was devastated. I cried, I screamed, I banged doors, I sulked for a week, but their minds were made up. To make matters worse, there was so much hype around the production that it seemed like every time I opened the papers or turned on the television there was some mention of the show. And looking back, I realise that it was the *Bugsy Malone* fiasco that marked the beginning of the end of my performing career.

* * *

A few months later I auditioned for Rotherham Operatic Society's production of *Carousel* on the urging of my form teacher, a lovely lady called Mrs Empson who had always been a huge supporter of my passion for performing. I landed the role of Enoch Snow Junior, quite a principal part, but it was a disaster. For the first time ever I suffered from crippling stage fright, exacerbated by the fact that I fluffed my lines on the opening night.

Overnight my confidence and self-belief literally vanished. It didn't help that adolescence was kicking in; I had turned from this cute blond kid to – well, a bit of a geek. My hormones were all over the place, my hair was going from angelic golden to plain old mousy,

I was getting a few teenage spots. I went from desperately needing to be the centre of attention 24/7 to not being able to bear the thought of people even looking at me. Almost overnight I realised that I wasn't going to be a child star after all; I wasn't going to be famous and live in London like Andrew bloody Summers. At the age of 13, I faced up to the prospect that I was probably going to have to find myself a proper job, one that involved neither tap shoes nor TV cameras, and later that year I left Lynn Selby and Phil Winston's, never to return.

Thankfully I still had my love of art to fill the void left by performing. At school I would find any excuse to liven up classes with a bit of drawing: my French vocabulary exercises were carefully illustrated with mini French loaves and bottles of wine and my geography books were filled with intricate sketches of volcanoes and fossils. I would often get my schoolbooks back from the teacher with a big red 'This is not an art class, Gary!' scrawled down the margin. But a career as a designer or illustrator seemed like a far more realistic goal than acting, and my parents were thrilled that I was focusing on what they had always considered to be my *real* talent. Without drama to distract me, I knuckled down and became a model student – until I found something else to distract me. And that new obsession was girls.

THREE

Girl Crazy

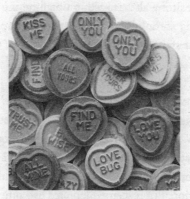

In my teens my future seemed all mapped out. I was going to meet and fall in love with a girl, get married and have kids; just like everyone else in Armthorpe. Having a girlfriend was the normal thing to do for lads my age – and after the drama (both on and off stage) of the past few years, all I craved right now was a bit of normality. So from the age of nine and those first shy, secret kisses with Kerry Geddes I was never without a girlfriend until I was into my twenties.

When that first romance with Kerry fizzled out I started going out with a girl who lived round the corner, Michelle Chappell. Again, the relationship was predictably sweet and naïve (a bit of kissing, some hand-holding, the odd fumble – real puppy love stuff) and my fledgling love life would have probably continued in the same innocent fashion if, at the tender age of 13, fate hadn't intervened in the form of my 15-year-old babysitter.

I had gone for a sleepover with my mate Scott Phillips, who lived at the other end of my village from me. His parents had gone out for

the night and left Jennifer, a friend of Scott's older sister Mandy, in charge of us two boys. Jennifer was 15, extremely skinny and as far as I remember pretty average looking. I'd met her once or twice before this particular night but hadn't given her a second thought. Anyway, by about 9 p.m. Scott had already sloped off to bed, leaving Jennifer and me sitting alone together watching the end of a film. I was just thinking about going up to Scott's room when I became aware of Jennifer shuffling a bit closer to my side of the sofa.

'Gary?'

'Yeah?'

'Do you fancy me? 'Cos I think you're really nice.'

I sort of shrugged, folded my arms across my chest and continued to stare at the TV. I had barely spoken to this girl before and certainly didn't find her attractive; besides, she was so *old*. I was out of my comfort zone and I hoped that keeping quiet would mean the end of the conversation. But it seemed Jennifer had other ideas. I could tell she was still staring at me, and when she realised I wasn't going to answer she swiftly pulled off her T-shirt, undid her bra and then grabbed my hand that was nearest to her and crushed it up against her tiny breasts.

Alarm bells went off in my head. Wide-eyed and barely daring to breathe, I continued to stare at the telly with one hand still stuck awkwardly against Jennifer's chest. Nothing in my 13 years had prepared me for this situation. Of course, I should have made my excuses and gone upstairs to join Scott on his Doncaster Rovers bunk beds, but I was frozen with fear and confusion – a rabbit caught in a pair of (very small) headlights.

'Well, what do you think of these, Gary?' Jennifer was getting impatient.

'Um …' I eventually mumbled. 'They're alright, I s'pose.'

Well, that was all the encouragement she needed. Off flew the rest of her clothes and then she was down on the floor and telling me to take off my trousers. I remember the musty smell of the carpet and

the light from the TV flickering on the wall as we lay there, Jennifer rubbing awkwardly against me while barking out orders. There was no kissing or caressing: it was cold and mechanical – I certainly wasn't enjoying myself and I don't think she was either. There was just a strong sense of embarrassment mingled with a vague curiosity, a feeling of *what the hell is happening here?*

Nonetheless, after a short while all the rubbing and touching led to its obvious conclusion, which seemed to satisfy Jennifer as she immediately sat up and got dressed then went back to watching the TV as if nothing had happened. I didn't mention a word of what had happened to Scott and after that night I never saw Jennifer again. At the time, I don't think I even realised that I had actually lost my virginity down there on that musty carpet.

* * *

Despite a few years of adolescent gawkiness and confusion, by the age of 15 it had all started to turn around for me. Physically I had filled out and mentally I had rediscovered some of that old Cockerill cockiness. Not only that, but I realised that I had in my possession a rare and precious gift: I knew how to talk to girls. After all, we had exactly the same interests – hair, make-up and fashion.

Well, after that there was no stopping me. I became obsessed with girls. Obsessed! Honest to God, Mum would come home at lunchtime during the week and catch me with my latest girlfriend. My usual type was blonde, blue-eyed and petite, and when the popular boys in school saw me hanging around with the prettiest girls they started to wonder, 'What's Gary's secret?' and I began to get lots of boy mates, too. I might have been useless at football, but I certainly got kudos for being a babe magnet.

At this stage of my life I didn't know anyone who was gay, openly or otherwise. The only exposure I'd had to gay men was watching the likes of Larry Grayson and John Inman on telly, those Eighties stars of the small screen who camped it up for laughs, but even then

no one actually referred to them as being gay or homosexual. I just could tell that they were a bit … well, different. But from an early age I had known that the feelings I had for my idol Madonna were very different from those I had towards the movie star Rob Lowe, whose poster also graced my bedroom wall. I worshipped Madonna and loved her music, but when I looked at Rob Lowe … I didn't know if I admired his talent, wanted to look like him or even to be him, all I knew was that I just found that face incredibly appealing.

Throughout my early teens the thought occasionally crossed my mind that I might possibly be bisexual, but I wasn't tortured by it. There was no particular angst or guilt that I was living a lie. When I was with my girlfriends I certainly wasn't pretending they were blokes – I really did fancy them. But just before my sixteenth birthday something happened that would drastically shift my whole perspective.

It was one of those incredibly hot summer evenings, 9 p.m, but still light, and I was riding my bike back to Armthorpe after visiting friends in a neighbouring village with my mate Robert Connor. It was getting late, so we decided to take a shortcut home across a stretch of rough ground. Soon the grass got too thick to ride so we got off the bikes to push.

I think we may have had a couple of sneaky beers earlier in the evening and the conversation quickly turned to girls and sex. The heady combination of underage booze and the sultry heat of the evening had an immediate effect, and it was soon obvious that both of us were getting turned on. Minutes later we ended up behind a hedge touching each other.

It was almost over before it started, but I remember thinking it didn't feel wrong. Quite the contrary: it seemed completely normal and natural to me. For the first time in my life I thought, 'Hang on a minute – am I gay …?'

Robert and I both picked up our bikes and continued the walk home in sheepish silence. But as I lay in bed that night going over

and over what had happened I made a conscious decision. Okay, so I might well be attracted to guys, but I knew that I definitely wanted to get married and have kids. Besides, I still really liked being with girls. I vowed the events of that night would remain a secret – after all, it wasn't as if anyone would suspect that Gary Cockerill, Armthorpe Comprehensive's answer to Mick Jagger, was actually gay!

It was only recently that I found out that when I was younger my Granddad Joe would tell anyone who would listen: 'I'll go to the foot of our stairs if our Gary doesn't bat for the other side when he's older …'

* * *

I breezed through secondary school. Bar a few girl-related incidents (I had a lot of lectures from a lot of different dads during my teenage years) I was a hard-working and well-behaved student, even being made a prefect in the final year. I did well in my O-levels – apart from Maths, which I took at CSE level and barely scraped a grade 5 – and gained A-levels in Art and English, taking Art a year early and still getting an A grade.

While my friends were planning on becoming electricians or plumbers, I was dreaming of a career as a graphic designer or illustrator. The school career advisers were quick to sound a note of caution – 'There aren't that many opportunities round here for that sort of thing, Gary. Why don't you get a trade?' – but I was determined I wouldn't end up on the YTS or in an apprenticeship. I was going to go to art college.

Mum and Dad were as thrilled as I was when I won a place to study design and illustration at college in Doncaster. They certainly weren't the sort of parents who would have supported the idea of dossing around India on a gap year. Sure enough, although I had three months off before the course started, any hopes I might have had of enjoying my last summer of freedom were dashed on day one

of the holidays when Mum came into my room, dragged me out of bed and said, 'Right, time to get off your arse and do something useful.'

I signed on the dole, but that wasn't enough for Mum, who was still badgering me about getting a job, so I decided to do a City and Guilds course – that way I'd earn a bit of money and learn a new skill at the same time. I flicked through the list of dull-sounding courses until I spotted one in Hairdressing. It certainly wasn't something I wanted to do as a career, but it sounded slightly more artistic than other options like 'Warehousing and Storage' or 'Drink Dispensing', which is how I found myself in a Doncaster city-centre salon called Mr Terry's, learning how to cut, blow-dry and set hair.

Getting a formal training in what had up until then been just a hobby set my creative juices flowing and triggered a period of serious experimentation with my look. One particularly striking style was a sort of mullet with benefits: short and spiky on top, arrowhead-shaped sideburns and longer bits at the back that I would then perm. It was the Eighties after all. I also put streaks into my mousy hair with Sun-In spray, although they ended up a garish orange rather than the sun-kissed surfer blonde I had envisaged.

Still, I thought confidently, at least my daring new look would help me fit in with all the cutting-edge creatives I would be meeting at art college …

* * *

Doncaster Art College was housed in a forbidding red-brick building – more Victorian lunatic asylum than vibrant centre of creative excellence. Inside it was always dark and cold, even on the hottest summer day, and the warren of gloomy corridors echoed with the drip-drip-drip of long-neglected plumbing and the lingering smell of damp and disappointment.

I had assumed art colleges would attract exciting, passionate people, bubbling over with creativity and imagination. That may

well be true, but not at the one I went to. It quickly became apparent that my course was a dumping ground for wasters who had gone to college because they couldn't be arsed to get a job and reckoned art would be a soft option.

The teachers weren't much better. I was there for five full days a week throughout term-time, but the work I actually did in that time could have been completed in half an hour. I had gone on the course to prepare me for a job in design, but the teachers were completely out of touch with the realities of the industry. They convinced us that we would walk into an amazing career as a designer or illustrator on graduating, but there was no preparation for how tough things were in the job market for new design graduates – particularly ones from the North.

I can't even look back fondly on the social side of college life, as I only made two friends on the course and went to perhaps a couple of functions a term at most. This wasn't me being unfriendly: most of the other students were only interested in getting drunk or high, and to be stuck in a room full of people off their tits on Ecstasy when the strongest thing you've had is a couple of vodka tonics is to experience a new level of tedium.

Perhaps my own expectations had been unrealistic – and I'm sure things are completely different these days – but I can't tell you what a disappointment those two years at college turned out to be. True, I gained a BTEC diploma in Design and Illustration, but I can't think of one useful thing that I learnt. The only positive to the whole experience was that it kept me off the YTS.

* * *

Thankfully, I had something to keep me sane during those dark years at college – Kim Foster, the girl who would very nearly become my wife.

I met Kim at a youth club party during my last months at Armthorpe Comprehensive. I had gone to the party with Robert

Connor (we were still friends, having made an unspoken vow never to talk about what had happened on that summer evening bike ride) and we were hanging around by the edge of the dance-floor, nodding along self-consciously to 'You Spin Me Round' by Dead or Alive, when I spotted a girl I had never seen before. She was petite and girl-next-door pretty with lots of curly blonde hair, a sprinkling of freckles and very white teeth. In other words, right up my street.

'Rob, check her out.' I nodded towards where the girl was standing with some of her friends.

'Oh yeah, that's Kim Foster,' said Robert. 'Her dad's a building contractor, does a bit of work with my old man. You've got no chance, mate.'

I turned and grinned at him, then went straight over to where Kim was standing and introduced myself, with Robert trailing sulkily along in my wake.

Kim was a year younger than me and lived in a village called Bessacarr that was only a few miles from where I lived but might as well have been on a different continent. I had known nearly all of the girls of my age in Armthorpe since infants school so there was an air of mystery about Kim, an alluring sense of the unknown that seemed almost … exotic. She knew nothing about me either, and I really liked the fact that I could reinvent myself when I was with her. I can't say it had exactly been love at first sight, but cycling home from the party that night I couldn't stop thinking about her.

Although we hadn't had a kiss that first evening – despite my best efforts – over the next few weeks Kim started to hang around with my group of mates and we gradually became closer. I knew that Robert fancied her too, and there was a bit of friendly rivalry over which of us could pull her first, but walking her home one night I took my chance, leaning in for a kiss, and from that moment on we were inseparable.

Kim lived a half hour bike ride from my house, but I would bomb round to see her on my racer every afternoon after school. Not only

did I love spending time with her, I really enjoyed going to her house too. Her family lived in a big detached house on a private lane – much posher than our little bungalow – and I got on brilliantly with her mum and little sister Clara. Her dad was away working most of the time so I would be in my element, surrounded by females.

We had a really sweet, romantic relationship, always sending cards and leaving little love notes for each other, having cosy nights in watching videos or occasionally going out to local pubs and restaurants on double dates with our best friends Joanne and Martin. We had sex for the first time on her sixteenth birthday and – it being the first time I had slept with someone I had actually loved – it felt really special. I was experiencing that heady falling-in-love high of wanting to spend every moment with someone and I began to think that Kim could be The One.

* * *

One of the things that first attracted me to Kim was that she was a real girly girl; we bonded over our mutual interest in fashion and style. After we had been going out for a year or so she started highlighting her hair and experimenting with her look, and it was around this time that she first asked if I could have a go at doing her make-up. Although I had been sketching women's faces for years, I hadn't had much hands-on experience with lipstick and eyeliner beyond those early experiments on my sister's dolls, but my artistic talent and lifelong obsession with glamour was more than enough to get me started.

Well, after that there was no stopping me. I'd transform Kim into Madonna from her 'True Blue' video one day, Cyndi Lauper in 'Girls Just Wanna Have Fun' the next. Stylewise, the Eighties were all about bright, clashing make-up, trashy clothes and frizzy perms – and I certainly didn't hold back in those early makeovers. The results are pretty horrific in hindsight, although it seemed fabulously cool and creative at the time.

By the time I started college Kim had blossomed from a pretty girl into a stunning young woman with a gorgeous figure, and when I needed a model for the photography module of my course she was the obvious choice. She had left school by this point and was doing office temp work while she decided on her future direction, so when she turned out to be extremely photogenic and a natural in front of the camera it got her thinking about modelling as a possible career.

As she was a good few inches too short for the catwalk, I suggested she might think about glamour instead; I remember showing her a picture of Linda Lusardi in the *Sun* and telling her: 'You could so easily do that.' Kim just had the right smile, the right look – that magical blend of sexy yet wholesome essential for Page 3 models. The thought of my girlfriend getting her kit off in front of the camera honestly didn't bother me; having been at stage school I knew it was just a performance. In fact the idea seemed impossibly glamorous to both of us, and I happily took a few topless photos of her that she sent to a local agency in Doncaster who then snapped her up.

I proposed to Kim on her 17th birthday. We had gone for a romantic curry at our favourite restaurant, the Indus in Doncaster, and I popped the question after we'd finished our dinner. I'd like to say that I hid a diamond in her saag aloo then toasted our future together with vintage champagne while a waiter played 'Endless Love' on the sitar, but the truth is rather less impressive. After our plates had been cleared away I got down on one knee and sheepishly presented her with a Cubic Zircona ring that I'd bought at Elizabeth Duke in Argos. Nevertheless, it was an incredibly special moment for both of us and we were in floods of tears as Kim sobbed out 'Yes!'

When we told our parents they pretty much laughed it off. They knew we were much too young, but I'm sure they assumed it would eventually fizzle out and so, to their credit, they didn't kick up a fuss. Good job too: if they had, we might well have done something daft

like running off to Gretna Green to get married – and God knows how *that* would have turned out.

As far as Kim was concerned, there was never any reason to question my heterosexuality. I remember one day we were watching some frothy American drama on TV when I nudged her and said, 'That actor's really good-looking, isn't he?'

Kim made some non-committal noise and continued watching.

'Don't you think it's a bit odd, babe,' I persisted, 'for me to think a guy is attractive?'

I was genuinely surprised she hadn't picked up on what I had just said; deep down, perhaps I was even hoping she might guess my secret.

This time she stopped looking at the TV and turned to me, confusion etched across her face.

'Why would that be odd, Gary?' she asked. 'I tell you if I think a girl's pretty and it's just the same thing, isn't it?'

'Um, yeah, I suppose,' I said.

And that was the closest we came in our whole six-year relationship to discussing my sexuality. Even towards the end, when I was having such a struggle to maintain the façade of being straight, she never seemed to have any inkling of the fact that I was, in effect, living a lie. My effeminate side clearly hadn't gone unnoticed by others though …

It was a Sunday morning and Kim and I had taken her Jack Russell Toby for a walk around the boating lake in Doncaster. It's a nice little park, well maintained and popular with families, and on this particular day it was busy with parents pushing prams, young kids running around and elderly couples enjoying a post-lunch stroll in the sunshine. We were about halfway around the lake when I spotted a kid who I'd gone to school with sitting on the wall with a gang of mates.

His name was Ted Peters and he was seriously bad news. He was always being suspended and constantly having run-ins with the

police; everyone was scared of him – even the teachers. He even looked like trouble: well over six foot and built like a brick shithouse with close-cropped black hair and a jagged scar right down the side of his face. At school I'd always given him a wide berth and he'd pretty much ignored me in return; even so, when I spotted him in the distance on this particular day alarm bells started ringing and I immediately said to Kim we should take a different path.

'Don't be silly, babe,' she scoffed. 'He won't even remember who you are.'

I figured she was right; after all I hadn't seen him for a few years. But as we walked towards him it became clear that he certainly had remembered me – and the uneasy truce we'd had at school clearly no longer held.

'Oi, poofter!' Ted shouted, nudging his mates, and then deliberately mispronouncing my name. 'Cockerel, you fucking nancy boy! Cock-a-doodle-doo!'

His mates started laughing and crowing along with him as he jumped off the wall and sauntered towards us.

I was instantly on my guard, but was reassured by the fact that it was broad daylight and there were so many people around us. I grabbed Kim's hand and started to walk away, but his mates cut us off and surrounded us.

'Who's your slag then, Cockerel?' Ted nodded at Kim. 'Alright darlin', what you doing hanging around with this poof? You should get yourself a real man.'

He grabbed his crotch and his mates laughed and taunted. Then suddenly Ted made a lunge at Kim.

'What the hell are you doing? Pack it in!' I screeched, trying to push him off her. That was obviously what he had been waiting for and Ted immediately launched himself at me, punching and kicking me to the ground. Kim was hysterical, sobbing and screaming, while Toby (whose lead I had dropped in the scuffle) was jumping around, yapping frantically.

On a relaxed Sunday afternoon you'd think that all the shouting and barking – not to mention a girl screaming for help at the top of her voice – would have attracted a bit of attention, but it was as if we were completely invisible. Perhaps people were scared for their own safety, but it was only when all the boys grabbed me off the floor and threw me into the lake that a couple of men finally stepped in and Ted and his gang sauntered off, laughing and jeering as they went. It was probably just a bit of fun to him, but I have no doubt that if it had been dark Kim could have been raped and … well, God knows what would have happened to me.

* * *

By the time I had finished my first year at college – one down, one to go – Kim's modelling career was taking off. She was heading down to London every few weeks for castings and had started to make a few model friends, including a pretty Geordie brunette called Jayne Middlemass who was already becoming known as a Page 3 girl and later, as Jayne Middlemiss, made a name for herself on TV.

Although I had a student grant to help support me through college it barely kept me in pencils, so I got a Saturday job at a hairdresser in a nearby village. The clientele was wall-to-wall *Coronation Street* grannies and I spent my whole time doing shampoos and sets, but the pay wasn't bad and I enjoyed hanging out with the salon's owner, a gay guy called Jason who was best friends with a hugely fat older woman he called Boobs. She was your classic fag hag, always dressed in some outrageous too-tight outfit with everything spilling out. 'Alright, love?' Boobs would greet me in her raspy 60-a-day drawl.

The salon work helped out with living expenses, but when the summer holidays came round I was desperately in need of funds. Scouring the local papers for work, I spotted an advert that immediately caught my attention: 'Have you got star quality? Do you love working with people? If that sounds like you, you could be a Red

Coat! Butlins Skegness is looking for bright young people to join our award-winning team.'

Well, it seemed like the perfect job for me. Not only did I have all those years of showbiz experience under my belt, I was a huge fan of *Hi-de-Hi*, the long-running BBC sitcom about a fictional holiday camp. What with the kitsch seaside setting, Ruth Madoc running around in her little white shorts, the beauty pageants and the ballroom dancing, it actually all looked quite glamorous to me.

I was interviewed by one of the camp managers who made working there sound like a trip to Disneyland. Perhaps I should have realised something was up – it was almost as if he was trying to convince me to take the job, rather than the other way round. But I was seduced by the prospect of returning to my showbiz roots, the camaraderie of camp life and the possibility of getting a tan while I worked, and I leapt at the job when he offered it to me, also persuading Kim – who was temping in an office to supplement her modelling income – to quit her office job and come along to live the Red Coat dream with me.

We arrived at the camp on a typical English seaside summer day – grey clouds and drizzle, which would in fact linger for most of our stay. We were shown to our digs. You know that advert where a flat looks like it has been burgled, but in actual fact it's just a complete tip? Well, that should give you some idea as to the state of our chalet.

I stared in horror as I noticed a cockroach scuttle beneath the wardrobe, praying that Kim wouldn't notice (she didn't, although she certainly didn't miss the rest of his mates who turned up later that night to join the party). The room stank of stale cigarette smoke and rotting food; after a few days we actually found a long-forgotten burger mouldering under the bed. The carpets, presumably once light brown, were now patterned with an incredible variety of stains and dried-up spillages which felt crusty underfoot – if you were stupid enough to take off your shoes, that is. And as for the bed – well, the wafer-thin mattress was bad enough, but the bedding

clearly hadn't been washed since last season's inmates had escaped. Once I discovered the communal laundry I realised why: the washing machines were so filthy that anything that went inside would come out with a whole new set of stains. Bearing all this in mind, I don't think I really need to spell out to you what the communal toilets were like.

Desperate not to linger in our chalet on that first day, we went off in search of the staff canteen. I still remember the smell of those huge industrial kitchens and the vats of grey slop bubbling away like some primeval swamp. That night dinner was sausage and chips, but the chips were still frozen in the middle and the sausages were made out of all the unmentionable bits that were left over after all the edible parts of the animal had been removed. You couldn't even get a drink to ease the ordeal of mealtimes, as the camp's staff members weren't allowed to drink alcohol onsite.

We later discovered that everyone got round this rule by having secret parties in each other's chalets with smuggled-in booze and, as most of the employees were single and bored out of their minds, these illicit gatherings usually turned into orgies. During our short stint at the camp there was an outbreak of crabs because of the feverish partner swapping that went on.

'Gary, we're leaving,' sobbed Kim at the end of that first night. 'I don't want to stay here another day. This is awful.'

'Come on, babe, let's give it a bit more time,' I begged. I was as horrified as she was, but I was desperate for the money. 'I promise I'll talk to them about the chalet. We've committed ourselves now, and I'm sure things will get better once we start our Red Coat training. Okay?'

But at the next morning's 'welcome' meeting for us new recruits there was another shock in store. Any hopes I'd had of revisiting my past glories on stage vanished as quickly as a glimpse of Skegness sunshine when we were told that we would have to earn the right to become Red Coats by working in other positions in the camp first.

Forget judging the knobbly-knees contest or teaching tap-dancing, we were going to be waiters. And far from a jaunty scarlet jacket and crisp white trousers with matching shoes, my new uniform consisted of a short-sleeve shirt, too-short black trousers and a name-badge that (thanks to some administrative cock-up) read 'Hello, I'm Barry!'

And so Kim and I spent the three weeks we lasted at the camp shuttling between the kitchens and cavernous dining room to serve up deep-fried nuggets and over-boiled vegetables to the largely disgruntled clientele. After a few weeks of drudgery, and desperate to salvage something from the whole disastrous episode, I took the manager to one side after our breakfast shift.

'Hi, Clive!' I said, dazzling him with my best toothy showbiz smile. 'I didn't want to make a big deal about this, but I should probably tell you that I used to be a professional performer.'

The manager seemed engrossed in the paperwork on the clipboard he was carrying, so I pressed on.

'I appeared in a nationwide theatre tour with Lionel Blair and was in musicals like *Carousel* and *Jesus Christ Superstar*,' I continued brightly, exuding what I hoped was Red-Coat-like bubbliness and positivity. 'I'm a really strong singer and I can tap-dance and do a bit of ballroom as well! So basically, given the chance, I think I'd make a great Red Coat and be a real asset to your team.'

Clive finally looked up from his clipboard, scratched his crotch and squinted at my name-badge.

'Barry,' he said slowly, with the look of a man who'd endured a lifetime of economy sausages, stained carpets and broken dreams. 'I really don't give a shit.'

FOUR

Hell on Earth

'So, lad, why d'you want to be a miner?'

The three colliery bosses – proper salt-of-the-earth Yorkshire men, with flat caps and flatter vowels – were looking at me expectantly from behind the trestle table that dominated the cramped office where the interviews were being held. Even in the dingy light of the room I could see the coaldust trapped under the men's fingernails and their leathery, calloused hands. *Miners' hands.*

I had queued up all morning with dozens of other local lads for my chance to be here, but now that I finally had my moment in the spotlight my mind had gone blank. Exactly why *did* I want to join the workforce at Markham Main, Armthorpe's colliery?

I'd never had a problem with interviews – years of waltzing through stage school auditions had left me confident to the point of cockiness – but today was different. Today, I was going for a job that I urgently needed, but was absolutely dreading getting.

* * *

Growing up, the view from my bedroom window was dominated by the hulking, coal-black silhouette of Markham Main. To my over-active young imagination, the distant outline of the colliery buildings was a vision of hell, with the mine's vast wheel and clanking conveyor belt rearing up out of the slagheap like some nightmarish fairground ride. The pit was only a mile from my home, but it might as well have been in a different hemisphere. Although the colliery was the reason for my hometown's existence and the main source of income and community for the majority of its residents – including most of my school friends' families – as far as I was concerned it had absolutely nothing to do with me. There were few mining families living in the smart new estate where we had our semi-detached bungalow, and my parents had drilled into me from a young age that I should never even think about joining the local industry.

'No son of mine is ever going to put his life at risk working down the mines,' Dad would lecture, stony-faced – and that was absolutely fine by me. I'd go round to friends' houses for tea and stare with barely concealed horror at their fathers' ruined hands and coal-blackened faces. And although I would see the miners trudging past my school every day in their luminous safety vests, helmets and hobnail boots, always covered in a blanket of coaldust, they might as well have been aliens for all the relevance I thought they had to my existence.

It wasn't just the thought of working in such dark and dangerous conditions that seemed so strange and scary to me, it was the whole lifestyle that came with the job. After a day down the pit I'd see my friends' dads head off down the pub or the miners' welfare club for pints of beer and games of darts and snooker and banter about birds and football, and I would silently vow to myself, *not me. Not ever.*

* * *

I had spotted the advert in the *Doncaster Free Press* when I was doing my weekly trawl of the job section.

WANTED – A NEW GENERATION OF MINERS FOR
MARKHAM MAIN COLLIERY, ARMTHORPE

It was the early Eighties, Arthur Scargill was raising hell and there was a drive to revitalise the colliery, a last-ditch attempt to save the local industry by injecting a burst of youthful energy. But it was the last line of the advert that jumped off the page and grabbed my attention.

EXCELLENT RATES OF PAY

I was 18 and in desperate need of money. When I had graduated from art college a few months previously I had assumed I would walk straight into a design job in Sheffield or Doncaster, but despite what the tutors had promised us the opportunities just weren't there. I knew that my only hope of success was to go to London, that magical place where the streets – if not quite paved with gold – were at least paved with advertising agencies and trendy design studios where an ambitious graduate might make their fortune.

Kim had by now secured a modelling agent in London, so we had decided to move down South and get a place together. Besides, Armthorpe no longer held any appeal for me. Most of my friends seemed content to remain in the village forever with their apprenticeships and girlfriends, their lives comfortably mapped out, but in my mind I was destined for bigger and better things.

I've got to get out or I'll be stuck here forever, I would panic as I sat through another night down the pub with people with whom I increasingly felt I had nothing in common. But to start a new life in London required serious funds, which is why, when I spotted the newspaper advert, I shrugged off a lifetime's prejudice and dialled the number without a second thought.

I didn't tell my parents I was going for a job at the colliery. There was no point; I knew what their reaction would be. Kim wasn't keen

either, but she understood we needed to get some money together in order to start our lives together in London. Which is why I found myself here, within the gates of Markham Main for the first time, sitting nervously in front of the colliery's three wise men.

'I don't come from a mining background and I haven't had any experience of this sort of work,' I told the panel of flat caps. 'But I want to put 100 per cent into this. I'm a hard worker and a quick learner, and I'm really interested in a career in, um, coal.'

'Well, Gary, you're a bit … over-qualified for this job,' said one of the men, glancing over my cv. 'But you've got a good attitude and seem like the sort of lad who'd do well here at Markham. You'll start the training next week. Well done, lad.'

On the walk back home, I thought about bottling it. Now I'd actually been offered the job all my old fears bubbled back up to the surface: I was convinced I would die or be hideously maimed in a tragic accident – at the very least end up with permanently blackened fingernails. But by the time I arrived back at my front door I had made up my mind to accept; if I'm honest, there had never really been any doubt that I would after they'd told me the dizzying figures I could earn by clocking up double shifts and over-time. For five hundred quid a week Mum and Dad would understand. Eventually.

* * *

There was no sign of the dawn when I got on my bike just before 5 a.m. and pedalled furiously through the freezing winter darkness towards the colliery for my first day down the mine. I was carrying a flask of strong tea and the sandwiches my mum had left out for me the night before. She might not be happy about her son's new career (in fact that would be a considerable understatement) but after a screaming argument she and Dad had at least grudgingly understood my reasons for taking the job.

I'd already sat through four weeks of classroom-based training to prepare me and my fellow recruits for pit life. There were a few lads

who, like me, saw this as an opportunity to earn a fast buck then move on to bigger and better things, but the rest of them were from mining families and landing a job at the colliery was the pinnacle of their ambition. I just couldn't relate to their mentality: go underground, do the job, get pissed – that was all they seemed to want out of life.

I thought they were thick and lazy, and I'm quite sure they hated me in return. They certainly thought I was a snob and picked up on the fact that I was a bit more sensitive and softly spoken, as I got called a 'fucking poof' on more than one occasion. Some of them had been to school with me and knew all about my dancing and singing career as a kid, so they had plenty of ammunition. They'd even take the piss out of my sandwiches, because Mum would put a bit of salad in with the filling instead of their bog-standard plain cheese spread or fish paste. But I really couldn't give a toss. I was impatient to start raking it in as quickly as possible so I could escape this hellhole.

I passed through the colliery gates, locked up my bike and reluctantly joined the mass of men clocking in for shifts, our breath showing like puffs of steam in the icy morning air. Then it was straight over to the changing rooms where I jostled through the throng of bodies towards my locker, avoiding eye contact as much as possible. I remember the smell of that room to this day – damp, dirty, earthy. It was the smell of the mine.

I tried to calm my ever-increasing nerves by focusing on the process of getting myself dressed in my kit: first the thermal pants, vest and leggings, a rough cotton shirt that felt like it was made from hessian then a one- or two-piece overall over the top. Big socks and those hard, heavy boots. And finally a big navy overcoat, the Armthorpe logo proudly stitched on the breast, and a white helmet with a torch. Nothing fitted me properly. I was a skinny thing when I was younger – tall, but with hardly any meat on me. I wasn't bred to be a miner like most of them down there.

My heavy boots rubbed and the helmet dug into my scalp as I followed the army of navy-coated clones trudging across the yard to a low concrete bunker. This nondescript building held the lift that would plunge us over a mile and a half down into the blackness. One of the foremen counted us as we filed past him so they'd know how many of us went in and (I realised with a stab of fear) how many of us came back out again.

You're going to die in there! screamed my inner drama queen, always alert to potential disaster. But it was too late to turn and run, as I was carried along by the tide of bodies into the bunker, through the double set of metal lift gates and into the mouth of hell. The lift was only a couple of metres square, but there must have been about thirty men crammed into the tiny space. A packed Tube at rush hour has absolutely nothing on a colliery lift. Bloody sardines, we were, squeezed so tight that it was impossible to take a deep breath – which was probably lucky what with the reek of farts and stale beer fumes. When every last millimetre of space was filled the heavy gates were shut with a deafening clank, a siren sounded, lights flashed and then – terror. Sheer bloody terror as we fell at unimaginable speeds down, down into the bowels of the earth …

After what seemed like a few seconds the brakes kicked in with a squealing, shuddering shriek and the lift lurched to a stop, my stomach arriving a moment or two behind it. Before I had time to recover, the doors slid open and a blast of icy cold air rushed into the stuffy lift as I was carried out by the crowd into … God knows where.

Once my eyes had adjusted to the unexpected brightness, I could see I was I was standing in a vast underground cavern lit by huge florescent lights. Coughs, occasional shouts of laughter and the constant drip-drip-drip of water echoed around the cavernous, freezing space. Under my boots the floor was slushy and damp, like it was covered with melting black ice. From here, tunnels radiated in every direction – some like subterranean super-highways supported by soaring steel arches, others (I would discover to my horror) so

tiny you'd be forced to get down on your hands and knees and crawl over the icy gravel.

You could be trudging for miles, often in complete darkness as the lights frequently failed – and at the furthest point from the lift shaft was the blistering-hot black heart of the mine, the coalface.

* * *

Life down the mine was one of extremes. You were either working in the freezing cold, or – depending on how near to the core you were – unbearable heat. It must have been 100 degrees at the coalface. The machinery used for cutting away at the rock got so hot that you constantly had to pour water on it to cool it down, one of my jobs as it turned out. Similarly, it was either completely silent or so deafening that despite wearing ear protectors you'd still have tinnitus by the time you got up next morning.

As I was one of the brighter of the new recruits – and possibly because I was built more for tap-dancing than rock-smashing – I was assigned a job that relied on brains rather than brawn. My responsibility was safety: making sure machinery was running smoothly and official procedures were correctly followed in whichever area I was assigned to that day. Sort of like the swotty school prefect who checks all the students' ties are done up and shouts at them for running in the corridors, except I was having to boss around men twice my age and size. Unsurprisingly, this role did little to improve my reputation with the other miners, especially as most of the time they paid next to no attention to the rulebook.

'Er, sorry, but you really should be wearing your helmet in this area,' I would mutter to some huge hulk of a man.

'Why don't you just fuck off, Cockerill?'

'Um, right. Okay.'

The men tended to do exactly what they wanted, which is probably why there were so many accidents. What with the very real threat of fire, explosion, poisonous gas leaks, suffocation, roof

collapse and the terrifying machinery – including an enormous corkscrew-like drill that could shear off layers of rock to reach the seam of coal as effortlessly as slicing through a joint of ham – a mine is hardly the safest working environment at the best of times. There were enough ways to die down there without some wanker lighting up a cigarette or forgetting to apply a safety brake. It didn't take me long to realise why the pay was so good on this job: that 500 quid I was pocketing at the end of each week was actually danger money.

One day I was working by the side of the tracks that carried the carts of coal up from the depths of the mine. Each of these wagons was the size of a small car and, filled to overflowing with its black cargo, unimaginably heavy. Suddenly there was a yell and a clatter and I turned, terrified, to see one of these monster trolleys careering out of control down the slope towards where I was standing. I threw myself out of the way, ending up with only a gash across my forehead and a few bruises. The lad I was working with wasn't so lucky – poor kid was stretchered out with a shattered leg, sobbing and screaming for his mum.

During my seven months at Markham Main a bloke had his arm severed in an accident and another, tragically, was decapitated when he became entangled in machinery at the coalface. I wasn't there when he was killed and I barely knew the guy, but I remember standing by the side of the street with the rest of the village as the funeral procession went past, an entourage of dozens of black-clad mourners following a magnificent horsedrawn coffin, barely visible for all the wreaths.

Death was a fact of life down the mine. The older miners would take great pleasure freaking us out with tales of ghosts haunting the tunnels and distant caverns of Markham Main. You'd be on your own, dozing off in the gloom, when someone would creep up on you – just to get a laugh by scaring the shit out of you. I began to dread the mine's dark corners as much as its more obvious dangers.

Honest to God, every single day I went down there thinking that I wasn't going to come back up again. The only thing that made me stick it out was the money and the thought that with every day I was a little bit nearer to London and a glittering future.

Almost as bad as the fear, however, was the boredom. The way that some of the men dealt with the tedium of long days stuck underground was by having a wank with one of the stash of well-thumbed girlie mags you'd find in the systems booths. My sexuality was all over the place at the time and it didn't even cross my mind to involve myself in anything like that. But, as it turned out, one of my colleagues had other ideas …

One of the unwritten rules of colliery life was that all the men showered together at the end of a shift. It was all part of the blokeish camaraderie – washing each other's backs, slapping each other with wet towels, bonding over banter about birds and football. Like a sports locker room, I suppose, but cruder, grimier and more threatening. As you can imagine, I was way, *way* out my comfort zone. When I got home I always got straight in the bath to wash off the filth of that grim communal shower room.

One evening I was doing my usual thing of soaping up and getting out as quickly as possible when I noticed that one of the men was smiling at me. Chris Johnson. *What the hell did he want?* I had few friends in here – and Chris Johnson definitely wasn't one of them. Hard as nails and built like Mike Tyson, everyone in the village knew you didn't mess with him.

'It's Gary, isn't it?' he smiled, sauntering through the wet bodies to where I stood. He must have been in his mid-thirties, and with his black hair and pale blue eyes he looked a bit like an ugly, pumped-up Oliver Reed. 'You alright, lad?'

I might have imagined it, but it seemed that the men who had been showering near me moved a little further away.

'Fine, thanks.' I tried to keep my eyes fixed on the grimy water swirling down the drain.

'How was your day?' Chris was steadily soaping himself as he talked. I couldn't help but notice he had the biggest dick I had ever seen. Massive it was, halfway down his leg. I was too terrified to speak.

'You know, Gary, I've been keeping an eye on you down the mine,' he said. 'I know it can be bloody hard when you're new. I remember what it was like when I started – scared shitless I was!'

He chatted away for a bit, telling me about his wife and kids, asking about my girlfriend, and I started to relax a little. He did seem genuinely friendly, and God knows I could do with having the colliery's resident hard man on my side.

And then it happened.

'Can you wash my back?' he asked casually, turning round. I quickly rubbed the greying bar of soap over his vast shoulders to get the worst of the soot off.

'Thanks, lad. Your turn now.'

I knew something was wrong almost immediately. Rather than the usual perfunctory scrub, Chris was moving his hands over me with slow, tender strokes, caressing my shoulders and exploring my chest almost like a lover. *Exactly like a lover*, I realised in horror as his hand moved lower down my back towards my bum. Then suddenly his fingers were everywhere. Touching, grabbing, probing … Horrified, I wriggled out of his clutching paws.

'Thanks!' I spluttered. 'Got to go now!'

'Bye then, Gary,' he said calmly, an amused glint in his eye. 'See you next week.'

It wasn't a question.

From then on, Chris cornered me in the showers every time we were working the same shift. I'd try my best to avoid him, but several times I couldn't. It fell into the same pattern: we'd chat pleasantly, he'd offer to wash my back and then try to grope me. I was completely freaked out, but too scared of the guy to tell him to stop – besides, I very much doubted that anyone in those showers would come to my

rescue if things turned nasty. Thankfully I never had to find out, as a few weeks later I gratefully clocked out of my last shift at Markham Main.

Although I had only been at the colliery for a few months, I was a completely different creature from the pink-cheeked boy of before. To put it bluntly, I was a complete wreck. Working underground for seven-day weeks, sometimes pulling double shifts (there was no such thing as the Working Time Directive in those days) had left me deathly pale, painfully thin and completely exhausted.

I had a constant hacking cough – and every time I coughed would bring up the most evil-looking green muck you can imagine – and convinced myself that I was going to die of Black Lung, the chronic disease that tragically killed so many miners. Every night when I got home I'd scour my hands until they bled to get the coaldust out from the dozens of little nicks and cuts and from under my nails. That time I fell and gashed my forehead I was so paranoid that I'd be left with what was known as a 'black man pinch' – a scar that was permanently blackened from trapped coaldust – that I scrubbed at the raw, bloody wound with a toothbrush for two agonising days to get the soot out.

But the biggest problem was with those boots. All that trudging for miles across rocky, uneven surfaces in ill-fitting footwear left me with the worst blisters you can imagine. I would gingerly take off my socks at night and my entire heel would be a puffy mass of agonising pink and white. Desperate to ease the pain, I would grit my teeth and pop the blisters with a needle – but of course I was always at the doctor's with infections and blood poisoning.

I admit I had started out at Markham Main a cocky little sod, convinced I was better than the other blokes, but after seven months down the mine I was left with quite a different attitude. As much as I hated every moment of the job and dreaded the miners' welfare evenings where I'd have to force down a pint and try to join in the banter feeling desperately out of place, the close-knit community of

a mining village finally made sense to me. I had learnt how to be a team player.

The miners' strike had left some families in the village on the verge of starvation, but all their neighbours would rally round, bring them food, help them through the hard times. I now had a genuine respect for these men who every day risked their lives to do a job that had been lined up for them since birth. While I was floating around with my head in the clouds, they knuckled down and unquestioningly did what was expected of them, despite the horror stories that they had no doubt been hearing about the mines from their fathers and grandfathers since birth.

And today, when I go back to Armthorpe, I see how these same men have completely rebuilt their lives since the pits closed, retraining as plumbers or builders, keeping their families together while the world they had always known fell apart.

With the few thousand we had saved up – together with a bit of money donated by our parents – Kim and I could finally realise our dream of moving to London. We found a little studio above a bathroom showroom in Ealing, a suburb of West London. The flat was tiny, barely 15 ft square, with a mini toilet in a cupboard (over which hung a shower attachment) and the constant drone of traffic thanks to the M4 Hammersmith flyover which was just outside the window, but it was clean and cheap – and, most importantly, it was all ours.

Dad hired a mini-van and drove us down along with Mum, my sister Lynne and Kim's mum, who cried all the way about her baby leaving home. We had a suitcase each and a few bits our mums had bought us – some bedding, sugar, tea and a pint of milk – but that was it.

That first night, after we'd waved a final goodbye to our parents, we celebrated with cheap fizzy wine (out of mugs as we didn't have any glasses) and burger and chips from our local greasy spoon, a place which would become our main source of nutrition as we didn't have a kitchen and besides, neither of us could cook. That

night we stayed up talking into the early hours, a combination of nerves, excitement and the M4 traffic keeping us from sleep. While we were both terrified at being on our own in a strange city, we were incredibly excited about the future. Kim obviously had work lined up and I had already gone through the London phone directories and made a list of advertising agencies, design studios, printers – anyone who might take on an enthusiastic art college graduate with Honours. I was giddy with optimism. It felt like our lives were about to begin.

Bright Lights, Big City

I pushed my way through the revolving glass doors of the advertising agency and out onto the rain-lashed London streets, silently seething at the smug receptionist who (in the nicest possible way) had just told me to piss off.

I had been in London for nearly a month and had lost count of the number of office flunkies who had barely glanced at my portfolio before dismissing me with the inevitable 'Sorry, we don't have any suitable openings at this time.' On the rare occasions I had actually managed to get a meeting with someone who actually made the decisions in a company, the message had always been the same: get yourself some work experience and then we might possibly be interested.

I had to stop myself biting the head off one well-meaning ad executive when he suggested, 'Perhaps you could try to get a job back at your local newspaper in Doncaster? There might be more opportunities for you there …'

The weeks of back-to-back rejection were putting a serious dent in my self-confidence, especially as Kim's modelling career was

going from strength to strength now that we were based full-time in London. She was working almost constantly, from commercial promotional stuff to the occasional appearance on Page 3 of the *Daily Star*. I was of course thrilled that Kim was doing so well, but I was beginning to seriously panic about my own future. In my darkest moments, I even started to fear that I might have to return to Armthorpe, tail between my legs, and move back in with my parents.

We had been living in London for six weeks when, sick of having a depressed, moaning boyfriend moping about the place – and probably worried that she would have to cover all the rent – Kim finally took matters into her own hands.

'I think I might have got you a job, Gary,' she announced breezily one evening, as she sprinkled vinegar onto the newspaper packages of chips for our usual tea. 'It's at that hairdressers where I go to get my blow-dries – Bashir's? They were looking for a junior stylist and I told them you'd had a bit of hairdressing experience and that you were really good. The owner wants to meet you, 9 a.m. tomorrow. Okay?'

Bashir's was a large, bustling salon, part of the trendy new 365 Paul Mitchell group, and was conveniently situated in Ealing Broadway just down the road from our little flat. The owner, Bashir, was a tubby Indian gentleman who compensated for his lack of height with a magnificent mane of hair and a flamboyant wardrobe of high-collared shirts, brocade waistcoats and too-tight trousers which struggled to contain his generous belly. Although he was the salon's front man it was his mother, Nujan, who was the real power behind the throne. This incredibly glamorous grandmother would put in a brief appearance in the salon a couple of days a week, regally greeting favoured clients from behind the reception desk or getting her nails done, and all the staff in the salon were terrified of her.

I was initially taken on as a junior stylist, mainly doing blow-dries to start with, but I soon progressed to cutting and styling. I seemed to have a particular talent for dressing hair and loved to create elab-

orate up-do styles for the local Indian community's extravagant wedding parties. For a boy who grew up in Armthorpe, where the only black faces you saw were those covered in coaldust, meeting people from different cultures and backgrounds was a real eye-opener. While I still had my sights firmly set on a career in graphic design, I'd go into the salon every morning with a big smile on my face. I enjoyed the work, was earning decent money (thanks to the tips) and Bashir was fine about me taking time off for job interviews. Not only that, but I made some incredible – and life-changing – friends amongst the other staff.

On my first day at the salon I walked in and immediately clocked this amazing-looking guy laughing and flirting with one of the clients as he expertly ruffled their hair. *Wow.* He looked like he had just stepped out of a *GQ* fashion shoot: tall and slim with glossy dark hair and perfectly chiselled classical features – real male model material. Dan was the salon's Artistic Director. He was confident, popular and stylish; I looked up to him and wanted to be just like him. It probably won't surprise you to hear that he was also gay.

Dan inspired me to start spending a bit of money on clothes, to save up for a trendy T-shirt or pair of designer jeans, and he taught me about male grooming and make-up. Nothing dramatic, just a bit of fake tan, bronzer and concealer – the sort of stuff I still wear today – but I remember being stunned at what a difference it made. Dan used mascara and a little gloss on his lips too, but I certainly wasn't willing to go that far – I was far too scared what people might say. I just wanted a little touch of the Dan magic.

My other best friend at the salon was a bubbly Londoner called Jo, who had spiky bleached blonde hair, wore as much make-up as my Auntie Mo and had a wicked sense of humour. Thanks to my new friends, my social life suddenly exploded. Every day after finishing work, a group of us from the salon would go to a place called Old Orleans in Ealing for cocktails or for dinner at a little local tapas bar, and at least once a week we would hop on the Tube or the number

53 bus into Piccadilly to go clubbing – often, thanks to Dan, to a gay club.

What a revelation! Not so much the men at this point (although I admit I got a real buzz when I noticed other guys checking me out) but the intoxicating atmosphere in those clubs. I didn't drink much and never touched drugs thanks to those gurning students at Doncaster Art College, I just loved the music. I remember being in the middle of the packed dance-floor at Trade, a classic like 'Ride on Time' blaring over the speakers, and feeling like I could literally burst with happiness. It all seemed so fabulous and colourful and vibrant – and it didn't take an ecstasy tablet for me to feel like that. It felt like I had been shaken awake after a long sleep and I was having an absolute ball.

Unsurprisingly, it didn't take Dan long to start teasing me about being gay – 'You bloody are, Gary, go on, just admit it!' – but I would always deny it, joking that I was just a bit camp and reminding him that I was actually engaged to be married. True, my eyes had been well and truly opened during that first year in London and I was desperate to see new things, try different experiences and meet new people. And that little voice inside my head telling me that I was gay wasn't going away; in fact, it was getting louder than ever.

But I still loved Kim. We'd been through so much together and besides, I knew if I made that decision to come out and admit to the world that I was gay there would be no going back – and that thought terrified me. I was a grown man now, I couldn't just dismiss it as a silly phase. If I decided to go down that road my life would be totally different: no wedding, no kids, no grandkids for my parents. It seemed like an unimaginable future. No, as far as I was concerned there was no question that Kim and I were going to get married.

It was during my daily flick through the job pages of the local papers that I spotted an advert looking for individuals with 'artistic flair' to work for a family-run business. There wasn't much informa-

tion beyond that, but it was enough to make me pick up the phone and speak to a woman called Mrs Brady who gave me an address in West London and told me to be there tomorrow morning with my portfolio.

Standing outside a windowless warehouse I checked the scrap of paper I'd written the address on again. Yes – it looked like I was definitely at the right place. Any hopes that the job might be at some trendy design studio instantly vanished. I eventually located a metal door and, in the absence of a buzzer or bell, banged on the peeling paintwork. After a couple of attempts, I heard footsteps from inside and the door swung open to reveal a dowdy middle-aged lady wearing a floral apron. She looked completely out of place in this industrial landscape.

'Yes?'

'Mrs Brady? I'm Gary Cockerill.'

She stared at me blankly, blinking in the sunlight.

'I called yesterday about a job here,' I continued. 'For individuals with, um, artistic flair?'

'Ah yes. Please come this way.' Mrs Brady gestured me into the eerie darkness of the silent warehouse and the metal door clanged shut behind us.

As I followed her and my eyes gradually adjusted to the dimness of the interior I became aware with a growing sense of unease that we were not actually alone. I began to make out groups of pale figures hanging around the recesses of the cavernous space, eerily silent and still as if they had been waiting for me, and were now staring at me. And then, to my absolute horror, I glanced up and noticed what looked like an arm dangling from the ceiling. Yes, that was definitely an arm, complete with pink-painted nails. And next to that I could make out a leg, and – oh God – was that … a head …?

I was about to turn and run screaming for the door when suddenly the strip lighting flickered on and I realised that I hadn't

stumbled into some serial killer's hideout but a warehouse full of shop dummies. There were groups of female mannequins (with and without arms), little child mannequins, square-jawed male mannequins with perfect pecs and so many dismembered limbs hanging around the place and stuffed onto shelves it was like walking into an extremely busy morgue. If you've ever seen the horror classic *House of Wax* starring Vincent Price you'll get an idea what I'm talking about. Unaware that a few moments earlier I had assumed she was a knife-wielding maniac, Mrs Brady showed me into a little corner office where her husband took just a few minutes to flick through my student portfolio and then offer me a job.

The Bradys ran a small but thriving business painting shop dummies, both brand new models for high street stores and recycling old ones (giving them a makeover, if you like) to sell to local boutiques. They employed a handful of people, each of whom had their own area of expertise, be that spray-painting the flesh tones, working on the hair or doing the lips.

My area of responsibility was to be creating the eyebrows and eyelids. I would be given a picture of one of the supermodels of the day torn out of *Vogue* or *Elle* and have to recreate the make-up on the mannequin using oil paints and fine brushes. It started off taking me an hour per face, but soon I could perfectly recreate the feline flicks of Linda Evangelista's eyeliner or the smoulder of Karen Mulder's smoky eye and finely arched brow in a matter of minutes.

I only stayed in the job for a few months, as I was getting increasingly busy at Bashir's and besides, there wasn't exactly much scope for job development; after all, what was I going to move onto next – lips? But in the absence of any formal make-up training my time with Mr and Mrs Brady taught me about contouring, brush control and facial structure, lessons that have since proved invaluable throughout my career. It gave me the chance to experiment with colour and shading and discover what worked and what didn't on a

client who had perfect bone structure and – best of all – couldn't answer back.

* * *

It's funny how seemingly random events and incidents in your past form a pattern that you only see with the benefit of hindsight. All those years of drawing women's faces and doodling eyelashes and lipstick on Dad's record covers during my childhood, then my early make-up experiments on Kim and now the job at the mannequin factory: everything was laying down the foundations for my future career. By this time I was often doing Kim's make-up for her modelling jobs and nights out, and some of the girls at the salon were asking me to do theirs too. I even did my sister's make-up for her wedding.

I had a particular talent for eyes; it was almost instinctive – where to shade, which areas to highlight, how to turn an average-looking girl into a regular Sophia Loren. I was buying the fashion glossies to get ideas and was particularly inspired by the work of legendary American make-up artist Kevyn Aucoin, whose uber-glamorous style has been a profound influence on my own work.

I was beginning to realise that I might actually be able to make money out of what had up until now been a creative outlet. So when I was introduced to a glamour model-turned-photographer named Joanie Allum by one of my friends from the salon, and she asked if I'd be interested in doing a few test shots with her, I jumped at the chance.

Gorgeous and feisty, Joanie is a bit of a legend in glamour modelling circles. Together with her husband John, himself also a photographer, they would use their huge South London home as the extravagant backdrop for adult magazine shoots, transforming a bedroom into a frilly boudoir or using the kitchen for a naughty maid story. That first job I did with Joanie, for the top-shelf title *Mayfair*, was a series of photos featuring a sexy secretary who started out fully

clothed in a little pinstripe pencil skirt, frilly blouse and glasses and ended up sprawled naked and glasses-less over her boss's desk.

The fact that it was basically porn (albeit of the softest variety) didn't bother me in the slightest; my only concern was to make sure the model looked beautiful, and besides, I kept out of the way while they were doing the more graphic pictures. And while I might not have been the fastest worker, the make-up looked great. I was also cheap, charging about £35 to get a girl ready, and soon Joanie started to use me for all her shoots.

Joanie was hugely influential in my career and a key figure in my transformation from talented amateur into a professional make-up artist. She advised me to go to Charles Fox and Screenface, the professional make-up supplies stores, and get myself a little basic kit together. She also introduced me to Elizabeth Arden Flawless Finish Foundation, which I still swear by to this day as it works on more or less everybody. With images from Joanie's shoots in my portfolio, I started to get work with other glamour photographers, including Leslie Turtle and Mel Grundy. As I established a reputation my rates started to creep up and soon I was earning about £100 per girl – not bad for a couple of hours' work.

After we had been in London for a year, Kim and I moved house. We were both earning decent money by now and the novelty of showering in a cupboard over a toilet every morning had worn thin some months ago, so we found a nice little garden flat in a Regency townhouse on Askew Road in Shepherd's Bush and got ourselves a flatmate – Dan, my friend from the salon. There was only one bedroom, so we turned the living room into another bedroom and put some sofas in the spacious hallway as a sort of lounge area. Kim liked Dan and, as he was gay, didn't mind sharing such cramped living quarters with another guy, whereas I liked the fact that I had direct and unfettered access to Dan's wardrobe of designer finery. We would often be standing in the salon together and he would suddenly say, 'Er, Gary, are those my new shoes …?'

But although neither of us wanted to admit it, it was becoming obvious that Kim and I were drifting apart. By now we each had our own group of friends – me with the crowd from the salon and her with her modelling friends – and while we would still make the occasional effort to go out together, more often than not we would just meet up at the flat for a quick cuddle after our respective nights out. We were both growing up: forming our own opinions and working out our individual take on life – and becoming increasingly incompatible in the process. Perhaps most tellingly, the physical side of things had all but dried up.

Although I was still in denial to an extent, my sexuality was definitely being awakened. One day I sneaked into a Soho sex shop feeling like a dirty old man and bought a video starring gay porn legend Jeff Stryker that I stashed at the bottom of our bedroom cupboard at home. I was ashamed, disgusted with myself even, but it didn't stop me watching that video over and over again when there was nobody home. I now knew my life was going to have to change radically – and soon – but I was still too scared to do anything about it. My relationship with Kim was like a security net, and neither one of us was confident enough to abandon it just yet.

Love at First Sight

'Fancy a drink at the Royal Oak tonight?'

We were just finishing our shift at the salon – I was still working at Bashir's to ensure a regular source of income while I tried to establish my make-up career – and it seemed that Dan was up for a big night out. The Royal Oak was one of our favourite haunts, a well-known gay pub and club in Hammersmith where you were always guaranteed a fun night out, either dancing to camp disco-dolly music (courtesy of the house DJ Jeremy Joseph, who would later become famous for setting up legendary club night G.A.Y.) or watching the cabaret of drag acts and male strippers. Jo, my other friend from the salon, wanted to come along too, and Kim was going to meet us there.

It was a hot summer night, a month before my 23rd birthday, and I was wearing a tight white T-shirt with a pair of little cut-off denim shorts, Timberland boots and a deep tan courtesy of the salon sun-bed. No doubt I was wearing a bit of man make-up too. (And no, I can't work out why more people didn't guess that I was

gay either.) Our group walked into the crowded bar and was immediately greeted by shouts of laughter and cheering. Everyone in the place was transfixed by the drag act appearing on the little stage opposite the bar. She made quite an impact with her long skinny legs, enormous platinum blonde wig and raspy Liverpudlian accent that sounded like it had been fine-tuned on a daily diet of vodka and Benson & Hedges. She was also hysterically funny.

'Her name's Lily Savage, she's bloody brilliant,' Dan shouted over the din as we ordered drinks.

We positioned ourselves near the bar to watch, when I became aware of a laugh coming from the other side of the stage. I noticed it because it sounded so charismatic, really deep and masculine, and it made me chuckle just hearing it. I kept looking over to try and work out where it was coming from when I spotted the most gorgeous bloke I have ever seen in my life. Honest to God, this guy was beautiful. He was tall, at least six foot, and must have been fourteen and a half stone of pure muscle, with the sort of perfectly ripped body it would take daily gym visits to achieve. With his pale blue eyes, chiselled jaw and bleached-blonde flat-top, he looked like a cross between Kevin Bacon and Dolph Lundgren in *Rocky V*. As I stared at him standing there, his arms casually folded over his chest, chatting to the group of girls who surrounded him, my first thought was: *what the hell is he doing in here?* He was so obviously straight, you could tell by the way he carried himself. And my second thought was: *I could really fall for this guy.* It was the first time in my life I'd ever admitted such a thing to myself.

Suddenly I heard Jo squeal next to me. 'Oh my God, there's my mate Phill! You know, Gary, the one I told you about who I really fancy? I've got to go and say hello …' I watched her push her way through the crowd and even before she got to him and he threw his arms around her and pulled her close to that fabulous chest, I just knew it would be him. Mr Laughter. Phill.

'Fucking hell, who is *that*?' muttered Dan, looking over to where Jo had gone. 'God, he's bloody gorgeous. See you later, guys – don't wait up!'

I desperately wanted to go over and join them, but I was completely thrown by the strength of my feelings for a man I hadn't even spoken to. I had never fancied a bloke like this before and was worried I would turn into a dribbling wreck if we were introduced. Besides, I was all too aware of Kim standing by my side muttering about needing to get up early for a shoot tomorrow. So when Jo beckoned us over I shrugged apologetically, gave her a wave, and then headed for the door with my fiancée.

The next day at the salon Jo was desperate to share the gossip.

'You'll never believe it, Gary,' she said, pouring us both a coffee. 'You know that mate of mine we bumped into last night, Phill? Well, he's gay!'

I was stunned, but somewhere deep inside me a tiny flame of hope flickered into life. Trying my best to sound casual, I quizzed her all about him.

Phill Turner was a self-employed carpenter who lived near Jo in Yedding, Middlesex and hung around with the same group of friends. None of them had known it, but for the past few months Phill had been seeing a guy in secret. Neither of them had admitted they were gay to their friends or family, and they never even went out together in public in case anyone saw them.

'So anyway, Phill finally finished things with this bloke last week,' Jo continued, plastering on a coat of bright red lip gloss, 'and then told everything to our mutual friend Louise – about how he was gay and this secret relationship and how this guy used to beat him up. Honest to God, Gary, it sounded awful! He'd never even been to a gay bar before, because he was so terrified of someone finding out. So Louise – who lives with Franny the Wonderpoof, you know that really camp gay guy – told Phill that he should come out to the Royal Oak last night with her and Franny, sort of like his gay debut, if you

like. Anyway, from the look of how things were going with him and Dan when I left, I reckon it was the best thing he could have done ...'

'Hello darlings.' Just at that moment Dan appeared at the door with a Cheshire Cat grin plastered across his face.

'So come on, what happened after I left? I need gossip!' gushed Jo.

I felt a pang of envy as Dan explained that after Kim and I left he had worked his magic on Phill and the pair of them had arranged to go on a date next weekend. What made it even worse was that Dan, who was usually a bit of a scene queen and far more into casual one-night-stands than monogamous relationships, seemed convinced that things were going to be different with Phill.

'I swear, he is too good to be true,' he gushed. 'I've got a feeling about this one ...'

The following Saturday evening I was supposed to be going to a party with Kim and some of her model friends, but I cried off, blaming a headache so that I could stay at home and catch another glimpse of Phill.

When the doorbell rang at 8 p.m. I rushed to answer it. And there he was, even taller and twice as gorgeous as I remembered him. He looked a little taken aback; Dan obviously hadn't mentioned he'd got a flatmate.

'Hi, I'm Gary,' I said. 'Dan's just getting ready, come in.'

'Oh, right, hi.' Phill stuck out his hand for me to shake.

There was a slightly awkward moment of silence as we stood together in the hallway, but then Dan appeared and whisked the two of them out of the flat.

I watched them drive off together in Phill's sexy little white sports car and then flopped in front of the TV, feeling utterly depressed. *Even his bloody car is gorgeous*, I thought miserably. I spent a horrible evening imagining Phill and Dan together, torturing myself with images of them talking and laughing. I tried to numb my feelings with a bottle of cheap white wine, but it didn't stop visions of the pair of them kissing and touching flashing into my head.

Nevertheless, by the time I stumbled into bed at midnight (by which time neither Dan nor Kim had returned to the flat) I had faced up to a few home truths.

I've fallen for this guy in a big way. Which means I'm probably gay. No, scrap that – I am definitely *gay. But I'm with Kim and we're engaged to be married.*

And as sleep began to drift over me, through the haze of alcohol I came to a decision. *I am going to have to do something about this – and soon.*

The following morning I was lying in bed next to a sound-asleep Kim when I heard Dan leave for work. I had a cold shower to try and shake off my creeping hangover, then – as was my usual habit – nipped into Dan's room to borrow a splash of his expensive aftershave.

I had gone just a few steps into the room when I heard the rustle of bedding and a voice, still husky with sleep, coming from the bed.

'Sorry, I didn't get a chance to introduce myself last night. I'm Phill.'

His hair was sticking up all over the place and he had a sexy, sleepy smile on his face. As he lifted himself up on his elbows the duvet fell back to reveal his incredible torso – honest to God, the guy had an eight-pack – and a pair of huge, muscular arms complete with beautiful hands.

I realise this sounds like a total cliché, but that moment when our eyes met I felt the most intense energy between us, a real lightning bolt – although that was quickly replaced by a shudder of embarrassment when I realised I was standing in front of this Adonis wearing only my slightly baggy pants.

'God, I'm really sorry, I didn't think anyone was here,' I gabbled, looking for a towel to cover myself up. 'I heard the door and just assumed—'

'Really, don't worry about it,' said Phill, still smiling. 'It's Gary, right? Nice to meet you – properly this time.'

'Good to meet you too.' *God, even his nipples are perfect.* 'Actually, I saw you at the Royal Oak with Jo and Dan last week, but I didn't come up and introduce myself as my fiancée Kim wanted to leave.'

'You've got a girlfriend?'

'Yeah, we're getting married.' I shrugged, as if to imply it was no big deal.

'Oh right.' Perhaps I was imagining it, but I thought I saw a flicker of disappointment in those piercing blue eyes.

We chatted for while, until I heard Kim shouting for me.

'I better get going,' I said, reluctantly heading for the door. 'Maybe see you again.'

'Yeah, that would be nice,' he smiled. 'Bye, Gary.'

I closed the door, a stupid great grin on my face, then headed off down the corridor to the kitchen to where Kim was making a start on breakfast.

When I caught up with Dan at work later that morning he was literally bubbling over with excitement.

'Oh my God, this guy is fantastic!' he gushed. 'I'm telling you, Gary, Phill is the one for me. I swear this guy is going to be the love of my life.'

Shit, I was so jealous. But I tried to console myself with the thought that if Dan and Phill were having a relationship, at least that meant I would definitely get to see Phill again.

Sure enough, over the next couple of weeks Phill would often turn up at our flat and each time we would have a brief chat. It was all very innocent (more often than not, Kim or Dan were in the room too), but there was some very deliberate eye contact and a growing flirtatiousness on Phill's part that planted within me a tiny seed of hope. I couldn't get him out of my head and would spend hours daydreaming about him taking me in those strong arms and kissing me.

One night the four of us – me and Kim, Phill and Dan – went on a double-date to an ice-rink. Phill and I spent most of the evening

skating and chatting together, and at one point when I fell he leant over to help me up. As I got back on my feet, joking with Phill, I saw Kim and Dan exchange uneasy glances, and at the end of that evening Dan pulled me to one side as we were taking our skates off in the locker room.

'Hands off my bloke, girlfriend,' he muttered with a friendly wink. But there was an edge to his voice that suggested he wasn't entirely joking.

Then one night everything changed. It was about three weeks after Phill and Dan had started seeing each other and we were having a house party at the flat with friends from the salon and some of Kim's model mates. The thing about Dan was that he had several personalities – and one of them was extremely flamboyant. But Phill had known nothing about it until that night, when Dan answered the door to him wearing a high-cut black satin teddy complete with dangling suspender straps, a fake fur stole and bobbed black wig. Rather than his usual subtle man make-up he had put on lipstick, eyeliner and nail varnish – the full works. To complete the picture, Dan was mincing around on his tiptoes as if he was in high heels.

I can only imagine the expression on Phill's face when he saw Dan dolled up like something out of the Folies Bergère. Certainly, when I saw him a few moments later he looked like he had been slapped. That night marked the beginning of the end of their relationship. Phill was into men who looked like men and the ultra-camp, lingerie-loving side to Dan was obviously a nasty shock him. He stuck around at the party though, and I very deliberately put on my Madonna and Barbra Streisand albums. Despite having a fiancée and living as a straight man, when Phill heard what was in my record collection he must have realised that I was gay.

It was about 6 p.m. on a Wednesday, a couple of days after the party, when there was a ring at the door. I was in the bedroom and Kim went to answer it, reappearing a few moments later with Phill in tow, a sheepish expression on his face.

'Dan's still at work I'm afraid, but you're welcome to wait for him,' she was saying.

'Thanks,' said Phill. 'Listen, I should probably tell you that I don't think I'll be coming round again. Things aren't really working out between me and Dan. I guess we'll be calling it a day.'

'Oh, Phill, I'm sorry,' said Kim. 'That's such a shame, isn't it, Gary?'

'Yeah, sorry to hear that, mate.' I couldn't make eye contact with him. I was terrified Phill would see how I really felt.

'Look, why don't you make yourself comfy and I'll get you a cup of tea,' continued Kim, gesturing towards the little sofa where I was sitting watching TV. 'I've just got to pop to the garage to get some milk. Back in a sec.'

Then she disappeared from the room and a moment later we heard the front door bang.

For the first time since that morning in Dan's bedroom we were on our own. Phill was still standing by the door when I finally plucked up the courage to look at him. Our eyes locked and in that instant we both knew something was about to happen. Something life-changing.

'Gary, I …' Phill sounded far from his usual confident self. 'Look, I've got to be honest with you. The thing is, I think I've fallen for you. I knew it wasn't right with Dan after just a few days, but I kept it going because I didn't know how else I would get to see you. So there's something I need to ask you. I know you're engaged to marry Kim, but I get this feeling that you might be gay. Just tell me if I'm wrong and we can forget this conversation ever happened, but I really need to know.'

It felt like time was standing still as I took a deep breath, looked him straight in the eye and said: 'Yes, I am. I'm gay.'

Then Phill was walking over to the sofa and sitting down next to me, and the next moment he was leaning into me and kissing me on the lips, a beautiful, soft kiss that sent electricity pulsing to the tips of my toes and light exploding behind my eyes. I had never kissed a

man before but it felt absolutely, undeniably right. When he pulled away he reached for my hands and we just sat there, holding hands, staring at each other.

Well, then it all came tumbling out – exactly how we felt, what a difficult situation we were in and what on earth we should do about it. We were acutely aware that Kim would be back any moment, so Phill gave me his mobile number and I promised to call the next day.

Ten minutes later the front door slammed and I immediately jumped up and leant as casually as I could against the wardrobe, no doubt looking as guilty as hell.

'Um, sorry, Kim, something's come up,' gabbled Phill. 'I don't think I can wait around for Dan after all, I'd forgotten I've got an … appointment to go to. Sorry about the milk. Guess I'll see you around. Bye!'

'Well, that was a bit weird,' said Kim, after he'd disappeared. 'What did he say to you?'

I was struggling to take in what had just happened. I was giddy with happiness that Phill felt the same way as me, yet I was terrified about the future. Now my wish had come true, I was faced with the harsh reality of the situation. What on earth was I going to tell Kim? We had been these lovestruck kids who had moved to London together, our head full of dreams and big plans. For the last six years our futures had been entwined – and now I was going to destroy her.

'Come on, Gary,' she said impatiently. 'What's going on? What's the matter with Phill?'

I took a deep breath. 'I think he's met someone else.'

Phill and I arranged to go out for dinner two days later. Kim was out on a shoot and Dan was at work, but I was still paranoid someone would see us, so he picked me up outside the chippy down the road from the flat. On the drive back to his flat in Middlesex we talked constantly, about our lives and families, just getting to know each other. I had told Kim that I was going to be out late and would

stay at Jo's house that night; Jo was happy to tell a little white lie for me and thankfully didn't ask any questions.

After dinner at the pub across the road, where we spent the entire meal trying to figure out how we could be together, we went back to Phill's flat – and then to his bed. God, I was so nervous. I wanted Phill desperately, but I had never been with a man before and had no idea what to expect. What if I did something wrong? What if he didn't like my body? His was so incredible, I felt painfully self-conscious as I was getting undressed. Besides, while there was no doubt in my mind that I was gay, my upbringing had taught me that this sort of thing wasn't natural – that it was wrong.

I felt Phill's stubble rub against me and it just felt weird. His body was bigger than mine, and firmer, whereas I'd been used to the soft curves of a girl. It was all so different and so utterly alien to me, but as Phill started to touch me I relaxed, and then … woah. It was amazing. Mind-blowing. It's true what they say, that the same sex know exactly what to do. Once we'd started I just didn't want to stop and we did it five times that night. I just wanted to try everything. I was a kid let loose in a candy store and I couldn't get enough.

The next morning, after a few hours dozing in each other's arms, Phill drove me to Bashir's and I bounced into the salon feeling ten feet tall. But my exhilaration turned to absolute horror when I saw who was waiting for me in reception: Kim.

Thankfully she couldn't have seen me arrive with Phill as he had dropped me off round the corner, but something was obviously up. She looked furious.

'What's going on, Gary?' she hissed, dragging me into a quiet corner. 'You've been behaving really weirdly for weeks now. Are you having an affair? Are you sleeping with Jo?'

'For God's sake, don't be stupid,' I snapped, instantly on the defensive. 'Me and Jo are just mates and besides, she's got a boyfriend.'

I suppose I did feel a bit guilty, but I was on such a high after my night with Phill that I was actually angrier with her than anything.

By some twisted logic, it suddenly seemed to me that Kim was trying to stop me from being happy.

It's my life, I thought furiously, *and I have a right to be with whoever I want!* Call it selfishness or self-preservation, but I was no longer worrying about how this mess might affect Kim. All I knew was that I had to be with Phill, and nothing – or nobody – was going to stand in my way.

* * *

The following day was my 23rd birthday and Kim and I had planned a day out in London: a bit of shopping, a nice lunch – a relaxed day with just the two of us. When we woke that morning we tried to carry on as if nothing had happened, but the memory of the previous day's row still lingered and by the time we had finished breakfast and walked to Hammersmith tube station, me carrying my cards and presents to open over lunch, our uneasy truce had collapsed into a full-blown fight. We stood on the platform and screamed our heads off at each other, not caring who heard us. It was horrible.

'Tell me the fucking truth, Gary!' Kim sobbed. 'I know you're having an affair with Jo, just be a man and admit it!'

'What about you?' I yelled back. 'You're always going away on trips, always going on nights out with some photographer or other. It wouldn't surprise me if you're the one who's sleeping around!'

Kim slapped me across the face as hard as she could. I threw my presents at her then stormed up the stairs and out of the station, diving into the nearest phone box and calling Phill to come and pick me up.

It was over.

* * *

For the next few days I hid in Phill's flat. We spent most of the time in bed, just talking and making love, but we knew we couldn't stay in that bubble of bliss forever, and two days after I had abandoned

Kim on the Piccadilly line platform at Hammersmith tube I plucked up the courage to call my sister.

'Gary, where the hell have you been?' screeched Lynne. 'Everyone's been scared to death – we thought you'd been murdered! Don't you ever do that to us again …'

'Lynne, I've got something to tell you,' I said. 'The thing is – I'm gay. I've met someone and I'm with him now, staying at his flat.' I burst into tears. 'Oh God, what the hell am I going to do?'

My sister, bless her, was her usual wonderful self – and if she was shocked she didn't show it.

'Shhh, don't worry, it will all be fine,' she soothed. 'You'll get through this, I promise. Maybe it's my fault for dressing you up in my clothes when we were kids!'

She said she would call our parents and Kim to tell them that I was safe and just needed a bit of time to think things through, but not to reveal where I was or what had happened. I began to relax, relieved that I'd bought myself a bit more time before I had to deal with the outside world, but just as we were saying our goodbyes Lynne dropped the bombshell.

'Gary, you are coming back for George's christening on Sunday, aren't you?'

How could I have forgotten? My nephew was being baptised at the weekend and I was to be his godfather. There was no way I could miss it. Whatever happened, in two days' time I would have to go back to Doncaster and face my family – and my fiancée.

Lynne had told me that Kim had fled back to her mum's house, so I picked a day when I knew Dan would be at work and Phill drove me to go back to the Shepherd's Bush flat to collect some of my things. But when I opened our bedroom door, I was greeted by a scene of utter chaos. Anything that could be smashed was lying in pieces on the floor; my art portfolio was ripped to shreds; my clothes had been attacked with a pair of scissors. I was devastated, not so much for my ruined possessions but at the realisation of what I'd

done to Kim – and she didn't even know the worst of it yet! I quickly packed away anything that wasn't smashed or in shreds and got back in the car with Phill.

But if I thought I could escape my guilt on the drive back to Middlesex, I was wrong. The route to Phill's flat took us directly past Bashir's and the traffic was terrible, so we were creeping along when Dan came out of the salon and looked straight at us. His shock quickly gave way to fury, and he started running towards the car, waving his arms and screaming his head off. The lights changed before he could reach us, but I'll never forget the look on his face as we pulled away.

* * *

Sunday, 4 October 1992. The day that I would ruin baby George's christening. That morning Phill drove me up to Doncaster. It was a horrible three hours; we both knew that by the end of the day we would have had to make some terrible decisions and possibly hurt a lot of people we loved.

As he dropped me off outside the church we kissed and clung to each other like shipwreck survivors. The sky was filled with black clouds and it had started to rain.

'You're not going to come back to me, are you?' said Phill. 'I can't bear it if this is the last time I ever see you.'

He was sure my family would convince me that I was just going through a phase, or that I'd see Kim and all my memories and feelings would come flooding back, and as much as I tried to reassure him I knew the only way I could prove myself was by turning up at the meeting point we had arranged: outside the Dome cinema in Doncaster at seven that evening.

The service had already started when I arrived at the church and as I walked down the aisle, my shoes echoing on the flagstones with each step, it felt like every person in the place was staring at me. I sat down in the front row next to my parents. Mum started

crying, while my sister grabbed my hand and gave it a reassuring squeeze. And behind us sat Kim, visibly shaking with anger. We later had to stand together by the font, while I took my vows as a godparent.

'Do you reject the devil and all rebellion against God?' the vicar was asking in a booming voice.

'You've got a lot of explaining to do,' muttered Kim under her breath.

'Do you renounce the deceit and corruption of evil?'

'I promise I'll tell you everything when we get back to the house,' I whispered.

'Do you repent of the sins that separate us from God and neighbour?'

'Well, you better have a decent excuse for what you did to me,' she hissed back.

* * *

Thankfully, my sister had kept the christening tea small, with just my parents, Granddad Joe, Great Aunt Connie, Great Aunt Eileen and her husband Simon's immediate family. Over sandwiches and cups of tea I made pleasant chitchat to my Granddad Joe, but they all knew something was wrong. I waited for the older members of the family to go and then gathered my parents, Lynne and Kim into my sister's bedroom. And once they were all sitting down, I got straight to the point.

'I've got something to tell you,' I said, as calmly as I could. 'I'm gay.'

Silence. Out of the corner of my eyes, I noticed my sister looking around the room for everyone's reaction.

And then – 'Oh my God!' Mum screamed, bursting into hysterical tears. 'I can't believe this. My son is going to die of AIDS!'

Dad, meanwhile, was in shock. While Mum ranted, he just sat there, shaking his head, staring at the floor in disbelief, saying the

same thing over and over. 'But what about my grandkids, Gary? Have you thought about that? How can you be so selfish?'

It was a terrible moment, yet in the midst of the horror and emotion, I felt a big wave of relief washing over me. I suddenly felt lighter, freer. It was done: I had come out.

While my parents sobbed and cried, Kim didn't say a word. There were no tears, no anger – just complete silence. Her expression was blank; I would almost have preferred a bit of screaming. And a few minutes later when my sister took my parents out of the room I got my wish. She went berserk, crying, screaming and kicking the hell out of me.

'How could you do this to me, you bastard!' she cried. 'It's Phill, isn't it? Dan told me he'd seen you together. Tell me!'

I tried to explain that she'd done nothing wrong, that it wasn't her fault, but I was gay and yes, I was with Phill.

'You can't be gay!' she sobbed. 'We're getting married. I want you, Gary! We can work this out. Let's just try and work this out, please …'

I told Kim she'd had a lucky escape, that it was far better this had happened now than when we were married with kids, that she was young and beautiful and would meet someone else, but she was inconsolable.

* * *

Later Kim's dad came and picked her up, leaving me to face my parents again. I walked into the sitting room, expecting the worse, but they immediately jumped up and put their arms around me and the three of us just held on to each other, crying our eyes out.

'I'm so sorry,' murmured Mum. 'It was just a shock, that was all. Whatever you want to do, we'll love and support you.'

'We're here for you, son, we love you,' said Dad.

I don't think I've ever cried so much in one day – and there were more tears to come. Dad drove me into Doncaster and dropped me

off outside the Dome cinema, and when the doors opened and people started coming out I spotted Phill looking around to see if I was there. Our eyes locked and we ran to each other and kissed, not caring that we were surrounded by crowds of people. I felt this incredible release. I was home.

Looking back, my parents were amazing during this time. Even though they didn't know any other gay people and were still getting used to the fact that their son now had a boyfriend, they phoned a couple of weeks later and asked Phill and me to come and stay for the weekend. They coped brilliantly – although they didn't tell the rest of the family for another year or so.

And what of Kim? A few months later she left London and although I can't say we're close friends, we do still speak. And ten years after the day we split I did the make-up for her wedding.

Tiffany Towers and Tawny Peaks

I stepped off the plane and into the cashmere-soft warmth of the early Caribbean morning. A gentle breeze ruffled the coconut palms and the Bahamian flag that fluttered from the terminal building. From here, Nassau International Airport, it would be a short hop via seaplane (*so Indiana Jones!*) to the tiny private island where I would be working for the next three weeks. I rummaged in my hand luggage for my Ray-Bans and Hawaiian Tropic oil, yet again congratulating myself for somehow stumbling into a career that involved all-expenses-paid luxury trips to the Bahamas as part of its duties. Little did I know that by the end of the day I would be literally begging – pleading – to get back on that plane and straight home to rainy old England …

I had been booked for this job by Kelvin Rodgers, publisher of a stable of best-selling top-shelf magazines catering to the big boob fan. And not Page 3 girl big, we're talking beachball big: mammoth mammaries that could only be achieved with the sort of implants that these days would be illegal, but in the early Nineties were de

rigueur for porn starlets. Girls that would make Katie Price look like Kate Moss.

Kelvin, a lanky, balding South African with a booming empire stretching from London to LA, had spotted my work in publications such as *Penthouse* and *Mayfair* and I had since become one of his regular make-up artists, working at the top end of the adult industry where the slick production values and modern studios were a world away from the seedy, dirty-mac vibe of most British porn. It was like the difference between working on a hit blockbuster and a home movie.

And the girls were just incredible: larger-than-life Glamazons with huge boobs, tiny waists and Carry On names like Tiffany Towers, Whitney Wonders and Tawny Peaks. Most of them had found fame as strippers and had a huge and devoted fanbase who'd turn up in their thousands whenever they went on tour. The adult industry was booming in America, beginning to rival Hollywood in terms of size and success.

I was under no romantic illusions about the nature of the business I'd found myself in, but for a boy who grew up loving the film *Gypsy*, about the legendary burlesque artist Gypsy Rose Lee, these stripping superstars possessed a sort of tawdry glamour. Besides, the sexual side of the job was never in my face. If the model needed her face retouching during a shoot she just came back to the make-up room. Sure, I'd see my fair share of naked flesh while doing their body make-up and covering imperfections and ingrown hairs (although I flatly drew the line when a girl once asked me to shave her for a shoot) but I was never in there watching them spread their legs.

Anyway, by then I was obviously crazy in love with Phill, so even if I had it would have done absolutely nothing for me. Yes, the only satisfaction I was getting from my new career was job satisfaction. I loved the challenge of making the girls look beautiful, even if that finely arched eyebrow I'd spent so long perfecting was never even

going to be noticed by the magazine's readership. In my mind I was never working on a porn shoot, I was creating the make-up for Madonna on the set of her latest video or transforming Demi Moore for the cover of *Vanity Fair*.

A few hours after touching down in the Bahamas, and one hair-raising ride in a rickety old seaplane later, I pulled up outside a large ice-cream-coloured villa set amongst tropical gardens leading down to a private beach. White powder sand, azure sea, palm trees: the whole desert island fantasy.

Inside, the villa was a vision in white – wooden floors, ceiling beams supporting huge lazy-spinning fans and wicker furniture – with displays of fresh-cut local flowers and modern art adding splashes of colour. Although I hadn't asked many questions when Kelvin had booked me for the job – the money and location having instantly won me over – I gathered I was going to be doing the make-up for a movie, a new experience for me as before I had only done magazine shoots. But from the look of this palatial mansion, which was to be the crew's home for the next few weeks, the production was obviously pretty high budget.

I barely had time to dump my bags and grab a Coke from the vast chrome fridge in the kitchen when a runner appeared.

'Gary, right?' said the girl, a harassed-looking young American. 'I'm Donna. I'm afraid you're going to have to get right down to work, Mr Rodgers has got us on a real tight schedule.'

'Is Kelvin here?'

'Yeah, of course, he's directing the movie.' She talked over her shoulder as she led me up two flights of stairs. 'There are three girls you'll need to get ready, Angelique is already waiting.'

I was shown to the make-up room where a blonde in a tiny tropical-print bikini was sitting in the chair, her long tanned legs curled underneath her. At first glance she could have been a young Jerry Hall, if Jerry Hall had been born in Minsk and got herself a serious boob job. I was used to working with fairly average-looking

girls – to put it bluntly, they were usually a pair of huge tits and everything else was an afterthought – but you could put this incredible 6 ft Russian next to a catwalk model and she'd still be jaw-droppingly gorgeous.

I got down to work. In those days, porn star make-up was nearly always the same – loads of black eyeliner, a streak of blusher and bright red glossy lips. Really tacky, cheap-looking.

'That's what men like,' I would always be told when I suggested something a bit less tarty.

Not that I ever listened. Instead, I would do beautifully smoky, sexy eyes with soft, creamy lips, taking inspiration from the likes of Brigitte Bardot and Linda Evangelista. The girls always wanted me to do their make-up because they knew they would end up looking like a supermodel.

I had finished Angelique's hair and face and was midway through fixing a set of lashes on the next girl, a sweet-natured redhead from Tennessee called Kandi, when Donna popped her head round the door.

'Gary, you're needed on set.'

'I'm in the middle of something.' *And I don't ever leave the make-up room,* I muttered under my breath.

'Sorry, you've gotta come now – Kelvin's orders.' Donna smirked. 'And bring some wet wipes.'

I followed her into the blazing sunshine and down towards a cluster of a dozen or so people at the other end of the private beach. As my eyes adjusted to the dazzling brightness I was horrified to see a naked man lying on his back in the sand with Angelique hovering over him on all fours, her bikini floating a few feet away in the gently rolling surf. Three cameramen surrounded them to catch the action from – *oh God* – every angle. I was just grateful that the 'action' had obviously now finished.

'Alright, mate?' The spreadeagled naked man grinned as I approached. He was a cockney lad with long black hair that was

crispy from too much mousse. 'I'm Marco. Nice to meet ya.' Thankfully he didn't offer me his hand to shake.

'There you are, Gary!' Kelvin shouted over from where he was conferring with one of the crew. 'Can you just tidy up Angelique a bit before we carry on filming? Thanks.'

Reluctantly I crouched down, brushes in hand, ready to do my usual powdering and reglossing job, and then I froze in absolute horror. Angelique's face was literally covered in, er, Marco. The stuff was in her eyebrows, spattered in her hair, dripping off her false eyelashes – it was bloody everywhere. There was hardly anything left of the red lip gloss I'd so lavishly applied earlier; I assumed (though tried very hard not to look) that the rest of it must have been smeared all over Marco's rapidly deflating cock. And all I could think was: *if you touch that stuff you're going to catch AIDS and die.*

I pulled out a pack of tissues, thrust them in Angelique's direction muttering apologies and then marched over to the director.

'I'm really sorry, Kelvin, but there's been a misunderstanding. I … I can't do *this*,' I gabbled, gesturing to where Angelique was dabbing ineffectually at her face.

Kelvin just laughed. 'Gary, you're a nice kid but you need to toughen up, get a bit streetwise. You're too sensitive.'

He was right. Looking back I was astoundingly naïve, although in my defence there wasn't much known about AIDS at the time. People still believed you could catch it through kissing.

'I'm so sorry … I just … I can't.' I was close to tears by now. 'I'll pay you back any expenses, but … I'd like to go home.'

'Well fine, if that's what you want,' Kelvin said. 'But you won't be able to get off the island until the seaplane brings the next lot of supplies.'

'When will that be?'

'Four days,' he smiled.

So that was it. I was trapped on this island with a load of sex-crazed porn stars who would probably be having orgies every night

and force me to join in. I was going to die a horrible death and my mother would never forgive me.

Kelvin put his arm round my shoulders. 'Look, Gary, you might as well do something useful while you're waiting for the plane and finish Kandi's make-up for the next scene.' He gave me a friendly shove towards the house. 'There's a good kid.'

* * *

That first evening on the island I had planned to barricade myself in my bedroom, but – tempted out by a desperate hunger and the delicious cooking smells wafting up from the kitchen – I decided I had to brave whatever debauchery was going on downstairs.

Cautiously pushing open the living-room door, I was stunned by the sight that greeted me. In one corner a few of the girls were playing a game of Monopoly with the cameramen; others were chatting and flicking through fashion magazines. At the long dining table a smiling Caribbean mama was dishing out huge plates of jerk chicken, fried plantain and salad while Kelvin opened a couple of bottles of white wine. *And everyone had their clothes on.*

In the end I stayed for the entire shoot, and once I chilled out and stopped worrying I was going to contract some hideous disease or be raped by a posse of rampant strippers I actually started to enjoy myself.

The movie was called *Wonderboobs*, a hardcore 007 spoof featuring a British secret agent called Brooke Bond battling the evil Mr Very Big and his sidekick Blowjob. For a porno there were some great special effects – aerial shots from helicopters, exploding speedboats – but most of the film's big bangs were of the sexual variety. There were orgies in the house, gang bangs on the beach, blowjobs in the bath and sex in the sea complete with an underwater camera capturing the action. Subtle stuff like that. The plot was flimsier than the girls' barely there costumes, but I doubt the film's audience would have minded much.

As the days went by, I gradually got more blasé about being on set. I would sit and sunbathe nearby until Kelvin stopped the action mid-fuck and called for me and the fluffer: me to touch up the make-up, the fluffer to, well, touch up the talent. (This unenviable job – giving the male star a hand or blowjob to keep him hard during a pause in filming – was usually taken care of by a runner. No wonder Donna was always so pissy.)

One day we filmed a scene where Mr Very Big's posse of evil henchwomen kidnapped Bond and took him to a remote part of the island where they all screwed him senseless. There must have been about ten girls involved. When Kelvin called 'cut' I had to step gingerly amongst the entwined mass of sweating, naked bodies reeking of sex and hairspray to redo ten lots of lip gloss, all the while desperately trying not to get splashed with the copious bodily fluids.

I really earned my money that day. Have you any idea how difficult it is to get cum off false eyelashes? Honest to God, I kept wet wipes in business during those three weeks.

After a week or so I decided to bite the bullet and phone home.

'Mum?' The line was terrible, crackly and with a long delay. 'Mum, it's Gary.'

'Hello, love! How are you?' I heard her cover the receiver and shout for Dad. 'Brian! It's Gary calling from the Caribbean! Yes, I'll tell him.' She was back again. 'Dad says hello. So, how's the job going, love? Is the weather nice?'

'Oh, it's all fine thanks, Mum. Busy. I'm getting a great tan.'

'Ooh, lovely. So, what's the job you're doing out there?'

Mum and Dad knew that I'd been working on girlie mags and they weren't exactly proud of me, but I'd tried to gloss over the worst of the details.

'Well actually it's a film,' I said. 'It's really big budget, we're staying on this gorgeous island in a beautiful villa. I'll, er, tell you about it when I get home.'

But the questions kept on coming – 'Will we be able to see it at the cinema? Is there anyone famous in it? What shall I tell Auntie Janice?' – and in the end I had to explain.

Mum was stunned into horrified silence. She passed the phone to my dad. There was a muffled conversation, and then – 'Gary, it's your father here.'

'Hello Dad.'

'Your mother's told me what you're, um, doing out there.' He cleared his throat awkwardly. 'Son, what are you thinking? You've been to college, for God's sake, you're a talented lad. You're supposed to be getting a job as an illustrator!' I heard a muttered comment in the background. 'That's right, Ann – Gary, your mother says the next thing you know you'll actually be doing it!'

As always, my parents eventually came round, in fact I think Mum still has a video copy of *Wonderboobs* somewhere in the house (still in its cellophane, obviously). And in case you're wondering, no, I never did end up *doing it*.

* * *

Every evening after filming had wrapped we would all sit round, the girls in their tracksuits with faces scrubbed of make-up, chatting, playing board games, eating the enormous dinners the resident chef prepared for us. I was fascinated to find out why these women, many of them so incredibly beautiful, had ended up doing this for a living. Not just having sex with a succession of strangers for the camera, but disfiguring their bodies with those enormous sacks of silicone that gave them constant backache and a whole host of horrific health problems, including haemorrhages, freakish scarring and exploding implants.

But then I found out how much they got paid.

Unlike most lines of work, it was the girls who commanded the really big bucks in the adult movie industry. Every act that the girls performed on camera was costed on a sort of sliding sexual scale,

with a hand job paying the least, then girl-on-girl, blowjobs and so on until you got to anal scenes at the very top. The girls were the stars, the ones whose name (and body) would sell the video, whereas the likes of Marco were really just glorified props, there only for their penises. Blokes working in straight porn didn't tend to be that attractive and, contrary to popular belief, they didn't all have huge cocks – far more important than size was the ability to get it up for the camera and keep it under control once it was up there.

Most of the porn actresses I met dreamed of having a normal life and, like me, were doing this job as a means to an end. These girls planned to keep the implants in for a few years, make as much money as possible and then get them removed and settle down with a nice man in middle America and become a soccer mom. But those would be the lucky ones; drugs or pimps would get most of the others.

You didn't have to look very hard to find the sordid side of the adult movie industry. Heroin and cocaine usage was rife. A lot of the girls would bring their boyfriends on set with them and they were usually the nastiest pieces of work, jobless sleazebags who controlled their girlfriends by making them feel as ugly and insecure as possible. Often they were the reason the girls had ended doing the job in the first place. I remember one actress called Crystal, a gorgeous-looking girl with the most beautiful, soft personality, who worked as a Rita Hayworth lookalike. Not only did she look like Rita (but with massive fake breasts) she spoke like her, dressed like her – I think she truly believed that she *was* her.

Yet she was going out with this vile, greasy old man who you could tell was forcing her to do jobs she didn't want to do, but she'd go along with it just to keep him happy. Tragically, a few years later I heard that Crystal had committed suicide. Another girl on *Wonderboobs* – a stunning green-eyed Brazilian called Juana – broke down in tears one day while I was doing her make-up.

'I hate this so much,' she sobbed, 'but I have no other choice – my family rely on me sending money back home.' It was heartbreaking.

But there were exceptions, a few rare girls who genuinely loved their job. Monika had long black hair, incredible legs and a sex drive higher than a horny 17-year-old boy. She tried to shag every single member of the *Wonderboobs* crew – men *and* women – including, on one memorable night, me.

We were all sitting around after dinner having a few drinks and some of the girls had turned up the music and were dancing around the room, showing off their strip routines. I was joining in, clapping and laughing along with everyone, but then I noticed Monika – who, as usual, had taken centre stage – was staring straight at me. Having caught my eye she smiled, mouthed 'Hello, Gary …' and then started shimmying sexily over to where I was sitting. I giggled nervously as she leaned down towards me, slowly running her hands over her breasts, and then suddenly she was kissing me.

'Um, I don't think this is a good idea,' I squeaked, but she pressed her finger against my lips to shush me and with the other hand started to unzip my flies. 'Seriously, you'll be very disappointed!' I pushed her away, my voice shooting up an octave, as everyone else in the room cracked up. 'It's honestly not worth going there, love!'

That night, for the first time, I kept my bedroom door firmly locked.

* * *

Despite eventually enjoying the *Wonderboobs* shoot, I never for one moment considered making my career in porn. Not that I was ashamed about the industry that I had found myself in – far from it. I met some incredible people and was given some amazing oppor-tunities. But to me it was all about getting a bit of cash together, learning some lessons and then moving on to bigger and better (and slightly less seedy) things; a steppingstone, just as my stint at Markham Main had been.

However, a couple of months after I'd got back from the Bahamas, Kelvin's secretary (a nice motherly type called Enid who looked like she should be knitting booties and baking fairy cakes rather than booking gang bangs) phoned to make me an offer I would find it impossible to refuse. Kelvin wanted to book me for another trip, this time to Los Angeles, staying in Groucho Marx's palatial villa in Palm Springs. It had been a dream of mine to go to Hollywood ever since I first became obsessed with those classic old musicals, and the idea of going out there to work alongside A-List stars – even if they were the A-List of the porn world – was hugely tempting.

The only downside was that it meant a month away from Phill. By this time the two of us were living in our first flat, a little one-bedroom maisonette at the top of a new-build Bovis-style block in Hayes that we had bought a few months after that fateful day I had ruined baby George's christening and nearly given Mum another heart attack. We bought new furniture and Phill painted it throughout. It was our little lovenest and we were obsessed with each other.

By now we had come out to our nearest and dearest (although my parents still hadn't told the rest of my extended family) and had our wonderful group of girlfriends – Jo, Jane, Wendy, Sally and Louise – who we would meet down the pub or go away with for weekends. We would go on these dirt-cheap package holidays together to Benidorm and Tenerife and have a real laugh.

Phill had also confided in his work colleague Steve, his best mate on the building site, and was relieved when he told him not to worry, he'd known for ages. Shortly after they had first met Phill had been out for a drink with Steve and his girlfriend, and apparently she'd turned to him at the end of the night and said: 'You do know Phill's gay, don't you?'

Now that we were out and living together as two gay men, we decided we would take part in Gay Pride, the annual celebration of gay and lesbian culture. There was a march through central London with floats and drag queens and festivities followed by a party in

Brockwell Park. It was an amazing day with a real carnival atmosphere and it was so great to be part of it. I'd never seen so many lesbians together in one place before!

The event obviously attracted quite a lot of media coverage, but I didn't think twice about the TV cameras around the place until I got a phone call from my very distraught mum later that evening.

'Oh my God, Gary, you're on the evening news!' she screeched. 'Are you causing trouble in London? I've just seen you taking part on some big demonstration or protest march or something!'

Worse was yet to come. The following day there was a piece on Gay Pride in the *News of the World*, together with a group photo of some of the celebrities taking part: Margi Clarke, Nathan from Brother Beyond and Jimmy Sommerville together with a couple of fans. Fans who just happened to be me and Phill. Mum tore round to my granddad's house that morning and nicked the paper before he'd had a chance to see it. In fact I think she spent the whole of Sunday trying to buy every single copy in the village.

After the Gay Pride drama my parents agreed that it was time we told the rest of the family that I was gay, and we chose the occasion of my dad's 50th birthday BBQ in July to do it. I brought Phill along too. After lunch my cousins and I went into my dad's garage and started reminiscing about all the shows and plays we'd put on there when we were younger. I was just trying to find the right time to drop my bombshell, when Julie blurted out: 'Gary, are you gay?'

It was a massive relief. Everyone was really accepting; Auntie Janice kept saying, 'Ooh, I knew all the time.' It was such a happy day. The only person I never spoke to about my sexuality directly was Granddad Joe, but he knew, of course, and he welcomed and accepted Phill as part of the family without blinking an eyelid.

* * *

Thankfully Phill wasn't bothered by the work I was doing at the time, in fact he found it quite funny, and so a few weeks later I found myself on a plane en route to Los Angeles. For someone who nowadays gets on a plane at least every other week I am not a confident flier – and back then I was even worse. It doesn't help that I seem to have had more than my fair share of in-flight nightmares. I've been through such bad turbulence that the stewardesses have had to throw themselves flat on the floor, made several emergency landings (including one on a tiny Caribbean island in a jumbo jet when even the pilot sounded nervous) and been trapped on a transatlantic flight with a mass murderer. Okay, so admittedly the guy was accompanied by twenty heavily armed policemen, but knowing a notorious serial killer was sitting a few rows away didn't exactly help me to 'relax and enjoy the flight'.

Over the years I have found the only way to ease my flying phobia is to have a drink or two. One time I was flying back from Sweden with Ulrika Jonsson where she had been presenting her homeland's national beauty pageant. It was so cold and snowy that the plane's wings kept freezing and they had to repeatedly de-ice them. We'd be just about to set off and they'd have to stop and spray them all over again. The passengers were starting to get edgy and I could see the Swedish stewardesses having serious-looking semi-whispered conversations in the aisle. I didn't understand a word of it, of course, and Ulrika took the opportunity to start winding me up.

'Christ, Gary, they're worried the wings might snap off when we're airborne,' she muttered, completely straight-faced. 'Do you think we should try and get off the plane?'

I love Ulrika to bits, but her humour is so bone-dry you're never quite sure if she's joking or not, and by the time the plane finally took off I was really freaking out. I barely had a chance to order a vodka and orange (my anti-anxiety drug of choice) when we hit severe turbulence. We were being thrown around all over the place and then – BAM! – such a violent bump that the masks were jolted

down from the overhead lockers. By this time I was literally crying. (So was Ulrika, although hers were tears of laughter.) By the end of that flight we had put a serious dent in the plane's vodka reserves and were both in hysterics.

Back to that first trip to LA-LA land. I'd been my usual jittery self during the long flight, but when the plane started its descent and I caught my first glimpse of the Hollywood sign in the bright sunshine, my nerves vanished in a puff of excitement. Los Angeles spread out beneath me like a glorious, glittering toy-town, bordered on either side by tree-covered hills amid which I spotted the occasional sapphire-blue glint of a swimming pool. This was it: Gary Cockerill had made it to the Promised Land.

It was a two-and-a-half hour drive through the desert to Palm Springs and to my movie-obsessed imagination it seemed that every new sight we passed was straight out of some Hollywood picture. That cactus-fringed mountain looked like the set of a John Wayne film, the diner where I had to stop for a wee was exactly like the one in *Peggy Sue Got Married*, that gas station could have been straight out of *Thelma and Louise* and, once we were deep into the desert, there were some seriously scary-looking locals who could quite feasibly have been the Hillbilly cannibals from *Wrong Turn*.

But the most surreal sight of all was the immense field of giant white windmills that suddenly rears up out of the desert scrub as you approach Palm Springs. There seemed to be thousands of these enormous wind turbines stretching out across the horizon in every direction, looking like some bizarre alien landscape dreamt up by Steven Spielberg. I wound down the car window and was blasted by a wall of unbelievably fierce desert heat.

Looks like we're not in Armthorpe any more, Toto, I muttered to myself.

And then out of nowhere appeared the perfectly manicured oasis that is Palm Springs, all lush green lawns, palm-fringed golf courses and sprawling pastel-painted villas.

The crew was staying in a beautiful cream-coloured house that used to belong to Groucho Marx, while I was lucky enough to be given the estate's pool house, a fabulous two-bedroom cabana complete with fur rugs and a real log fire (perfect for those chilly desert nights) where I would also do the girls' make-up.

For the month I was based in Palm Springs I worked on a variety of jobs for Kelvin, usually magazine photoshoots, and the location we used for most of these was the most incredible house I have ever been to in my life, the home of the flamboyant pianist and TV entertainer Liberace. Hidden behind huge electric gates, Casa de Liberace was a temple to gold-plated, marble-floored excess, with leopard-skin carpet on the floors (and walls and ceilings) and pink crushed velvet sofas. It made Groucho Marx's mansion look like my parents' bungalow.

One day Kelvin wanted to shoot in a room dominated by a lifesized portrait of Liberace. The house's current owners were apparently unaware exactly what kind of shoot was currently taking place in their property and so (for obvious reasons) Kelvin didn't want the picture to be in shot, but it was too big to be covered up and couldn't be moved as it was nailed firmly onto the wall. In the end it was decided we would just have to shoot around it, but just as the models (I think it was the Rita Hayworth lookalike Crystal and another mega-boobed starlet called Luci Lips) were getting into position for the first shot, the portrait suddenly fell off the wall with an almighty smash. It seems that Liberace wasn't too keen on starring in a porno either.

* * *

It was on this trip that I managed to blag a ticket to the most prestigious event in the adult film calendar, the Adult Video News Awards, popularly known as the Porn Oscars. Just like the Academy Awards, the AVNs attract superstars from all over the world to strut down the red carpet in their designer finery and meet the international press, except the gowns are a bit skimpier and the breast

implants are considerably bigger. And as well as the usual Best Actor and Best Director categories you get at the Oscars, the AVNs also celebrate talents like Best Blow Job, Best Three-way and Best Speciality Release (Foot Fetish).

The ceremony was taking place in a cavernous, chandelier-bedecked Las Vegas ballroom packed with white linen-covered tables that were set with extravagant floral arrangements and crystal champagne flutes, with only the freebie sample bottles of anal lube at each place setting suggesting that this wasn't quite the BAFTAS. It was a brilliantly bizarre night. Just like at the Oscars, the previous year's winners handed out the awards (a transparent block engraved with a picture of a man and woman embracing known as the Woody) to this year's crop of triumphant stars, and you got the same gushing acceptance speeches and tearful thankyou – although I can't imagine you'll ever see Kate Winslet celebrating bagging Best Actress by spreading her legs and flashing her Brazilian at the audience.

After the ceremony had finished the music got louder, the drinks got harder and bits of clothing started to come off. As everyone mingled – there was no VIP area at the AVNs – I found myself chatting to a famous director and a couple of gay porn stars. Oh my God, these guys were so beautiful. As I mentioned before, the blokes in straight porn tended to be fairly average-looking as the focus was on the girls, but Jed and Scott were absolutely gorgeous: totally ripped, chisel-jawed, all-American beefcake.

'So, Gary,' said Jed with a flash of his Colgate-white smile, 'you're a good-looking guy – have you ever thought about trying your hand at acting?'

'Well actually,' I began, 'I did do a little when I was younger …' And then the penny dropped. 'Ah, right. I see. No, I'm happy sticking to being a make-up artist. But I admire what you do.'

And I really did. To be able to perform to order while a load of people stand around watching, especially considering this was in the days pre-Viagra, was quite a talent.

Then Jed moved a little closer and spoke softly in my ear. 'Listen, Gary, I'm having a party back at my hotel room later. Just a few, *special* guests.' He snaked his hand behind my back. 'You wanna come?'

I can't deny it was tempting, but I said no of course. Looking back, I am so glad I'd met Phill by this time. If I'd been single I might well have gone back to Jed's room, and then my career could have taken a completely different path …

* * *

During the month I was in Palm Springs I managed to make a few pilgrimages to Los Angeles, which was everything I hoped it would be and so much more. I ticked off every LA must-see: window-shopping on Rodeo Drive, rollerblading at Venice Beach, checking out the celebrity handprints on the Hollywood Walk of Fame. I found the whole place utterly intoxicating – the climate, the incredible lifestyle and, of course, the people. It was my first proper contact with Americans and I found their have-a-nice-day attitude and positivity instantly infectious. I was smitten, and desperate to return.

On my last day of the trip I took a final drive down Sunset Boulevard and while waiting at a red light spotted an enormous poster of Melanie Griffith, stretching several stories high, advertising her latest blockbuster. At the time she was one of the movie world's hottest stars and as I looked up at that famous face, blown up to superhuman proportions across the side of a building, I offered up a silent prayer to the Hollywood gods.

Please, please let me come back here again one day to do her make-up. And then the lights changed to green.

EIGHT

The Superbabes

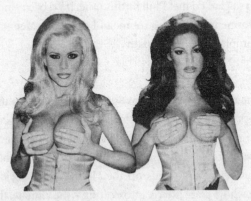

Since getting back to Britain after my X-rated adventures in Palm Springs I had been frantically busy trying to establish myself as a mainstream make-up artist. I was doing a lot of what's called testing, which is basically where a model, photographer, make-up artist and stylist will get together, pool the costs, and combine their talents. Although a test isn't a shoot that's necessarily been commissioned, you can often sell the resulting images. It's basically just a way of gaining professional experience – and pictures to use in your portfolio – while giving your creativity free rein.

I was working with all sorts of up-and-coming photographers and models, not just of the glamour variety but also more commercial ones too. I had met a woman called Christina Vaughan who ran a picture agency, Image Source, that provided lifestyle images: people cleaning their teeth, going jogging, doing the gardening – that sort of thing. A very different prospect than making up porn superstars, but I wanted to get as broad an experience as possible.

Although I was now working with a different sort of model, I was still using the skills and techniques I'd learnt in America, where the Pamela Anderson *Baywatch* look – all smoky eyes, golden skin and pale glossy lips – was currently huge. During my time in LA I'd perfected that face, so when I came back to the UK where the make-up style was generally still pretty naff and dated (red lips, brown eye-shadow – really basic stuff) I was offering something completely unique, a look that no one else in the country was doing at the time. Whatever the girl looked like, I could draw on this incredibly sexy face and she would be transformed into a sun-kissed Californian beach goddess. It was a style of make-up that would fit in perfectly with the publishing revolution that was about to take place.

* * *

I had been booked to work on a test for a new men's magazine that was just set to launch. The magazine was called *Loaded* and the models included a few unknowns keen to get their big break. I turned up at the studios at 8 a.m. sharp and started setting out my kit. We were shooting seven girls so it was set to be a long, hard day, but I was really excited about the prospect of getting my work in a commercial magazine. Then the first girl walked in and my heart sank. She was perhaps 16 or 17, with long, lank hair in a greasy centre parting and baggy clothes which – together with her hunched shoulders and almost embarrassed air – suggested she would rather be anywhere other than here in this studio. She told me she had just left drama school and had her heart set on being an actress.

Her name was Kelly Parsons. I sat her in the make-up chair and examined her features: a podgy face with a dimple on the chin, slightly wonky nose, eyebrows that had nearly been plucked into oblivion, a brace on her teeth and an unfortunate outbreak of teenage zits. None of her features seemed to work together.

'And you've got to start growing those brows back,' I told her.

But there was something about her bone structure, eyes and mouth that vaguely reminded me of Cindy Crawford, so that was whose face I started to draw onto this gawky, geeky schoolgirl.

I created a pair of strongly arched brows with a sexy, smoky eye and creamy lips – the supermodel's signature look. I literally painted on a mask. Suddenly everything fell into place – the too-far-apart eyes and overly broad nose were balanced out. She looked breathtakingly beautiful. And then she took off her robe. Well, none of us had been expecting that body. It was unbelievable. She had this incredibly natural, womanly figure: big boobs, hips, tiny waist – a real Monroe-style hourglass. Together with that stunning face and her freshly styled hair (which I had set in rollers to give it a bit of oomph) the effect was startling. It was a case of a geeky duckling – forgive me, Kel! – being transformed into the hottest swan you could possibly imagine.

We shot Kelly in lingerie (she didn't want to do topless because of her acting ambitions) and she looked fabulous. She wasn't that comfortable in front of the camera, although she was confident thanks to her time at drama school, but I knew we'd be seeing more of this girl.

After Kelly we shot Jo Guest, who was very hot at the time, and a handful of other established names. It was like a very glamorous production line – I'd finish with one, then it would be straight onto the next. Our last girl, like Kelly Parsons, was a new face, but that was where the similarities between them ended. She was an hour late and I had just nipped out of the make-up room to get myself a much-needed Diet Coke when I heard this loud, confident voice ringing out: 'Who's doing my make-up then?'

I turned round to see a girl wearing a low-cut top with her boobs hoiked up as high as they could go, skin-tight leggings and incredibly high heels on which she clomped around like a baby giraffe. An exhibitionist, is what Mum would have called her. Yet despite her

best attempts to create a killer cleavage, her figure was actually quite sporty, almost boyish; her legs were amazing, but you could see she was pretty flat-chested.

The girl plonked herself down in the make-up chair and fished out her chewing gum. She had the longest, wildest corkscrew curls you've ever seen, a big mole by her nose and huge goofy teeth, but she had beautiful long lashes and a gorgeous little face.

'Right, when I do mascara I like at least five or six coats,' she ordered. 'And make sure you put on loads of lip-liner to make my lips look really big and pouty. Okay?'

I suggested that her lashes might look a bit clumpy with that much mascara.

'I like them like that,' she snapped back.

This girl was so self-assured, so ballsy – and she was only 16! *What a bloody nightmare*, I thought to myself as I got to work, although part of me envied that cast-iron confidence.

I made her up in soft bronzes, a more natural look than perhaps she would have liked, although she did eventually get her way over the mascara and overdrawn lip-line. But then, as you probably know, Katie Price nearly always gets her own way in the end.

Kate was a complete professional in front of the camera, although she was in and out of that studio like a whirlwind.

'Bye, Gary!' she yelled, as she clomped off down the stairs with a cheery wave. 'See you around.'

* * *

I was thrilled when the pictures from the shoot appeared in *Loaded*, as it was my first mainstream published work, and even happier when they were picked up by the *Daily Star* a few days afterwards. The picture they had chosen for the front page was one of Katie Price sitting on a speaker in a pair of little yellow knickers with all that wild curly hair tumbling over and covering her boobs. It was quite a look.

Later that week my agent called to say that my work had caught the eye of a photographer called Jeany Savage who was now keen to meet me.

'She thinks your make-up is fantastic,' she told me. 'I've made you an appointment to see her next Monday. Oh, and, Gary,' she added as I was about to ring off, 'you better not be late.'

The lift at Chalk Farm Studios was one of those old-fashioned jobs with a sliding gate that clanked and lurched as it shuddered slowly up to the third floor where Jeany had her office. I was feeling sick with nerves, because since our meeting had been arranged I had discovered just how influential Jeany was in the industry.

'If she likes you, you've got it made,' a make-up artist friend told me. 'But she's a really tough cookie. Savage by name …'

I walked into Jeany's studio to find it completely empty, so I sat down in the little kitchen area to wait. After a few minutes – and getting increasingly panicked that I had got the wrong time – I became aware of a woman's voice raised in anger, evidently talking (well, yelling) into the phone.

'You can tell them to fuck off!' she screeched in a cockney accent. 'If they want me to do that, then they're going to have to fucking pay for it!'

Oh God, was that Jeany? She sounded worryingly angry. Then suddenly this tiny blonde woman stormed past me, still shouting into her mobile. She was in her mid-forties, barely over five foot and dressed like a Status Quo roadie in jeans, a grungy rock tour T-shirt and trainers, with minimal make-up and a mad tangle of golden curls. For the next ten minutes this furious ball of energy bounced around the studio, effing and blinding at the poor unfortunate at the other end of the line, apparently completely oblivious to my presence despite my tentative smiles and waves whenever she seemed to glance in my direction. By now I was shitting myself, terrified I'd be next for a tongue-lashing, and I was just thinking about creeping out of the studio when she abruptly ended the call.

'And who the fuck are you?' barked Jeany.

'I'm Gary,' I said. 'We had an appointment …?'

'Well why were you sent here now? I've got a shoot. Jesus Christ … Look, what did you say your name was?'

'Gary Cockerill. I'm a make-up artist … I can come back if it's an awkward time …'

Checking her watch, she sat down next to me and gestured impatiently for my portfolio. And as she flicked through my images, she started to soften.

'Oh yeah, you're that bloke who did that shoot that was in the *Star* the other day.' She finally smiled for the first time. 'I love your make-up! Come back here tomorrow at nine sharp. I'll book you for a day – 250 quid. We'll see how it goes. And don't be late.'

We might not have got off to the best of starts, but Jeany Savage has since become one of the most important women in my life. I absolutely worship her. When we met she was already a legendary photographer; not so much Page 3 (although she has done that in her time) but anything from fashion to uber-sexy lingerie or bikini shoots with models, singers, soap stars, It girls, actresses – whoever was famous and fabulous at the time – for magazines and newspapers.

Soon I was working four days a week with Jeany, fitting in up to three jobs a day. We did countless cover shoots for magazines like *Maxim* and *Loaded* and built up a fantastic relationship with the editor of the *Daily Star*. They just got our vision – and we couldn't do enough pictures for them. This was in the days before airbrushing, so a photographer had to use clever lighting and make-up to ensure the girls looked their best – and for some reason, my make-up and Jeany's lighting just worked together. Jeany used a ring flash, which softens shadows and bleaches out imperfections, while I was turning out dozens of big-eyed, lush-lipped goddesses.

Our pictures from this time are very distinctive: big eyes, big hair, pale lips and ultra-flattering lighting. It may sound arrogant, but

together we defined the look of the era. It was a real boom time for glamour, with the arrival of the lad's mags and the *Sun* and *Star* newspapers in a daily battle over who could feature the hottest girls. The age of the Superbabes had arrived.

* * *

I turned up to the studio one morning to find Jeany all excited about a new girl she had booked for a shoot that day. She was from Swindon and had become famous in her local area for appearing lingerie-clad in an advert for a double-glazing firm. She had made the news because the posters were so sexy that they were being nicked from bus shelters, although she hadn't had many other modelling jobs.

'Her name's Melinda Messenger,' Jeany told me. 'Can you believe it – Melinda fucking Messenger! Great name – I wonder who made that one up …?'

Melinda arrived hand-in-hand with her boyfriend Wayne, a cute Bobby Ewing lookalike. Having seen the double-glazing ad I had been expecting a bit of a dolly bird, but while Melinda was undoubtedly pretty, with the sexiness of a young Diana Dors, she had a bit of a grungy, rock chick edge to her too. She was well-mannered, intelligent and confident but not pushy, and I liked her straight away.

At the risk of sounding big-headed (again) a girl could walk into the studio looking pretty average and by the time I'd finished drawing a face on her – be it Cindy Crawford, Pammie or Linda Evangelista – she'd be drop-dead stunning. But I didn't have to draw anyone's face on Melinda; doing her make-up was an absolute pleasure. Her full lips were perfect, she had a cute little pixie nose and beautiful bone structure. When she hopped off that make-up chair Jeany and I both knew instantly and indisputably that this girl was going to be a massive success.

'Let's have a look at your tits then,' Jeany said matter-of-factly – not that we were shooting her topless, but she always liked to see a

girl's body before starting taking pictures to see what sort of lingerie would best suit her.

Melinda's boobs were perfect. 'Have you had a boob job?' Jeany asked.

'No, I haven't,' she said quickly – although of course it was later revealed after she appeared topless on Page 3 that she'd had an operation to boost them to a 34DD.

Jeany shot roll after roll of pictures of Melinda, some in a pink satin basque, others sitting down with her legs crossed in front of her boobs, some against the leopard-skin rug that was one of Jeany's favourite props. We were both so excited about the pictures that Jeany got them developed that afternoon and then sent them straight over to the *Star*, who put them in the newspaper the following morning. Meanwhile Jeany suggested Melinda sign with a top glamour agent.

Well, the rest is of course tabloid history. The *Sun* had long been searching for a girl to replace their last Page 3 icon, Samantha Fox, and there was a furious bidding war between them and the *Star* to sign Melinda. Overnight, she became the most famous woman in Britain; I don't think she even went back to her home in Swindon for two weeks after that original shoot with Jeany. We did another set of pictures with her the day after the first, but by that time the *Sun* had got her. They had found their Page 3 Girl of the Thrillennium.

Melinda quickly developed her career beyond modelling and within six months had her own TV show, but although I carried on working with her and we became close friends, she never worked with Jeany again. I know Jeany was disappointed, as she'd played such a key part in her success.

'She never even sent me a bunch of flowers,' Jeany would tell everyone. The pair of them met at my birthday years later and although it's always been very friendly Jeany never misses an opportunity to remind Melinda: 'I helped make you!'

After Melinda was poached by the *Sun* the *Daily Star* were desperate to find another girl to replace her. Jeany had taken Melinda's defection personally, so she too was keen to discover the next big thing. Suddenly I remembered Kelly Parsons, the girl I'd worked with way back on that *Loaded* shoot and I suggested her to Jeany. 'No fucking way,' she snapped.

Jeany just did not get Kelly. She had already seen her at agency castings and had not been remotely impressed with this geeky-looking teenager. Although she had by now appeared in a few advertising campaigns, Jeany was convinced that she didn't have what it took to hit the big-time – and she was usually right on such matters (although Kelly wasn't the only girl I would have to force on to Jeany – of which more later). I was determined, however.

'Just let me show you what I can do with her make-up,' I pleaded. 'I promise you're going to love her.'

Eventually, after days of nagging, Jeany admitted defeat. 'I know she won't be right, but you might as well get her in anyway.'

The shoot did not get off to a good start. 'This is not going to work, Doris,' muttered Jeany when Kelly arrived (she has always called me Doris; still does to this day). 'You're going to have to work a miracle on this girl for me to change my mind about her.'

By this time Kelly had managed to grow back her brows so they were beautifully thick, her skin had cleared up and she'd had her hair layered to give it a bit more bounce. I got to work, painting on another Cindy Crawford face; this time I even drew on the supermodel's famous mole.

And when Kelly walked into the studio wearing a bikini Jeany's jaw just dropped to the floor. 'Fucking hell, it's Cindy Crawford,' she muttered.

As soon as the flash hit Kelly's face the magic happened – in that moment a new star was born. During that shoot we recreated those first pictures we had originally done with Melinda: the same pink satin basque, the same leopard-skin rug, the same provocative cross-

legged pose. Jeany even made up a back-story for Kelly to rival Melinda's, claiming that she had been discovered on an advert for laminated flooring and sending the pictures off to an overjoyed editor at the *Star* with the typically saucy headline, 'The Only Way to Get Laid'.

Over lunch that day Jeany told Kelly she needed to do something about her name. 'Kelly Parsons isn't right,' she said firmly. 'It's too much like Nicholas Parsons. Nah, we need something sexier …'

And so the three of us sat round trying to come up with a suitable alternative. As well as Cindy Crawford, Kelly had the same strong beauty as Brooke Shields, and we played around with a few variations on that. Jeany also mentioned the American actress Kelly LeBrock, who she'd worked with in the past. And by the time the sandwiches were finished we had hit on the perfect new name: Kelly Brook.

* * *

One of the most interesting things about my job is meeting people before they become famous and then watching them evolve into a star. I did Amy Winehouse's make-up before she'd become really well known, long before the bouffant beehive, flicked eyeliner and tattoos, and she looked like a completely different girl. With her sexy little short skirt, pushed-up cleavage and long dark hair, she was more girl-next-door than music icon. The difference might not be so dramatic in Kelly's case, but even today she will be the first to admit that Kelly Brook is something that's created when she's sitting in the make-up chair; up until that point she's Kelly Parsons.

Just as Melinda before her, when Jeany's pictures of Kelly appeared in the *Daily Star* it turned her into a household name overnight. She too was keen to develop her career beyond modelling as quickly as possible and although she had her heart set on acting, when she was approached to present Channel 4's hit morning show *The Big Breakfast* alongside Johnny Vaughan, Kelly leapt at the chance.

I remember getting her ready for the press launch in January 1999. She was so nervous that day, bless her, but then she had every reason to be: she was only 18, it was her first mainstream TV presenting job and she was taking over from Denise Van Outen who had been so incredible in that role. The odds were overwhelmingly stacked against her and, sure enough, after a few on-air gaffes the press were gunning for her. Kelly was absolutely devastated by the storm of criticism during that time – and by the lack of support on the show – and she left barely six months after her debut. Looking back, there is no way she should have been thrown in the deep end like that.

And that might well have been it for Kelly; after all, it certainly wasn't the first time I'd seen a girl rocket to superstardom only to plummet back into obscurity once her 15 minutes were up. Kelly kept a low profile for the next few months, spending time with her then boyfriend, the actor Jason Statham, and doing a few shoots. Then the following year I got a call asking me to get her ready for the London premiere of Jason's new movie, *Snatch*.

I turned up at Kelly's flat together with the stylist, a fiery Italian with black hair and red lipstick called Marcella Martinelli whom I met on the first ever shoot I'd done with Jeany. Today, she is one of the top fashion stylists in Europe (and one of my closest friends) but in those early days she was working on a lot of men's magazine shoots and we usually ended up being booked for the same jobs – me to do the make-up and Marcella the styling. We were a great team and I always had fun on shoots with her. Before I started on the make-up, Marcella pulled out the dress that she wanted Kelly to wear. Well, I say dress, but it was actually little more than a tiny strip of pink sequins and a pair of matching knickers. It might not seem particularly daring now, but ten years ago this Julien MacDonald showstopper was way ahead of its time.

'This was actually designed for Liz Hurley, but I got my hands on it for you to wear first,' Marcella smiled.

Kelly looked horrified. 'Wow, that's amazing,' she said tactfully, 'but there's no way I can possibly wear it. Sorry Marcella.'

'Come on, Kel, just go for it,' I said to her. 'You're young, your body is fantastic and you're absolutely gorgeous. If anyone can wear it, you can. Go on …'

Eventually, after much stressing on Kelly's part, we talked her round. Marcella had to rush off, so I was left with the task of sticking Kelly into the dress using several rolls of Tit Tape. (And yes, I do know I must be the envy of every man in Britain at this point!) I styled her hair with a few extensions so it tumbled over her shoulders in tousled waves and used soft pinks and browns for her makeup. To be honest, she was probably a little big for that dress – her boobs certainly were. Kelly was a womanly size 10, and the dress had been designed with the considerably less curvy Liz in mind. But boy, did she work it. It looked absolutely sensational on her.

Kelly had another attack of nerves on the way to the premiere, but when we arrived she took a deep breath, climbed out of the car and my God, the press went mental. Buzzing off the reaction, Kelly worked that red carpet like I've never seen anyone work it in my life. I was terrified the dress would come unstuck – you can actually see it peeling off one of her boobs in some of the press photos – but Kelly was oblivious. After being so down following the *Big Breakfast* disaster it was just what she needed, and next day she was on the front page of every newspaper. Just as that safety-pinned Versace number launched Liz Hurley's career, that night Kelly Brook was reborn.

With Jason unable to attend the premiere as he was filming, I went to the after-show party with Kelly, together with Phill and Marcella. We chatted to Guy Ritchie, but the man we most wanted to see was the film's star, Brad Pitt, so we headed off to the VIP section downstairs. We were just reaching the bottom of the steps when Marcella suddenly stumbled and fell. Phill immediately reached out to catch her, but another guest leapt into action and got

there before him, so the only thing that Phill ended up catching was this guy's bum. And whose perfectly peachy butt was it? Yup, you've guessed it.

'Sorry, mate, I didn't mean to grab your arse,' said Phill when we joined Brad and his friends for a drink.

'Hey, don't worry about it,' he grinned. 'Happens every day.'

Unlike some of my clients, Kelly has got really good taste in men. I've liked all her boyfriends, although they couldn't be more different from each other. After she split from Jason she started dating Billy Zane. In his prime Billy was just so hot – I remember lusting after him in *Dead Calm* with Nicole Kidman in the late Eighties. Although he had lost a bit of hair by the time he started seeing Kelly, he was still very charismatic. He loved the whole English country gentleman thing, the tweed caps, waistcoats and old-fashioned manners, even though he was from Chicago.

I thought Billy was a really nice guy – and Kelly's other high-profile boyfriend, the rugby player Danny Cipriani, was a real sweetie and so gorgeous. But I really loved Jason. I guess him and Kelly's lives just took very different paths, but they got on so brilliantly together and besides, look at him now: he's a major Hollywood star.

* * *

Kelly Brook wasn't the only girl I had to work hard to convince Jeany to shoot. Jeany was into voluptuous girls, so when I suggested we do some pictures with Katie Price she was not keen. 'Too boyish, too flat-chested,' was Jeany's verdict. Kate had appeared on Page 3 of the *Sun* a few times, but that natural, girl-next-door look really wasn't for Jeany. To put it bluntly, Kate just wasn't sexy enough for her.

Nevertheless, I persuaded Jeany to shoot her for a lingerie spread for the *Daily Star*. I know how keen Kate was to impress Jeany on that shoot. She was – and still is – extremely ambitious, and she was well aware how powerful Jeany was in the glamour game, so she

wanted to get her on side. However, for some reason Jeany had decided to do this shoot on Brighton Beach on a late autumn day. It was freezing – and anyone who knows Kate will be well aware that she has a real problem with the cold. Her house is always heated to a 100 degrees and she always carries a duvet with her in the car.

Looking back, this shoot must have been a real ordeal for Kate: we were all wrapped up in coats and scarves and she was wearing little more than a frilly g-string and a pout. Nevertheless she gritted her (chattering) teeth and didn't complain once.

It was around this time that I met Kate for lunch at Balans café in Soho, which even today is one of our favourite hangouts. She was starting to make a name for herself, but she was still far from hitting the big-time and she was obviously getting impatient.

'I want to be famous, Gary!' she said. 'Why isn't it happening for me?'

'Don't worry, it will happen,' I soothed her. 'You will be famous.'

And I was convinced that she would be. I always knew Kate had something special.

'But how?' she pressed on. 'Why are you so sure?'

I smiled at her. 'Trust me, Kate. I've just got a feeling about you.'

My Real-Life Girl's World

Years ago, during my first trip to America, I went to see a psychic. I had never been to one before (to be honest I was a bit scared what they might tell me) but my aunties, Janice and Mo, went to get their cards read every week and I thought it might be a bit of a laugh. During my reading, the psychic told me a few things that were spot on, including claiming that the colour blue would be important in my career – and it just so happened that I was in the States at that time working on those 'blue' movies. But there was one thing she kept coming back to throughout the reading that made no sense to me at all.

'You will meet a woman with jet-black hair and green eyes,' the psychic declared. 'She will not be a sorceress – in fact she will be one of the strongest, most inspiring people you will ever meet – but she will be misunderstood. And she will change your life.'

It was only during the media hysteria in the wake of her split from Peter Andre, when for a time she became the most controversial woman in Britain, that I realised the woman that the psychic was talking about that day must have been Katie Price.

Once in a while, someone comes along who pushes boundaries, who refuses to conform and – through some weird showbiz alchemy and a sprinkling of stardust – captures the public's imagination and becomes an icon. Such people are so revolutionary, so groundbreaking, that they inspire adoration and hatred in equal measure. Madonna was one of them, and Princess Diana – and I believe Katie Price is too.

Okay, I don't always agree with everything she does, but I doubt you'll ever meet anyone so interesting and addictive – and I've dealt with a lot of famous people over the years. With Kate, you never have any idea what will happen next and I think that's what people find so fascinating about her. She's not a reality star – her fame goes well beyond that. I don't actually think you can put her in any particular category of celebrity; in fact, she has created her own category. There's simply nobody else like her.

There are few people in the public eye who have been as misunderstood, misrepresented and misquoted as Kate. The woman I have often read about in the press – 'Evil Jordan' – bears so little resemblance to my kind, loyal and generous best friend that it would be laughable if it weren't so upsetting.

She has been through so much – sexual abuse, divorce, a media witch hunt – and yet she is still soldiering on, being a fabulous mum and an incredibly hard-working businesswoman. Kate is a true survivor. But she's not a robot, so of course the horrible, hateful things that people write are going to affect her – and me. She might put on a brave face publicly, but at one stage she was in tears every day over the newspaper headlines.

People might say, 'Well, she lives her life on camera – what does she expect?' But no one deserves the abuse she has received over this past year. And there are so many more things that have gone on behind closed doors that the public don't know about. There are many, many aspects of her life that are private; she certainly hasn't sold her soul like people seem to think. But whenever people are

judging her I always say this: Kate is a star. She was a star before any of the tabloid hysteria over her split from Pete kicked off, and she will shine as long as *she* chooses to. Everyone else can have their fifteen minutes, sell their stories, make a quick buck – but I can guarantee that Kate will be around for as long as she wants to be.

* * *

First things first: there is no difference between Kate and Jordan, they are two sides of the same coin. She'll take on whatever role people want her to assume at the time, but it's basically all Kate. Maybe it's the Gemini in her, but her character can change so quickly it's unbelievable. She can turn from a virgin to a vixen in a matter of moments. She has this really vulnerable, almost childlike quality that reminds me of Marilyn Monroe, and she's actually quite shy: if she's getting changed during a photoshoot and someone comes in the room she'll immediately dive for a towel to cover her up. It's when Kate's had a drink that she becomes more playful and her inhibitions go out of the window, although it's always harmless fun.

Creating a distinction between these two personas – Katie and Jordan – obviously proved very useful in the wake of her first appearance on *I'm A Celebrity … Get Me Out of Here!* when both Kate and her new management wanted to move her away from her old party girl image and present her as wholesome, more family-friendly. It worked brilliantly, of course, but with hindsight it was impossible to expect Kate to suppress her not-at-all-unreasonable need to let her hair down every now and then.

So I was really angry when everyone started to say, 'Uh-oh, Jordan's back', when she had a couple of nights out after her marriage broke down. One of the biggest misconceptions about her is that she's a heavy drinker. She rarely has alcohol at home. The problem with Kate is that she has such a slender frame she will be drunk after only a couple of Bacardi and Cokes. Then it can go one of two ways

– she'll either decide she's sleepy and go home, or she'll want to party, and that will be the trigger.

She never does anything bad – she just gets very chatty and friendly and wants to get to know everyone – but because she's in the public eye everything is magnified. The number of camera phones and videos make it impossible for her to go out and let her hair down like any other young woman would do. She is put under so much pressure and intense scrutiny that she cannot be herself, which is obviously what caused the problems in the media after the split from Pete. But more on that later …

Phill and I are Kate's best friends. The public might assume that she only has me around because I do her make-up and tell her what she wants to hear, but it's nothing like that. If I'd been a yes-man and licked her arse she'd have got rid of me ages ago. We get on brilliantly, but if I disagree with her I'll tell her – and a lot of the time she'll listen. We do have our little tiffs where we'll not text each other for a day or so, but I've never once had a major fallout with her. More often than not, the few rows we have are over her make-up.

Don't get me wrong, Kate is an absolute joy to work with as she's one of those rare celebrities who is secure enough to experiment with her look. Most of the time she will let me do exactly what I want. Having worked together for so long we have developed our own private code for different make-up styles.

Kate might say, 'Let's do Linda today', which means the look supermodel Linda Evangelista made famous in the early Nineties – creamy lips, false eyelashes, arched eyebrows. Or if she's feeling outrageous she'll ask for 'Ru', meaning drag queen extraordinaire Ru Paul. But occasionally, if she's had a knock or a bit of bad press (or if she's on her period) then that confidence vanishes and it's back to the old Jordan mask. I love plastering the slap on Kate – if anyone's face can take it, hers certainly can – but only if the occasion is right.

When she went to the Oscars in 2010 I had really wanted to try a different look on her, to get rid of the hairpieces and four sets of

false eyelashes. Kate had been having such a bad time in the press I thought we really had get it right for a change.

To be honest I hated her dress that night – a bright blue sequinned sheath the stylist had found for her. It was far too old for Kate, like something Shirley Bassey would wear to the Royal Variety Performance. It would have looked marginally better without these two great big flowers that were attached, but I couldn't get them off without ripping the dress. The thing is, when you go to the Oscars I really think you either have to get a dress made for you or go for a big name designer; when you're on the red carpet with all those stars it's a big risk to go high street or off-the-peg. But Kate had just married Alex and had hardly seen him as he'd been busy filming, so I do understand that she didn't want to spend their time together shopping for another dress.

She was dubious about letting me try a different make-up look on her, but eventually agreed to let me do what I wanted. I styled her hair in a classic bun and toned down her make-up, using only one set of false eyelashes. I thought she looked fabulous, but although she went along with it, she hated it.

'What have you done to me, Gary?' she kept saying.

Outside of her immediate family, Kate can count the number of people she trusts on one hand; certainly her network of friends is getting smaller and smaller. The thing is, when you're as famous as Kate you change – not for the worse, just to something different. Kate will always say, 'I'm still the same person, Gary, aren't I? I haven't changed.'

But of course she has. When you're a star you start to expect more from people, to demand more. It's natural; it would happen to anyone. But the thing that most people don't seem to acknowledge is that the people around the famous person change as well, especially if they've been with them since the beginning. And some of those old friends will struggle to accept that their mate has become a celebrity, and while they might not mean to leave them behind,

their lives become totally different. You no longer have things in common, there is less you can talk about – and some people can't handle that and become jealous.

Which is why Kate has lost so many friends through their having sold stories on her over the years. Luckily she has a fabulous family – her mum Amy, dad Paul, sister Sophie and brother Daniel – who are more important than ever now she's got so few other people in her life. Her mum, Amy, is her backbone. However much she might moan at her (and believe me, she does) Kate will always in the end realise that she was right. Amy is the only person Kate will really listen to. They're so much like each other it's unbelievable, although she will hate me for saying that!

When Diana died, the media changed. They needed someone else to appear in the daily celebrity soap opera, and one of those people was Kate. But the paparazzi attention has been so extreme that I can't help but think it's going to end badly; I've had so many sleepless nights worrying about Kate. I'll be in the car with her trying to drive somewhere and we'll have twenty, thirty guys chasing her on motorbikes. I have these awful images flash through my mind, of her being killed in a car accident – even more so over this past year. And then I think back to that skinny little girl in Balans, looking beseechingly at me with those green eyes, asking me when will she be famous, and I just think – *careful what you wish for …*

* * *

When Jeany and I started work with Kate she wasn't a great model. She was actually quite stiff in front of the camera and had this unnerving tendency to stare in photos. Jeany's nickname for Kate was Dick Emery, because Kate's slightly awkward posture and trademark outfit of skinny leggings, low-cut tops and ridiculously clompy high heels reminded her of the veteran TV comedian who used to dress up as a busty blonde woman. But Jeany gave her a few pointers on what to do in front of the camera and as Kate watched other girls

posing, she really got into it, and today she is just fantastic – one of the best models I have ever worked with.

Although the pictures from that first Brighton Beach shoot looked great, Jeany was still not convinced that Kate was model material. She's not one to beat about the bush, and during the shoot she was saying to her: 'You've got a pretty little face but nothing looks right on you, none of the underwear fits properly.'

But if Kate's B-cup boobs were a problem for Jeany, they were even more of a problem for Kate. From the first time I met her when she was 16 it was clear she didn't really like the way she looked: she wasn't pretty enough, her legs were too skinny, her tits were far too small. Kate got it into her head that she wanted to have a boob job.

Everyone tried to talk her out of it: me, her mum, even the readers of the *Sun* newspaper, who in a poll on whether Kate should have them made bigger voted overwhelmingly against. But once she gets an idea into her head it's frankly impossible to talk her out of it, so Jeany introduced her to Dr Prakash, a surgeon who had worked with some of the other models. Kate was adamant that she wanted to go several cup sizes bigger, so had asked for a 470cc implant.

But just before the operation Jeany secretly told Dr Prakash to only go up to a 360cc, as she was worried the bigger implants wouldn't suit her tiny frame. Kate probably doesn't know that to this day! Which is why soon after she'd had them done the first time she went under the knife again as they weren't as big as she had wanted. But although I do think she sometimes goes a bit mad with the Botox, in general I do think the work she's had done has improved her appearance. She's always been beautiful, but – speaking as a make-up artist – her face is better now; it's more symmetrical, more balanced. She has a bit of filler as she's so tiny and if she loses any weight at all she can look gaunt quite quickly. Not that Kate will ever be happy with her body because what she sees when she looks in the mirror is so different from the reality.

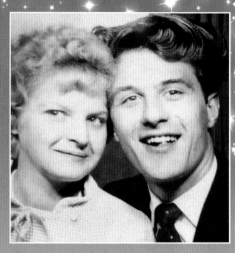

Mum and Dad photo-boothing it, aged 19, way before I was a twinkle in their eyes.

Mum and Dad's wedding day, working the fashion trends of 1963 in sunny Doncaster.

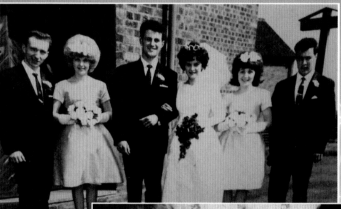

Auntie Janice, Mum and Auntie Mo getting merry at Mum's 21st birthday.

Clockwise from top left: Baby
Gary, ah!; The von Trapps of
Doncaster; Happy days at
Bridlington; Having fun with
Granddad Joe in Scarborough.

My sister Lynne and me. Butter wouldn't melt in my mouth!

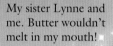

First time around in Monaco, outside the palace. Who knew I would be taking them back one day?

With Dad. (I'm the other cheeky monkey on the right!)

In *The Good Old Days*. There's
no business like show business!

Once in a Lifetime,
with Lionel Blair,
and my first girlfriend,
Kerry (far left).

Gnoming around in the back garden.

Taking myself seriously in Rotherham Operatic Society's production of *Carousel*.

A lucky escape from a runaway coal cart. Oh, the perils of being down the pit!

Markham Main Colliery, Armthorpe. Smile for the camera, boys!

Baby George's christening on the fateful day I came out.

Mad for Madge.

My first Gay Pride – out and proud!

The love of
my life, Phill.

Phill, Joanie and me – my
introduction to Elizabeth
Arden's Toasty Beige.

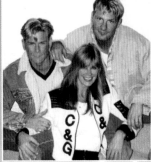

Me and Phill. What were
we thinking? Trust me,
it was fashionable then!

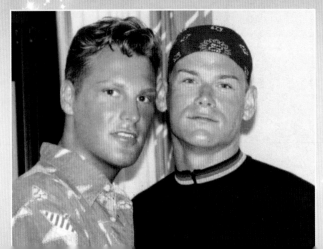

Ooo, the glamour!
Helicopters, boobs and
the beach. Eat your
heart out James Bond.

Wonderboobs Are Go!

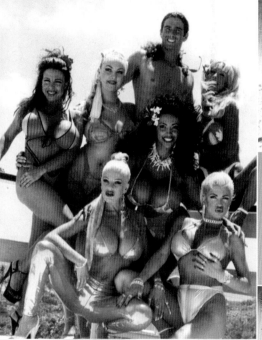

On set in the Bahamas.
Kleenex at the ready!

In Palm Springs at Liberace's old house. Thank God he never knew what went on there!

Another plane, another country, another sickbag to hand.

Me, Phill and any excuse
to get in a frock.

Jeany Savage. Savage by name
but definitely not by nature!

A proud uncle with my
nephew and godson, George.

Me and my fabulous
friend Christina Vaughan,
on a shoot in Miami.

Phill and Katie on an early
modelling job. Keep your hands
off him, Miss Price, he's mine!

Katie, always the exhibitionist,
even at eighteen!

Katie and Phill in Antigua,
trying to shock as usual.
Nothing ever changes.

On the beach in Barbados.
It's a hard life but
someone has to do it.

Clockwise from top left: Me and
Ulrika-ka-ka; Marcella, Phill and
Brad Pitt at the *Snatch* premiere;
Mel and Melinda – separated at birth;
Phill, Daniella and me at her beautiful
wedding; Marvellous Martine and me;
With Kelly Brook in La La Land;
My surrogate
mum, Barbara
Windsor.

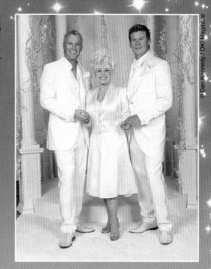

Me, Barbara and Phill.

Having fun with Rachel Hunter.

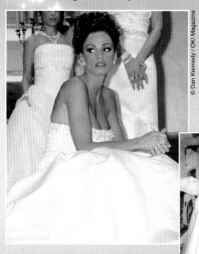

21 December, 2005. History is made – the wedding of all weddings. It doesn't get much camper than this! Katie reflecting on the day.

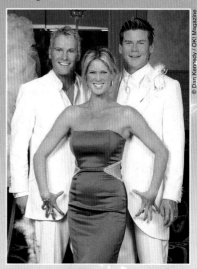

My wonderful nieces, Georgina and Bella, the perfect flower girls.

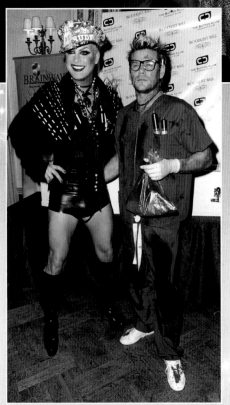

At my 37th birthday
party. Pete, me, Kate,
and some gorgeous
hunk in golden hotpants
I picked up on the way.

Me and Phill at the
Halloween Bloodlust
Ball. Torture Garden,
here we come!

Me and Katie having
fun at the Oscars.

Leaving the Ivy
with Barbara.

On the morning
of our wedding
vows, trying to
leave the hotel.
Oh, what
drama!

Alex and me fooling
around. Get me in
that cage!

© 2011 Getty Images

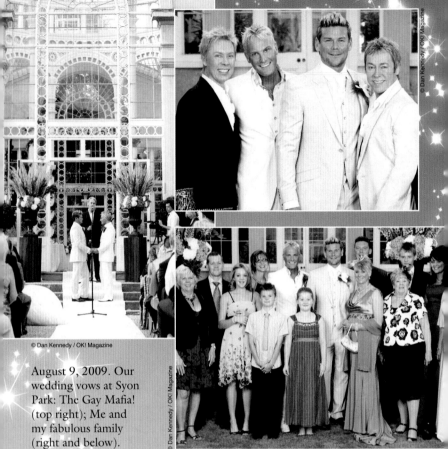

August 9, 2009. Our wedding vows at Syon Park: The Gay Mafia! (top right); Me and my fabulous family (right and below).

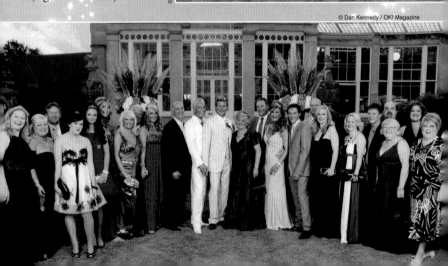

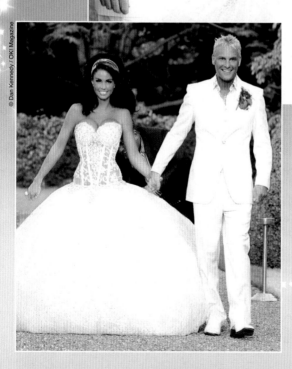

Our best friend
Katie gave us
both away on
our special day.

Hang on a
minute, am
I marrying
Phill or Kate?

Our special
friend Melanie.

Surrogacy?
No, Lola Ferrari.

Me and my sister
Lynne, all grown up.

Lynne, Simon and
my amazing nephews
Jason and George.

Me, Lynne, Mum and Dad, back in Monaco all those years later.

My fabulous and inspirational Auntie Mo, the last time I saw her before she went to heaven.

Me and Phill with
Scarlett O'Hara
and Dolly Parton.

The only thing I nag Kate about is that she uses sunbeds too much. I think you can get away with it when you're young, but once you hit your thirties the damage starts to show, and if she's been using them intensively it makes my job harder as the foundation doesn't sit right and ends up looking a bit dirty.

While I was so busy working with Jeany, Phill had started to do a bit of modelling himself. He had already had a taste of the limelight when our friends Louise and Jane sent his photo into *The Big Breakfast* for their Builder of the Week competition. He ended up sitting on the show's famous bed with Paula Yates, naked only for a pair of little denim shorts and work boots, with Paula stroking his chest and cooing: 'Ooh, look at my bod with the hod!' (She might not have been classically beautiful, but Phill said Paula was the sexiest woman he had ever met.)

A few months later he was spotted by a model scout when we went to the Clothes Show Live exhibition and was signed by two agencies: Gavin's and Samantha Bond, which had been my ex Kim's agent and for a while was also mine for make-up. Phill had the height for commercial fashion and the perfectly buff body for glamour, so as well as modelling menswear in catalogues, he also started popping up as a topless Page 7 Fella in the *Sun*.

One day he was booked by the *Sunday Mirror* to appear on the cover for a special supplement that they were doing called The Lover's Guide. It was your typically cheesy stuff: soft-focus shots of a hunky bloke in a nearly-naked clinch with a sexy girl. Phill arrived at the shoot at Canary Wharf, where the *Mirror* had their headquarters, and ended up hanging around for a good hour as the female model was running late. She eventually arrived, and you probably won't be surprised to hear that the late-running girl was Katie Price.

(A quick note about Kate's legendary lateness. Her problem is that there aren't enough hours in the day to do everything she wants. That girl never has enough time. A prime example is when you go out to dinner with Kate: she'll ask for the bill straight after she's

ordered from the menu. She can't leave it until the end of the meal, because it's all about her not being able to wait. Not that she minds keeping other people waiting though …)

Anyway, Kate breezed into this *Sunday Mirror* Lover's Guide shoot, full of her trademark cockiness, and immediately declared she was starving. I know people find it hard to believe as she's so slender, but Kate really is always hungry and eats like a trouper. Much to Phill's surprise, this skinny little slip of a thing ordered two jacket potatoes with cheese and wolfed them both down – and once she'd polished off the food, she turned her attention to Phill.

She's not subtle when she takes a fancy to someone, although she's all mouth and no action – a real tease. Phill was quite shy about stripping off and recreating all these steamy poses, but Kate really made the most of it, sticking out her boobs, bending over to pick something up to see if he was watching – that sort of thing. So by the end of the shoot Phill was thoroughly embarrassed and couldn't wait to get out of there, and when he came home and told me all about this gobby, flirty girl who kept wiggling her boobs in his face it didn't take me long to work out who he was talking about.

Although I had worked with Kate a few times by now, she didn't have any idea that I was gay. I hadn't been out for long, and I suppose I was still a bit flirty around girls; I don't think Kelly realised about my sexuality to start with either. When I saw Kate on a shoot a few weeks or so later I told her: 'You do realise that bloke you were trying to pull is my boyfriend?'

She was in shock. 'Phill? No way, he's definitely straight!'

Even to this day she'll admit she fancies Phill. I'll joke with her and say, 'What about me, Kate?'

And she's like, 'Nah, Phill's always been the one for me …'

* * *

Kate was still living in Brighton and she started staying the occasional night with Phill and me if she was booked for an early job in London and there wasn't a model flat available. By this time we had moved to a beautiful conversion flat in an old country house set in magnificent grounds in Stoke Poges in Buckinghamshire. The three of us had a real laugh together and quickly became friends. I remember one night I had my parents visiting from Armthorpe and we were planning a quiet evening in with a takeaway when I got a call from Kate.

'Can I stay at yours tonight, Gary? I've got to get up early for a shoot in town.'

'That's fine,' I told her, 'but my mum and dad are here so just be careful with your language because I know what you're like and they're easily offended. Okay?'

Well, that was the worst thing I could have possibly said to Kate. It was like waving a red rag at a bloody-minded bull.

We'd had a curry and were sitting watching TV in the living room –it was a documentary on body art and piercings. Despite my fears, Kate had been on her best, most charming behaviour. Mum and Dad were on the sofa and she was sitting in between them, all quiet and sweet like butter wouldn't melt, when suddenly she turned to Mum and said, 'Have you got any piercings, Mrs Cockerill?'

'Oh no, dear, I haven't got anything like that,' Mum said. 'Why – have you?'

Kate shot me a naughty little look. 'Yeah, I've got a piercing on my clit,' she said, smiling triumphantly.

That bloody girl, I thought furiously, *she just can't help herself*. It's just how Kate was – and still is today. If she's told she can't do something then she'll do anything to prove that person wrong. She's really not a bad girl and she doesn't ever mean things maliciously, but because she's such a show-off and craves attention she likes to cause controversy and push boundaries. I guess it's one of the reasons for her success.

Not that it worked on this occasion. What Kate didn't realise was that my parents were always very open about sex and we used to have frank discussions around the dining-room table, so if she'd hoped to embarrass my mum it didn't work.

'Oh, that's lovely, dear,' Mum smiled at her before turning her attention back to the telly. 'Very nice. Not for me though.'

* * *

Kate loves gay men and lesbians – and they adore her in return. She's one of the few modern gay icons; after all, she's got all the qualifications in spades: drama, tragedy, glamour and balls. There are the likes of Kylie, of course, but Kate takes it to the extreme. Even today, if she wants to have a big night out and let her hair down we'll go to a gay club. She knows she'll be able to have a dance and a drink without someone tipping off the press or selling photos; she's always safe with the gays.

There's a very special relationship between a girl and her Gay Best Friend. Phill and I can grab hold of her, kiss her and pick her up for a cuddle like only a gay man could without her husband or boyfriend getting jealous. We can be sitting having a chat and Kate will be totally naked and not give it a second thought – and she probably wouldn't even be that relaxed with her girlfriends. It's a really unique bond.

Sometimes, I admit, I do get jealous when she's talking to other gay men, who always tend to home in on her when we go out. It doesn't bother me how many girlfriends she has, but when it comes to gay best friends me and Phill already have that job – there is no vacancy! I'm very protective like that; in fact to be honest I'm probably really bad. And Kate knows how jealous I get and she'll play on it to wind me up, flirting and giggling with other gays.

One time she was doing a shoot with Rupert Everett. He really admired Kate and his agent had rung to fix up a shoot with them both. He was a lovely guy and the two of them got on really well,

giggling and flirting together, and I sat there watching them feeling unbelievably threatened. I remember thinking, *Just hang on a minute sunshine* ... Here was this charming, good-looking movie star who'd been best friends with Madonna (which basically meant he was like some uber gay best friend, for God's sake) and now he was moving in on my Kate! I got in a right old state about that, I can tell you ...

I remember the first time we took Kate to a gay club. It was the legendary club night G.A.Y. at the Astoria and it was a total revelation to her: the glamour, the music, the gorgeous men, the dancing. By that time she was making a name for herself on Page 3 and she was in her element as these fit guys came up to her saying, 'Ooh, it's Jordan!' Yet she didn't have to flirt or stick her tits out or try to impress anyone – she could just be herself, have a drink and a laugh.

That was also the night we introduced Kate to Sally Cairns. Sally was a friend of Phill's from Middlesex, one of the group of girls we used to hang around with. She had trained as a hairdresser and done a make-up course, so when I started to get frantically busy with Jeany I taught her my make-up style, gave away a few of my secrets, and took her on as my assistant. Well, Kate and Sally really hit it off, swapped numbers, and pretty soon they were inseparable – later even moving in together.

That summer the four of us went on holiday to Ibiza. Phill and I loved Ibiza and would go every year; we definitely weren't into the drugs scene, but we loved to dance and found the Old Town quite glamorous and cosmopolitan. (Mum and Dad even came with us once – we took them to a few gay bars and they absolutely loved it!)

On this particular trip we were staying in a tiny studio apartment; me and Phill had the bedroom, Kate and Sally slept on the sofa. We had such a laugh. One night we went to a gay bar called Amphora in which there was a Dark Room. Kate had never heard of them, so we explained to her that it's basically a completely dark room where men go to have sex or just a quick feel – all very sleazy. Phill and I

have never been into it, but Kate gets it into her head that she wants to go in for a laugh.

After a few drinks and a dance she still wouldn't let up about going in the bloody Dark Room, so eventually Phill agreed to sneak her in.

'But do not, whatever you do, say anything or touch anything 'cos it's meant to be men only and we'll get in serious trouble,' he warned her. 'Hold my hand and stay close.'

Well, Kate can't resist, can she? As her eyes started to become accustomed to the dim light and she could just about make out men getting up to all sorts of naughtiness, she suddenly gave a girly shriek. It caused a riot.

'Oh my God, there's a woman in here!' the men were screaming.

By this time Kate and Phill are in hysterics, and we ended up getting kicked out of the bar. But that's Ms Price all over, isn't it? She just can't resist a bit of controversy …

* * *

It was one of the nights that Kate was staying with us at our flat in Stoke Poges and I was woken in the early hours by the sound of our front door closing. Kate was obviously back from her night out – she'd been to some celebrity party or other with Sally. I expected she'd go straight to bed, but suddenly I heard a soft knock on our bedroom door.

'Gary, Phill, are you awake?'

I switched on the light. Kate looked shocking. There was no expression on her face whatsoever and she was deathly pale. She certainly didn't look drunk; if she had been drinking that night, something had happened to make her sober up pretty quickly.

'God, what's happened to you?' I said, sitting up in bed. 'Bit of a long night, was it?'

Kate sat down on the bed. 'I think I've just been raped,' she said simply.

Phill and I were momentarily stunned into silence.

'I don't know if I have,' she went on. 'I'm not sure if you could class it as rape, but I did something that I really didn't want to do. I was … I was held down.' She looked down at her hands. 'I kept telling him I didn't want to do it, I told him to stop …'

My immediate reaction was to get help. I told her I'd call the police, a doctor, her mum – but Kate was adamant that she didn't want to tell anyone.

'I just need to think about this, I need to sort this out in my head,' she kept saying.

She was numb. I've never seen her like that before. She didn't cry; she just totally went into her shell.

'Kate, don't you think you need to involve the police?' I said. 'This guy raped you.'

'No, I need to deal with this in my own way,' she said firmly.

The next morning she told us that she wanted to forget what had happened and never talk about it again. She made a decision to put it behind her and moved on, like she always does in her life when some trauma happens. That's the thing about Kate – she's always looking forward.

And sure enough, that night was never mentioned again, until she brought it up last year after her then boyfriend – now husband – Alex Reid was accused of filming a movie rape scene. To be honest I was gobsmacked. I was worried she was opening the floodgates and that they would drag her and a lot of other people into another media shit-storm.

* * *

People probably think that Kate and I have always been close friends, but that's certainly not the case. In fact there was a period of about five years when I'm ashamed to admit that Phill and I made a conscious effort to distance ourselves from her.

It started when she signed with a new publicist and the whole bad-girl Jordan thing really exploded. Kate had always been up for a party, but she became notorious as this sex-crazed party animal, frequently snapped flashing her tits or stumbling out of clubs in the early hours looking a right old state. She wasn't taking care of herself and had put on a lot of weight. She was making a name for herself, but it wasn't really a good one.

She was getting such negative press at that time and like an idiot I started to believe it, even though I knew all too well what the press could be like. Besides, by this time my career was really taking off and I was making the transition from the world of glamour to fashion and advertising, working with fabulous photographers, world-famous actresses and pop stars, leaving Sally to take my place on shoots with Kate.

I guess I became a snob. We'd speak every now and then and bump into each other occasionally at events and Kate would be like, 'Ooh, look at you now, Gary, working with all your big stars!' and we'd have a laugh about it over a few drinks and have a goodbye cuddle at the end of the night, but it was obvious that we had drifted apart.

I'm sure she thought I had turned into a wanker – in fact I was a wanker. My head had been turned; I thought I was better than she was. I'd look at the papers and go: 'Oh God, what's Kate done now?'

I made the same mistake as everyone else: we all judged her, even though nobody had a clue what was really going on in her life. Nobody knew about the shit she was going through with Dwight Yorke and Harvey's birth, what she went through with Dane Bowers. She's not the sort of person who would ask for help, but all the tell-tale signs were there in the headlines and photos. I should have been there for her during what was a really tough time for her – and to this day it's one of my biggest regrets that I wasn't.

Bailey and Beyond

It was the beginning of the new millennium and I was in serious demand. The amount of jobs I was trying to cram into a day was ridiculous. Forgive the cliché, but I really was working with anyone who was anyone. From hot young TV presenters and actresses (Martine McCutcheon, Ulrika, Cat Deeley, Mel Sykes) to pop starlets and bands like The Spice Girls, The Corrs, Steps and Jamiroquai and Hollywood movie legends, I would have been powdering, grooming or glossing them.

I was working with some seriously heavyweight photographers too, including Rankin, Bob Carlos Clarke, Clive Arrowsmith and Sante D'Orazio. Some of the resulting images were so stunning that they were almost works of art; in fact some of my pictures have actually ended up hanging in the National Portrait Gallery. And then one day I got the call I had been waiting for: David Bailey, the most famous photographer in the world, had agreed to see me.

My agent had arranged the meeting at Patisserie Valerie in Soho; I was very lucky, as Bailey didn't tend to do many go-sees with

make-up artists. My portfolio was looking good but was by no means high-end fashion, so I was incredibly nervous as I climbed the stairs to the crowded upstairs restaurant. And then I realised that I didn't really know what David Bailey actually looked like. I thought that he might have had brownish hair – and possibly a moustache? – but that hardly narrowed it down. I stood in the doorway feeling incredibly stupid, trying to work out which of the dozens of men could be the legendary lensman, when a little guy wrapped up in a huge winter coat and woolly scarf shouted over: ''Ere, are you Cockerill?'

I sat down with him and his assistant who were tucking into Eggs Benedict. He was a nice, chatty bloke – he reminded me of Dudley Moore, or a male version of Jeany Savage – and I thought I did a good job of selling myself. Sure enough, a week later my agent rang to say I had a booking with Bailey on a job for the *New York Times*.

We were shooting a few of the cast of a Stephen Daldry production of *The Tempest* at the Old Vic. I walked into the auditorium and it had just been transformed into this incredibly watery landscape. It was utterly magical. Bailey was standing near the stage, so I walked over to him and started chatting.

'Hi, David, how are you?'

No reply.

I tried again. 'Wow, this place looks really amazing, doesn't it?'

Bailey didn't even look at me. 'Don't speak to me until you're spoken to,' he snapped, then turned on his heel and walked off.

I was stunned. He had been so friendly during that first meeting – which is why I'd gone up and spoken to him in the first place. I started to worry that he'd booked the wrong make-up artist.

Bailey continued to be extremely off-hand with me for the rest of the shoot, but he must have been happy with my work as he kept on booking me for jobs. Each time I never knew which David Bailey I was going to get. It was a real hot and cold thing; sometimes he

could be a real laugh, a bit of a cheeky Michael Caine charmer, others you knew just to keep your head down and get the job done. His mood dictated the atmosphere of the whole shoot.

Bailey's studio was in a mews house in central London. It was nondescript from the outside and you had to walk up a dark stairway, but then you opened the door and you were in this huge, bright studio, the walls of which were covered with enormous black-and-white photos of … well, vaginas. They were massive, blown up into eye-wateringly explicit detail. I don't know if they were his wife's or belonged to various different ladies, but I found the whole thing really quite unnerving. I didn't know whether to laugh or cry. I talked about that for weeks afterwards, I can tell you …

My relationship with David Bailey came to an end on a shoot with the American TV anchorwomen. My old friend Marcella was styling the shoot and had been told this particular anchorwoman was a size 6 to 8, so had called in lots of designer clothes to fit. But when she turned up she was a 10 to 12, so of course nothing fitted.

Then Bailey came marching into the dressing room and I could hear snatches of an extremely awkward and heated conversation. Marcella is a really tough cookie, but she fled the studio in tears. That was the point that I thought life's too short to deal with things like this – and I never worked with Bailey again after that. But then, if I'm honest, the only reason I wanted to work with him in the first place was to get the name on my CV. If I was going to meet someone about a job it never hurt to throw David Bailey into the equation – it still doesn't to this day.

I've since come across other characters like that, especially in the fashion world. It's one of the reasons I decided not to take my career in that direction – I didn't want to work with people who I felt didn't know how to laugh at themselves. In my industry, you really need to decide what particular area you want to specialise in as you very quickly get pigeon-holed. If you want to do high fashion, you have to go to Milan, Paris or New York. If you want to work with

Hollywood stars full-time then you move to Los Angeles. But if you're not too precious about your 'art' – and you want to make money – then you go commercial, which is the route that I decided to take. I want to look forward to going to work, not be stressed out and miserable.

Having said that, it's often a lot easier making up fashion models than it is with celebrities. It's like the difference between working with those fibreglass shop dummies back at Mr and Mrs Brady's and real live people. Models sit there, keep their mouths shut and would never offer opinions, whereas you have to listen to celebrities and work with them. Of course, there are some exceptions. I remember working with a pretty blonde model who was signed to Select quite a few years back who was so bubbly, so chatty, so – well – *hyper*, that she just never stopped talking. She couldn't sit still, always running around everywhere with this gorgeous grin on her freckly face. Her name was Sienna Miller.

* * *

At this time I was also doing the make-up for a lot of press junkets. A junket is basically when a production company with a new movie or TV show to promote will hold a day of media interviews with their biggest stars, usually in some flashy hotel. Do you remember that scene in *Notting Hill* where Hugh Grant ends up interviewing Julia Roberts and pretends he's from *Horse and Hound* magazine? Well, that's basically what it's like.

It was on one of these that I was booked to do the make-up for the comedienne and actress Tracey Ullman. She had made it big in America and was coming back to the UK to do a few press interviews; I was really excited about working with her as I'd been a huge fan of her in *Three of a Kind*, the BBC sketch show she did with Lenny Henry back in the early Eighties. Well, she sat down and was so sweet and funny, and told me to do whatever I thought best for her make-up.

'Just keep it really light and fresh,' she said.

So that's exactly what I did – I gave her a polished, natural look, using bronzy, shimmery shades, and I thought I'd done a really nice job.

And then she looked in the mirror. 'Oh no,' she gasped. 'I'm sorry, but I can't have this. You'll need to take it all off. It's beautiful, but I need to feel like me. Maybe I didn't explain it right, but I just need a bit of blush and some lipstick, that's all.'

I was so embarrassed. I quickly wiped it all off and redid it to the absolute minimum: spot foundation, cream blush, mascara and lip gloss. She looked fine, but really, she didn't need a make-up artist to do that for her. Afterwards I thought about how she becomes all these different characters in her sketch shows and I realised that by making her look too glamorous and polished maybe I'd taken away her real identity – she no longer felt like Tracey Ullman.

But I remember going home that day feeling totally awful about myself. She certainly wasn't unpleasant – she was actually very sweet and apologetic – but it's a very unpleasant memory, as it's the only time anyone has told me to take off the make-up.

* * *

As I hope I made clear at the start of the book, this is not a kiss and tell. There are certain people who I need to protect, others who would no doubt sue if I recounted a no-holds-barred account of our time together. I'd probably never work again if I told you exactly which of my celebrity clients threw up over me after a three-day booze and drugs bender, or which bubbly, chatty Hollywood starlet began our 7 a.m. session by powdering her nose – and I don't just mean with make-up.

I would love to reveal which A-List actress casually told me: 'Hang on a minute, I'm just going to give my boyfriend a blowie', only to reappear a short while later with make-up smudged all over her face, giggling: 'Um, you might need to redo my lip liner, Gary.' Or which

chart-topping pop star sat in sullen silence while I worked, barely responding when I asked a question about her make-up, before letting out the loudest, most vile-smelling fart and then turning to me with an innocent smile to say: 'Well, that certainly broke the ice, didn't it?'

And I would love to tell you about working with a veteran TV actress who excused herself midway through our session to go to the bathroom, only to spend half an hour locked in there with one of the young runners having extremely noisy sex.

But there have been a few stories that I think are just too good to leave out, that so perfectly sum up the craziness of my adventures in the world of celebrity, so I recount them here, and hope you'll forgive me if I don't name names …

I had been booked to do the make-up for a very famous Hollywood actress, a legendary beauty who was in London to appear in the West End. I'll often be asked to get visiting stars ready for press or photoshoots or sometimes even just to get them ready if they're going out for dinner and know they're going to get photographed. This woman wasn't exactly in the first flush of youth, but she had been in some iconic movies and I was looking forward to meeting her. As arranged, at 8 a.m. I arrived at the apartment she was renting on Parliament Square and her assistant Carla ushered me into a spacious living room. I was just admiring the views of Big Ben and unpacking my kit when I became aware of raised voices coming from the neighbouring room.

'I need you to get him on the phone *now*! Oh God, I can't believe this is happening, how could I have forgotten Alfie's birthday …' I recognised the famous actress's voice immediately, even though it was edged with hysteria.

'He's only three, goddammit, he needs his mommy there!' she finished in a sob.

Bloody hell, I thought, *she's forgotten her kid's birthday!* Not that I was aware she was even in a relationship – let alone a mum.

I was busying myself with my brushes, trying to pretend I was oblivious to the drama that was unfolding, but out of the corner of my eye I caught sight of the assistant who had let me in earlier rushing out of the room, closely pursued by another woman carrying a suitcase and a tall streak of blonde that I recognised as my famous client.

'Yes, I know it's the middle of the night in LA, but I have to talk to him now! … Thank you, Carla, I'm well aware that the play starts tomorrow, but right now I don't give a fuck! Just cancel everything and get me on the first flight out.'

There was more frantic activity and people rushing from room to room, then I heard the actress again, her voice suddenly sweet and baby-soft, cooing into the phone.

'Hey there, gorgeous, how's Mommy's little angel? Mommy is so, so sorry she's not there, but what I'm going to do is jump on a plane right now and I'll be there tomorrow – I promise. I love you, Alfie. Kiss kiss. Love you … *Love you* …'

Suddenly Carla appeared, a fixed smile on her face. 'Uh, I'm really sorry, Gary, but there's been an emergency, and I'm afraid Miss _____ is going to have to fly back to LA this morning.' A muffled scream and a bang came from the bedroom and Carla glanced back nervously at the closed door. 'You know, I think it would be best if you could just leave now.'

I shouldn't have been listening, of course, but while I packed up my kit and the drama continued to unfold with more phone calls being made and the stressed-out assistants kept trying in vain to calm down their boss, I began to realise that the birthday boy was not in fact the Hollywood star's son. He wasn't even human. Alfie was a dog.

Another time I was working with a legendary European actress – an older lady, but still stunning with gorgeous hair, flawless skin and a voice like silk. She'd obviously had a bit of work done (though you'd be hard pushed to find a celebrity who hasn't) but it had been

done beautifully. I spent about an hour on her face: creamy lips, soft velvety brown smoky eyes, a few lashes in each corner. It was a real pleasure to put make-up on her.

When I finished she took a quick look in the mirror then disappeared into the bathroom. She had been speaking to her assistant in English, but suddenly now she switched to French. I was instantly suspicious.

Does she hate the make-up? Is that what she's saying …?

She had left the door to the bathroom open and I saw her fill a basin up with freezing cold water and then watched in horror as she filled her cupped hands with the water and threw it over her face. *Fucking hell, it's Tracey Ullman all over again!* I thought to myself. I was getting ready with a grovelling apology when the actress came out of the bathroom with a radiant smile on her face.

'Zis will 'elp ze make-up set,' she said to me. 'It will make it last longer, *non*?'

It's not so strange I suppose; I've had several clients who like to 'set' their make-up by spraying hairspray or perfume all over their face. God knows if it works, but if it keeps them happy then it's fine by me. I'll often get people ready for *GMTV* the night before because they don't want to get up too early in the morning: I'll go round there at 10 p.m., they'll sleep in the make-up, then they'll get to the studio and just get my work retouched by the *GMTV* make-up artists. In fact, I've had clients who've kept their make-up on for two or three days and just kept tracing over my original lines. It happens surprisingly often.

* * *

While my career was going from strength to strength, so too was Phill's; in fact he was even becoming something of a celebrity himself. It all started when I was on a shoot with one of my clients, Anna Ryder Richardson, who at that time was a designer on the hugely popular home makeover TV show *Changing Rooms*. Anna

was starting work on a new daytime show called *House Invaders* and mentioned they were looking for a new Handy Andy-style sidekick to appear alongside herself and Linda Barker – and did I know anyone who might be suitable?

'Well, my partner Phill is a carpenter and does a bit of modelling,' I told Anna, showing her a photo.

'Bloody hell, he's gorgeous!' she said. 'I'll get him in for an audition.'

Well, Phill got the gig and for the next seven years *House Invaders* took over his life. He was great on it – good-looking, charming, a bit cheeky – plus he really knew his stuff. It led to other TV jobs too, and soon Phill was making regular appearances on *GMTV*, *This Morning* and countless other shows, and getting saucy fanmail (and the occasional pair of frilly knickers) from smitten housewives.

As most of our work was in London it made sense for us to move into London, so we found a small two-bedroom flat above a pizza restaurant on Wigmore Street, just off Oxford Circus. By this time we had two cats – Charlie and Arfur, rescue cats given to us by Jeany – so they obviously had to come too. And as if that wasn't enough of a squeeze we also got ourselves a flatmate, a lovely Northern lass from Leeds called Tracey. I had met her a couple of years back on a shoot with Jeany, shortly after the glamour wars had kicked off in the tabloids. We'd hit the jackpot with Melinda and Kelly, and the next girl to come along was our Tracey.

One morning this absolute goddess strode into the studio: six foot in her heels, an incredibly athletic body (with perfect surgically enhanced boobs) and a very beautiful face. But I didn't notice any of that at first. It was her hair – or rather lack of it – that really grabbed my attention. This girl was completely bald. Well, I was horrified. She was so gorgeous; why would you do something like that? Tracey said it had been for a job in Germany, but I'm not sure if it wasn't just that she wanted to do something to stand out from

all the other girls – and credit where it's due, if she had, it had certainly worked.

At the time Tracey was signed with a fashion agency and hadn't really done any glamour, but Jeany did her usual subtle thing – 'Come on, get your kit off and show us your tits' – and persuaded her to pose naked in a barber's chair for the *Daily Star*. Yet again Jeany made up some fabulous story to go with the pictures and then turned her attention to Tracey's name.

'We've had a Mel and a Kel …' mused Jeany, 'and you've got a body like Elle MacPherson … So how about Nell?'

And so Nell McAndrew was born – although just as I'd never dream of calling Katie Jordan, I would always call her Tracey. Almost overnight she was offered the gig as the real-life Lara Croft and Nell became seriously hot property, going to Monaco for the Grand Prix, appearing in *Playboy*, featuring on countless magazine covers. Jeany and I were shooting her at least twice a week and we'd become really good friends, so when she was looking for a place to live in London Phill and I invited her to move in with us. She had started seeing a lovely guy called Paul Hardcastle from back up North and he would often spend weekends with us too. By now I'd drifted apart from Kate who was busy being the bad girl about town, and for years the four of us – Me, Phill, Nell and Paul – were inseparable.

It was while we were living with Nell that Phill and I decided we wanted to celebrate our relationship by getting married. Obviously it would be a few years before civil partnerships would be made legal in the UK, so the only option was to go abroad. Looking back, the research we did for that trip was laughable; actually it was nonexistent. We simply thought: what's the gayest place in the world? San Francisco! So gay marriage *must* be legal there. And even if we weren't able to have a wedding, we would definitely be able to get some sort of blessing or commitment ceremony – no doubt about it.

We decided to make a holiday of it, flying to Los Angeles and then driving to San Francisco. Nell and Paul were going to come too; Nell even bought a little white frock to wear for the ceremony. We were all bubbling over with excitement. We were going on a Californian road trip – and we were going to get married!

We flew into Los Angeles and stayed a night at the Grafton Hotel on Sunset Boulevard, where I usually stayed during work trips, then got up bright and early the next morning and set off in our big Cherokee SUV on the three-hour drive to Palm Springs. From there we planned to drive to Vegas where we would stay another night, then on to San Francisco to get married and back to LA again. This, we assumed, would take us about a week. We had absolutely no concept of the distances involved; I don't think we even took a map.

We arrived in Palm Springs and – as the others had never been there before – went for a wander round town for a couple of hours in the scorching heat. By the time we got back to our hotel, the Holiday Inn, my feet had completely swollen up and were a mass of agonising red and white blisters, so it was agreed that it would probably be sensible to hang out by the pool for the rest of the day to give me a chance to recover. A couple of hours later and Phill's face was in a similar state to my feet: he hadn't bothered to put on any suncream (despite the fact that we were basically in the middle of a desert) and ended up looking like a burns victim.

Nevertheless, when we piled in the SUV the following morning for the four-hour drive to Vegas, turning up the music (and aircon) full-blast, we had just about recovered the holiday spirit.

'Vegas, baby!' I yelled, as the famous strip emerged shimmering out of the desert.

We checked into one of the first hotels we came across, The Luxor, based on a giant pyramid which was utterly tacky and fabulous and typically Vegas. But while Nell and Paul went straight to have a go on the slot machines, I was still struggling to do anything that

involved walking so I stayed in the room and ordered room service. Honest to God, I hadn't had such bad feet since working down the mines.

The next morning our little party was in a distinctly subdued mood. I was still moaning about my feet, Phill was pissed off that I had spent the whole evening in the room popping my blisters and Paul had lost 500 quid on the slots. The staff at the hotel had told us it would take ten hours to drive to San Francisco on the freeway, but over breakfast we got chatting to a local guy in a cowboy hat and boots who said he had a better idea.

'Seriously guys, you gotta take the scenic route!' he whooped. He seemed really excited about our plan, and started drawing us a little map on the back of a till receipt. 'It might take a little bit longer, but the scenery through Death Valley is just frickin' AWESOME!' He punched the air for emphasis. 'I guarantee it will BLOW YOUR MIND!'

Hopefully we won't blow a tyre as well, I thought to myself.

And so, clutching his hastily sketched map and smugly ignoring all the road signs pointing to San Francisco in the opposite direction, we set off into the desert. Pretty soon we found ourselves on a dusty track that stretched straight in front of us for miles and miles, as far as the eye could see. It was a complete wilderness, there were no trees, towns, people – nothing. Not even a cactus. This road took us thousands of feet up sun-scorched mountains, around bends so steep we'd be shitting ourselves about falling off the edge, then would plunge down into dark, barren valleys. We were either in blazing, brutal sunlight or the blackest shade you can imagine. I noticed these huge vulture-like birds circling above us in the dazzling blue sky and shivered. If we ran out of petrol here we'd be dead within hours.

And then, about six hours into our journey, and starting to fear we'd never see civilisation again, we suddenly heard a police siren behind us. What the hell …? We were in a vast, deserted valley –

quite literally in the middle of nowhere – and hadn't seen another vehicle for hours.

The police car was flashing its lights, signalling for us to stop, so Phill, who was driving at the time, pulled the SUV onto the verge, with the cop parking up a little way behind us.

'Stay in the car and roll down your window,' came a voice over a loudspeaker. We looked at each other nervously, memories of all those horror films coming back to us.

'I really hope this isn't some nutter dressed up as a policeman,' muttered Phill. But he did as he was told, the desert heat hitting us like a furnace as he wound down the window.

In the rearview mirror we watched a well-built guy in mirrored shades get out of the car and saunter up to our car.

'Sir, are you aware that you have just broken the law?' he drawled. 'You failed to stop at the Stop sign back there.'

'You are joking, mate?' said Phill. 'I didn't really see much point in stopping when I could see that there wasn't another car for miles around.'

It was not the right thing to say. 'No, sir, it was not a joke,' said the cop, completely deadpan. 'I'm gonna need you to step out of the car please.'

He told Phill to put his hands on the bonnet, patted him down and then, to my horror, took him back to the police car.

'Oh my God!' I screeched. 'He's going to murder Phill! What are we going to do?'

'For fuck's sake, Gary, calm down,' muttered Paul.

A few minutes later, much to my relief, Phill emerged shaken but unscathed and got back in our car. The cop had apparently booked him and given him a fine. Before letting him go he had taken his passport number and told him this was a serious matter and that if he didn't pay he would 'track him down'. We drove off, but for the next half hour that guy stayed on our tail. You can't really blame him, I suppose. Fancy being a traffic cop in a place like that! He must have been bored out of his mind.

By now it had started to get dark and we were all so stressed and exhausted that we had started to blame each other for deciding to take the bloody scenic route – and we were still nowhere near San Francisco. So when we saw the lights of what looked like a small town we made the decision to stop there for the night. 'Welcome to Fort Independence Indian Reservation' read a sign. We stopped at the first motel we found, which was instantly familiar from countless American road movies: a flickering neon sign announcing 'vacancies', a strange-looking guy behind the desk who walked with a limp, basic rooms with the odd Indian knick-knack hanging on the wall. It looked like we were the only guests. As we got ready for bed, a strange, ghostly howl broke the silence. No doubt it was an owl or a coyote, but I hurriedly wedged a chair underneath the doorknob – just in case. Well, it works in the movies …

We set off the next morning in complete silence, each of us gazing grumpily out of our respective windows. But in the space of an hour the scenery miraculously changed, from barren desert to snow-topped mountains and a lush, green forest of the tallest, most magnificent trees I have ever seen with signs warning to 'Beware of the Bear'. Those few magical hours made the whole nightmare drive worth it. The mood in the car suddenly lightened and we started getting excited about San Francisco again. It felt like we had been following the Yellow Brick Road and finally had the Emerald City in our sights.

A huge black cloud seemed to be hanging over San Francisco as we approached. As we looped around a one-way system, trying to find our hotel, the first drops of rain started to fall. None of us had brought any warm clothes as we had quite reasonably been expecting Californian sunshine, so the first thing we did on parking the car was to duck into a tourist shop and buy some fleeces. To make matters worse, the hotel I'd booked was an absolute hole and – from the look of some of the characters hanging around in the foyer – appeared to be in the middle of the Red Light district.

It was all too much for Nell. 'Gary, let's get you married and then we're driving back to LA,' she said.

In a last ditch attempt to cheer everyone up I opened a bottle of champagne which we polished off while getting changed into our wedding outfits (with the fleeces over the top) then we jumped into a taxi.

'Can you take us to the gay area?' I asked the driver.

He turned to look at us, an incredulous expression on his face. 'Fella, this whole town is gay,' he said.

'Well, you see, we wanted to get married, and we wondered whereabouts we might be able to do that …'

'Are you crazy?' said the driver. 'You guys can't get married in San Francisco. The only people who'll marry you here are the Sisters of Perpetual Indulgence, a bunch of crazy drag queens who dress up like nuns.'

So that was it. We had driven all this way, and gone through that whole ordeal, for absolutely nothing.

'No, the only place you guys could get married for real,' continued the driver, who by now was laughing uncontrollably, 'is in Las Vegas.'

Well, I don't think Nell spoke to us for the rest of that trip. Phill and I were utterly deflated. Even though it was already mid-afternoon, we piled back in the car and started the drive back to Los Angeles, stopping for the night at a motel by the freeway in a place called Bakersfield. I remember lying by the pool in the late-afternoon sun, trying to forget the whole nightmare, while cars roared by just metres away. We had one more night after that, which we spent in LA, and had to fly back first thing the following morning. It took Nell and Paul several weeks to forgive us, but we can laugh about it now. Just.

* * *

A couple of years later it was Nell's turn to get married. She was planning a small beach wedding in Dubai with just a handful of people and wanted Phill and I to be there. I had been booked to do the make-up for the *Phantom of the Opera* premiere in New York and unfortunately the dates clashed, but I was desperate not to miss Nell's big day.

'Whatever it takes, even if I have to get on 10 planes, I'll do my best to be there,' I told her.

But about a week beforehand, despite my best efforts, I realised it wouldn't work out. The schedule was just too tight.

Nell was understandably furious. 'Surely it's not all about work, Gary?' she said.

And she was right; of course I should have been there. But I've seen what this industry is like, how someone can be flavour of the month one moment then disappear without a trace the next, and even now I have this little voice inside my head telling me that if I turn down just one job then that will be it – my career will be over.

From that day forwards my whole relationship with Nell changed. I don't think she's ever forgiven me for missing her wedding. She was such a special friend, but I barely see her any more and it's a real shame.

Legends

''Ello, darlin' – are you Gary? You nearly missed me!'

A woman wearing a colourful little hat and a huge pair of dark glasses that almost covered her face had come bustling out of the salon door just as I was about to go in. I had hardly given her a second look, but then I heard that oh-so-familiar giggle and noticed the sexy wiggle to her walk and I instantly realised that this tiny dynamo of a woman was the person I had come to meet: Barbara Windsor.

When I received the phone call about working with Barbara it had felt like a royal summons. I'd done a lot of celebrities and TV presenters by this point, but Barbara Windsor – well, she was an icon! Before I was given the job, however, the two of us were to meet at a salon near her home in Marylebone so we could discuss her hair and make-up preferences and I could show her the sort of thing I could do. After all, she had been around for a long time and worked with all the top make-up artists, so she was taking a real risk with a young guy who was really still just starting out.

But now that I was face-to-face with her in the street, all I could think about was that famous scene in *Carry On Camping* where she memorably loses her bikini top during an exercise session with Kenneth Williams and Hattie Jacques, or that moment in *Carry On Doctor* where she's lying on a hospital trolley wearing nothing but sparkly red hearts on her boobs. And when she took off her dark glasses, even though decades had passed, her face had barely changed. She still had that saucy *Carry On* twinkle in her eye.

Phill had driven me to the meeting and Barbara spotted him still watching from the car.

''Ello, darlin'!' she grinned, giving him a showbizzy little wave. 'Now I know you've come to have a chat about my hair and make-up,' she continued to me, 'but I've got another appointment now, so you can just do my hair for me.'

But instead of returning to the salon so I could try out a few different styles, she just handed me a plastic carrier bag and then set off down the street. 'Come back to me tomorrow morning and we'll have a look to see what you can do,' she called over her shoulder. 'I like my hair full, high and glamorous. Ta-ta, darlin'!'

When she had gone, I peered inside the bag and fished out a blonde wig. I don't know why I was surprised. Like Joan Collins, Barbara had become famous in an era when all the starlets wore wigs. It made perfect sense: instead of sitting there for two hours getting your hair done, you could pop on a wig in two minutes and voilà, instant glamour. I'd not really worked with wigs before, but I did my best, curling and pinning and backcombing – the full Dolly Parton.

The next day I dropped it round at her house and she must have been happy with what I'd done with her hair, because I was booked for a job the following evening.

The shoot was for the cover of an album Barbara had recorded called *You Got a Friend*. People mainly think of her as an actress, but she grew up in that music hall tradition and she really can turn her

hand to anything: singing, dancing – the lot. Barbara had been film-ing *EastEnders* all day and arrived in her Peggy Mitchell make-up and another of those jaunty little hats. She told me she wanted the make-up to be glamorous, and gave me free rein – her only instructions being: 'I like lashes and I don't suit red lips.' And so I got to work.

Barbara has got the most fabulous face: really open and expres-sive features, beautiful eyes, the skin of a woman half her age and a strong mouth with naturally full lips which haven't got any thinner as she's got older. She's a brilliant canvas; you can create all sorts of fabulous looks. And on this particular occasion, if I do say so myself, she ended up looking amazing. I applied a set of false lashes, created bronzy, smoky eyes and glossy lips. It was a very modern look, and when I'd finished she looked at least two decades younger than her 61 years. It was, however, quite a departure from her usual make-up, which I hope she won't mind me saying had changed little from her Carry On days.

At the time Barbara didn't wear contact lenses and so she couldn't actually see what I was doing as I worked, so I was feeling extremely nervous when she reached for her glasses to examine the end result. I thought I might have gone over the top and put too much on her, but she had the sort of face that could just take it.

She stared at herself in the mirror. Seconds ticked by in unnerv-ing silence as she examined herself from every angle, turning her head this way and that. Eventually, her face broke into this huge smile.

'Wow,' she beamed. 'My God, you look a bit good, Windsor!' And then she turned to me. 'You can *definitely* come again, darlin'!'

* * *

I often joke with Barbara that she's my surrogate mum – in fact, I sometimes give her flowers on Mother's Day addressed to: 'my London mum'. She is such a wonderfully special person and I feel very lucky to have her in my life. Not only do we have a really lovely

friendship, but over the many years we have known each other she has given me invaluable advice; not just about my career, but also about attitude, how to treat people.

If she says we'll be starting work at 9 a.m., what she actually means is that I should be set up and ready to go by 8.30. Because she gives 100 per cent when she is working, she expects everyone around her to do the same. She's a total professional, a true star in every sense of the word.

If anyone comes up to her in the street for an autograph, a photo, or just a chat, she will do whatever she can to make sure that person goes home happy. I've never seen her turn anyone away, whatever she's in the middle of doing. She never for one moment forgets that she wouldn't be where she is today without her fans. It's an attitude that's all too rare in today's celebrity world, and is why so many of today's so-called stars are here today, gone tomorrow.

After that first album shoot Barbara started to book me for all her personal appearances, book covers, events, award ceremonies, photoshoots, TV shows – whenever she needed a make-up artist. I did her make-up before she met the Queen to receive her MBE, which was lovely because she was so excited. I now can't wait for the day that she becomes Dame Barbara Windsor; which really must happen, by the way, or else there is no justice in the world.

Another memorable occasion was when Barbara was doing the Royal Variety Show with Cilla Black and Paul O'Grady. The three of them were playing the strippers from the film *Gypsy*, singing that famous number 'You Gotta Have a Gimmick'. Cilla was Electra, Paul – who was bringing back Lily Savage for that one night only – played Mazeppa, and Barbara was Tessie Tura, the ballet-dancing butterfly. You might remember it because Cilla's incredible legs were all over the papers the next day, although I think Barbara's incredibly youthful-looking skin should have got some credit as well.

The stage really is Barbara's spiritual home and the three of them brought the house down that night. Having made her theatrical

debut at the age of 13, she believes all the old-fashioned superstitions, including that it's bad luck to whistle in the dressing room. This has caused me many a headache over the years. When I'm doing Barbara's make-up she loves to have a sing-song – she's always got Radio Two on in the background – and usually I'll forget and start whistling along. Well, apparently the only way to avoid the bad luck is to go outside the dressing room, turn around three times and swear, and I've lost count of the number of times I've had to shout fuck or bollocks in the corridors of the BBC or London Studios. They must think I'm mental.

After I'd been working with Barbara for a while we started experimenting with a few different wigs and hairpieces. I moved her away from those bubbly curls to a shorter, sleeker bob, which looked fantastic on her. Her husband Scott preferred her normal hair so I suggested Barbara try hair extensions to add fullness and so she went to see a woman called Lucinda Ellery. As well as having worked her magic on countless celebrities, Lucinda specialises in helping people who've lost their hair through cancer or alopecia; the woman is an absolute genius.

From that time onwards Barbara never went back to wigs, and nowadays we can create all sorts of wacky styles using her own hair. That's one of the things that makes it such a pleasure to work with Barbara – that she's happy to experiment with her look. I never watch *EastEnders* because I just can't get my head around the fact that this tough-talking matriarch is actually Barbara; she's such a sexy, vibrant woman in real life. She is one of the most intelligent people I know and her general knowledge is astounding, from politics to celebrities to history. And she knows all about whatever new talent is coming along, be it actors, bands, singers. Sometimes it's like talking to a 21-year-old!

The fact that Barbara is so youthful and so outgoing made it all the more distressing when in 2003 she developed the debilitating Epstein-Barr virus and was transformed into this desperately frail

old lady virtually overnight. It happened terrifyingly suddenly; Barbara got out of bed one morning and her legs just collapsed beneath her. The doctors couldn't tell her when she'd be able to work again, she was just told she would have to stay at home and rest until she was better, which could have been six months or five years.

One of the saddest memories of my life was going to visit her during this period. She opened the door and in front of me was this shuffling little 100-year-old who I didn't even recognise; overnight she had lost a huge amount of weight and just looked so desperately fragile. We both just burst into tears.

'I don't know what do, Gary,' she sobbed. 'I can't even walk, it's so awful.'

She didn't really want to see many people during this time, but I would often take her flowers and sit with her, trying to make her laugh. That famous twinkle had gone from her eyes; she was virtually bedridden for a year and had to take a two-year break from *EastEnders*. It was a really awful time, but she gradually began to improve and get back to her old self – although she definitely started to take things a little bit more easily after that scare.

Not that I think Barbara will ever retire. I know she could have played Peggy forever, but I think she wanted to challenge herself and try new things. Besides, she keeps getting offered such exciting projects. I recently got her ready for the premiere of Tim Burton's *Alice in Wonderland*, in which she played the voice of the Dormouse. She looked wonderful that night in a two-piece, silk taffeta petrol blue suit with matching mini trilby, proving she can keep up the best of today's starlets on the red carpet. I wouldn't be surprised if you saw her back in the theatre in the next few months; maybe she'll even do panto again.

She's a real grafter is Barbara, but then she's had to be: she's never had it easy and has always worked hard for what she's got. She's not like Joan Collins who went to Hollywood or Cilla who fronted all the primetime TV shows. Throughout her life Barbara has certainly

hit the lows as well as the highs – she's survived her own personal crises and had to rebuild her whole career. But thankfully she's now right up where she deserves to be, comfortable and established enough to be able to take it easy and to pick and choose jobs, and rightly regarded as a true British institution.

* * *

Over the years I've been lucky enough to work with some truly legendary divas – and I mean that in the most positive, powerful sense of the word. There's Barbara, of course, but also Judi Dench (such a lovely, graceful woman – almost regal), Angelica Houston, Helen Mirren and Jerry Hall. I was booked to do Jerry's make-up for the publicity shots when she was appearing on the West End stage in *The Graduate*, playing the femme fatale Mrs Robinson. We were talking about what we would do for the make-up, when Jerry said to me in her famous Texan drawl: 'You know, ah feel like changing mah hair. Ah want you to cut it off.'

Well, I was shitting myself. All those iconic Jerry Hall images: partying with Mick Jagger at Studio 54, on Roxy Music's *Siren* album cover – they're all distinctive for that famous curtain of long, blonde hair.

'Ah haven't had it cut short for something like twenty years,' she said a little nervously as I got out my scissors, trying desperately to stop my hand from shaking.

I trimmed her famous locks into a shoulder-length bob and thankfully she absolutely loved it, although at the end of the shoot she took what I'd cut off home with her.

'Don't want to forget mah hair,' she smiled at me.

* * *

I do get quite nervous when I'm working with those *grande dames* of showbiz. I was booked to do the actress Honor Blackman for a magazine shoot. I was so excited: I was going to be working with

Pussy Galore! I had been such a massive James Bond fan when I was younger – although I suspect that was more because of the Man with the Golden Gun's, er, golden gun, rather than any of the bikini-clad Bond Girls.

Anyway, Honor strode into the room and woah – my jaw dropped. She was in her seventies, but she was even more beautiful than back in her Bond days and still devastatingly sexy. She was lightly tanned, perfectly groomed and wearing a neat little trouser suit with a waistcoat, and she just seemed to have a halo of light around her thanks to this amazing mane of thick, platinum blonde hair. And she was so tall! Celebrities tend to be quite short, especially the men. Tom Cruise, Mark Wahlberg – I've met them all, and they're all pretty titchy. But Honor must have been at least 5ft 10' and carried herself like a supermodel.

When she got in front of the camera she knew exactly what to do and when she opened her mouth and that famous husky voice came out: 'Daaaaaahling …' Well, it was a real honour to work with her, and she even sent me a letter after we worked saying she'd never felt so fabulous and thanking me for turning the clock back twenty-five years.

Another former Bond Girl I have worked with is Ursula Andress. But while Honor was happy to give me free rein over her make-up, Ursula was quite a different story. She arrived at the shoot at Blakes Hotel accompanied by her son Dimitri (who, by the way, was utterly gorgeous and the dead-spit of his dad Harry Hamlin in his *Clash of the Titans* prime). When I saw her, that iconic image from *Dr No* instantly flashed through my mind – Honey Ryder emerging out of the sea in that white bikini while Sean Connery hid behind a palm tree.

I'm often struck by how tough it must be for women who were once legendary beauties as it is their destiny – and curse – to be forever compared to how they looked in their prime. People handle this in different ways: some have so much work done they start to

look like a caricature of their younger selves, others throw in the towel and completely let themselves go. I'm sure it must be very difficult to get the right balance.

A common mistake, however, is that older women often cling to the make-up look that they were famous for in their prime – and this problem actually applies just as much to everyone, as much as celebrities. My biggest make-up tip for all women would be to every now and then take a really good look at your face, so you don't fall into the trap of doing the same make-up at 40 as you had at 16. The key is experimentation. There are no rules with make-up – and the best thing about it is that you can always do a Tracey Ullman and wash it off at the end of the day if you don't like it!

Anyway, sure enough Ursula was wearing a full face of make-up when she sat down in the chair – and it was exactly the same look as when she was in *Dr No*, although obviously it was not exactly the same face.

'This is how I like my make-up to be done,' she explained, talking me through her handiwork. 'Now I'd like you to take it off and redo it as I have shown you.'

And so I did as she asked, wiping her face clean and then painting that exact face back on again. During our session she kept stopping me, taking out a magnifying glass and peering at herself in the mirror to check I was doing exactly as she wanted. I would have loved to give her a fresher, modern look – she was still very beautiful and I knew I could make her look even more so – but as a make-up artist your job is to give the client what they want, to listen and work with their vision. Besides, I was more than a little bit scared of her …

* * *

I don't think you girls ever appreciate just how lucky you are to be able to wear make-up. Think about it: the way a guy looks when he wakes up in the morning is pretty much how he'll have to present

himself to the world. Even if he's one of those very rare men who goes in for a little light bronzer and concealer (as I often do) it's not going to make a huge amount of difference. We're basically stuck with what we've been given.

But the amazing thing about being a woman is that you have this incredibly powerful tool in your hands – and most of you don't even realise it! With a few simple tools and techniques you are able to create so many different illusions, from strong and powerful one day to sweet and innocent the next. You can go from businesswoman to babe to bimbo with just a few subtle tweaks. And that's the other thing about make-up – you don't necessarily need to use a lot of it to make a big difference.

There are very simple things you can do to totally transform your face. For example, just plucking your eyebrows properly can give you a completely different look. In fact, when I meet a woman for the first time I will usually look at her and think, '*God, you're wearing far too much make-up …*' If make-up is done badly, or not in the right way, I find it far more noticeable than someone who is completely barefaced.

The thing is, nobody is born perfect. A woman might have incredible eyes or flawless skin or fabulous lips, but I've never met anyone who has the full package; it takes make-up to create that *illusion* of perfection. Yes, Angelina Jolie might have a great mouth, amazing bone structure and photograph beautifully, but when I met her at the *Tomb Raider* after-party I was surprised just how girl-next-door she looked in person. You strip someone back to the basics and everyone needs a bit of help, no matter how good the raw material.

* * *

When people go on safari they talk about seeing the Big Five: Lion, Elephant, Leopard, Buffalo and Rhino. They catch a glimpse of those great beasts and can go home happy. Well, I have always had a

personal Big Three, a trio of personal icons whose faces I am desperate to make up – and while I've come frustratingly close over the years, up until now they have all eluded me.

One day I got a phone call from a stylist friend of mine called David Thomas that sent me into a frenzy of excitement.

'I'm getting Liza Minnelli ready for an event in London,' he told me. 'She would absolutely love your make-up – it's just up her street! You have to come and do it.'

Well, I didn't need asking twice. Judy Garland's daughter? Sally Bowles from *Cabaret*? Hell, yeah! I spent hours cleaning my kit because I needed everything to be total perfection for Miss Minnelli. At the appointed hour, I made my way to her hotel in London and was waiting in reception, buzzing with anticipation, when I got a call from David.

'I'm so sorry, Gary, she's brought her own make-up artist with her.'

I slunk off home, thoroughly disappointed.

I have since met Liza at the Royal Variety Show when she had the dressing room opposite Barbara, who introduced us. Liza was exactly how I'd hoped. She kept telling me how beautiful my skin was, which literally made me glow with happiness (*Liza Minnelli thinks I'm beautiful!* **And** *she's Judy Garland's daughter!* **The** *Liza Minnelli!*) and when I mentioned about the time I'd nearly got to do work with her she gave a throaty laugh.

'Sweetheart, I nearly always do my make-up myself,' Liza told me. 'And if someone else does it, more often than not I'll wipe it off and do it myself again anyway!'

* * *

My next near miss was with Alexis Carrington Colby – sorry, with Joan Collins. She had apparently rung Barbara up after a shoot I'd done with her appeared in the magazine and said, 'My God, you look amazing. Who did your make-up?'

When I heard I was booked on a shoot with Joan it instantly took me back to my childhood when I would spend all those hours sketching pictures of her face in my bedroom. And now I was getting to work with the real thing! But when I arrived at the studio, Joan was already sitting there fully made-up.

'Darling, if you could just be on set to take the shine off me,' she smiled graciously. And so I spent the entire shoot just powdering her down.

Was I disappointed? Of course I was. But you don't argue with Alexis. And I wasn't actually that surprised: she is another one of those established stars who has such a strong signature make-up look that it must be difficult to trust other people to get it spot on. Besides, what probably took her twenty minutes to apply would have taken me two hours – and it looked amazing.

It was a pleasure to meet Joan – she was a truly wonderful lady, just as fabulously old-school Hollywood as you'd imagine. But I've got this terrible habit, particularly when I am working with someone who I really admire, that I can't stop singing. So as I was powdering her down I found myself humming the *Dynasty* theme tune. It was mortifying. I kept telling myself, *Gary, just shut the fuck up!* But I couldn't stop doing it. The same thing happened when I met Liza. I think I must have some sort of weird showbiz Tourette's.

* * *

My ultimate icon is Madonna. I've bought every one of her records, seen her on every one of her tours, know even the most insignificant fact about her life and career – and in 2002 I finally got the chance to meet her.

The Victoria & Albert Museum in London was holding a retrospective of the late Gianni Versace's work and his sister, Donatella, was throwing a glittering celebrity fundraiser to celebrate the launch. I walked in and the place was wall-to-wall A-List, and then I spotted this tiny, doll-like woman who just seemed to radiate star quality.

Oh my God, I thought, *it's Madonna!* She had recently moved to London and looked even more beautiful in real life than she does in photos. There's something about her eyes that is just hypnotic; I couldn't stop staring at her. Soon I found myself pushing my way through the crowds until I was standing right next to her. This was my big chance – I might not ever be this close to her again. I decided to do something I had never done to anyone before or since: I went up and told her exactly what I thought of her.

'Um, hi,' I said, thinking at any moment her flunkies might step in and have me removed. 'I just wanted to tell you that I think you're absolutely amazing and an inspiration for everyone.'

She stared at me with those mesmeric eyes and then her mouth broke into this huge toothy grin and she just said: 'Why thank you. What's your name?'

We chatted briefly, but I was so starstruck that I realised as she walked off that I had forgotten to tell her what I did for a living. I had totally missed my chance to sell myself as a make-up artist! I beat myself up about how stupid I'd been for ages after that. A friend of mine does her nails when she's in London and she keeps telling me to give her an introductory letter so she can pass it on to her, but I'd just feel like a silly fan. As far as I'm concerned, Madonna is the ultimate and the only way I'll get to do her make-up is if I'm approached. So if you're reading this, Miss Ciccone …

TWELVE

Celebrity Circus

My first appearance in front of the camera as an adult was, it has to be said, a complete disaster. I had been invited to appear on a daytime magazine show on the short-lived lifestyle channel Granada Breeze to talk about being a celebrity make-up artist.

The show was being filmed live in Manchester and my train had been delayed, so when I arrived at the studios I was already running late, and by the time I had run up several flights of stairs to get to the dressing rooms (it was this shabby old building and there was no lift), got changed into my TV outfit and run back down again to the studio I literally had seconds to spare. I plonked myself down on the sofa next to Claudia Winkleman, who was presenting the show, a soundman dashed over to wire me up with a mic and then just as he pulled away we were live to the nation.

'… And my next guest is a man who knows even more about lip gloss and eyeliner than I do!' Claudia smiled to the camera. 'Here to share his celebrity clients' secrets, please give a warm welcome to top make-up artist Gary Cockerill!'

As Claudia introduced me I realised to my horror that I was sweating – and not just a bit of a shine, I had rivulets trickling down my face and my shirt was clinging damply to my chest. Trying to wipe it away would have just drawn further attention, so I just sat there grinning stupidly, trying desperately to focus on the interview. But it was no good; between the sweat and the stress of live TV I was utterly lost.

'So tell me about a few of the celebrities you work with, Gary,' Claudia was saying.

Okay, I can do this. 'Oh, I've just done this fabulous shoot with Caprice,' I said breezily.

'Great, great … Any other names we might recognise?' said Claudia. 'I know you've got quite an impressive client list!'

My mind went totally blank. *Who the hell do I work with?* I couldn't think of anything except for this huge, flashing, neon CAPRICE.

Claudia was looking at me expectantly. 'Gary …?'

Caprice Caprice Caprice.

'Well …' I finally said. 'I've done quite a lot of work with Caprice. Lots of magazine covers, calendars, um … that sort of thing …'

As if that wasn't bad enough, Claudia later asked if I had any funny stories about working with the rich and famous.

'There was this one time,' I laughed nervously, 'when I was doing a shoot with Caprice …'

* * *

Despite my first live TV flop – the Caprice catastrophe – I soon landed a regular spot on *The Big Breakfast*. I would pop up once or twice a week to talk about new products, the latest make-up trends, a bit of gossip about which celebrities I was working with. I found it really easy when I was chatting away to the show's usual presenters at that time, Amanda Byram and Patrick Kielty, but occasionally Donna Air would be hosting – and that was a completely different matter.

Donna threw me totally. We would be chatting about a new lip gloss and she would suddenly go off on a tangent and witter on about what she'd got up to last night. Or she would grab the product and waste a minute of the three-minute slot putting it on herself.

'Ooh, doesn't this look fabulous, this is just great!'

I mean, it was breakfast telly – not the shopping channel. I found her really hard to work with on TV, although I had done her make-up a few times for shoots and she was an undoubtedly striking girl – really beautiful. The first time I met her she had these mad, thick, wayward eyebrows that would have put Brooke Shields to shame.

The Big Breakfast led to regular TV guest slots including *This Morning*, a show called *The Truth about Beauty* with the lovely Martine McCutcheon (one of my favourite clients, and a real beauty) and then I was asked to be a regular contributor on a new Channel 4 makeover series called *10 Years Younger in 10 Days*. Once they realised that the whole ten days concept was completely unworkable it was renamed *10 Years Younger*, but for that first series I'd be trying to put make-up on a woman who had only just had a chemical peel and was still in the process of shedding several layers worth of skin.

But although the timing of the makeovers caused issues, I loved working with members of the public for a change. Although anyone could book me to do their make-up (and still can!) my schedule was such that I was struggling to fit in my celebrity clients, let alone those people whom Liz Hurley memorably referred to as 'civilians'. But I still get far more job satisfaction working with a woman who has never had their make-up professionally done and seeing the expression on their face after the transformation, rather than with someone who takes the whole process for granted.

One particularly memorable TV experience was working on a show called *Jennifer Does Thailand* in 2004. The Jennifer in question was Jennifer Ellison, the ex-*Brookside* starlet turned lad's mag favourite who was a regular client and a good friend. Sexy, blonde

with incredible va-va-voom curves, she looked like the English Britney. Not only that, she was a really good little actress and a fantastic singer and dancer too.

Jennifer was approached to take part in a travel series for Sky One in which various stars were taken abroad to record their experiences of a country: sort of part travelogue, part celebrity reality show. I was booked to do Jennifer's make-up, but as we had become so close she invited Phill along too and we ended up appearing on the show alongside Jen and her then boyfriend Tony.

Things started badly even before we got to Thailand. The plane was unbelievably old and rickety – with the upholstery hanging off the seats and the lingering smell of cigarette smoke – and I spent the whole twelve-hour flight obsessing over the medley of bangs, squeals and clanks coming from the engines. We arrived in Bangkok late that night and had to be up early to start filming the following day. As the producers were keen to show all sides of the country, both good and bad, we started in an area called Pattaya, which is infamous as a sex tourism mecca.

My God, the things we saw over the next few days. I watched in horror as a Thai woman in a seedy club did that trick with ping-pong balls while her four-year-old daughter stood by the side of the stage, watching her mum. Another club, this one full of young lads with numbers attached to them so the punters could pick them out. I couldn't stay in any of those places for more than a few minutes – I just wanted to get on a plane straight home. The worst thing was that nearly all the clientele in those awful places were Westerners; vile, sleazy men, like dozens of Gary Glitters. I hated it. Jennifer hated it. We left that place with some really terrible memories.

Another day we were scheduled to film in one of the city's posh hotels but the manager wouldn't let us in as some of the crew were wearing shorts.

'I bet they wouldn't care if the King walked in here in a pair of shorts,' one of the researchers muttered.

Well, all hell broke loose. The Thai people have the utmost respect for their royal family and the punishment for insulting them is severe.

'How dare you abuse our King!' the manager was shouting, as a troop of worryingly angry-looking hotel security guards surrounded us. 'I will call the police!'

Thankfully, the researcher thought on his feet and managed to talk his way out of it.

'No, I was talking about Elvis – you know, the King?' he jabbered as the guards closed in. 'I just love rock and roll, man! "Blue Suede Shoes" … um, "Heartbreak Hotel" – yeah!'

And that was how Elvis saved us from Thai jail.

To top if off, one night in Bangkok we went to a famous seafood restaurant at the top of one of the city's tallest buildings. My guts started to gurgle and lurch worryingly on the ride down in the lift and by the time we had climbed into a tuk-tuk for the drive back to the hotel I was in all sorts of trouble, pale, sweating and obviously in the opening throes of a bout of serious food poisoning. We had only gone a short distance when I knew I needed to find a toilet – and fast.

I stumbled out of the tuk-tuk and dashed into the nearest place I could find, which just so happened to be a brothel. Suddenly I was surrounded by crowds of young women, grabbing at my hands and trying to steer me to a table.

'You want us to dance for you, mister?' they were saying.

'No, I just need a toilet!' I shrieked with increasing desperation, as I became horrifyingly aware of the spreading stain on my shorts.

Eventually someone understood and showed me to a little back room. Honest to God, it was the most disgusting toilet I've ever seen. It can't have been cleaned for months; the smell was indescribable. But worse was yet to come: there was no loo roll. Well, I could have cried. In fact, I think I probably did. In the end I ripped my pants off, wiped my bum and legs on them and chucked them out the

window. Phill and Jennifer found it all hysterical, of course, but weren't too impressed with the smell on the journey back to the hotel.

Another day we were filming at a martial arts centre that just so happened to be right next door to a chicken market. Seeing as it was at the height of the Bird Flu epidemic and everyone was going round wearing masks, I didn't think it was a brilliant idea to set up a shot in the middle of hundreds of squawking (and frankly diseased-looking) chickens. In the end I threw a hissy fit, refused to get out of the car and they did the shot without me.

But then halfway through the trip we went to a beautiful place called Chiang Mai and from then on my outlook on Thailand was completely transformed. We had an amazing week visiting beautiful beaches, deserted islands and picture-postcard villages. Everyone relaxed and I went from hating everything about the country to thinking it was paradise on earth.

Shortly after the Thailand trip Jennifer landed the role of Roxie Hart in the musical *Chicago*. Many people thought she was far too young for that role – plus, like Kelly on *The Big Breakfast*, she was following directly in the footsteps of Denise van Outen, who was so incredible in that role – but Jen, bless her, was just fantastic. She was appearing opposite the very charming and extremely attractive John Barrowman, a man as famous for his immense performing talent as for his immense, um, package.

It was 2003 and my career was on fire. I was earning more than ever and, now that my profile was getting a boost from my TV appearances, I was starting to benefit from some of the perks of fame myself. I seemed to be invited to a different party every night – a movie premiere here, a charity ball there – and I didn't want to turn anything down. The champagne, the cocktails, the designer goody bags, the roped-off VIP areas: suddenly I was living the celebrity dream! I would go out for dinner every night – and not at Pizza Express, we're talking Nobu, The Ivy, Mr Chow's: wherever was

fabulous at the time. On average I was spending about a grand a week just on restaurant bills.

With my glittering new social life, I obviously needed a glittering new wardrobe to match. Soon I was spending thousands of pounds a week on fabulous new outfits. It wasn't that I was a clotheshorse so much as a clothes whore – I would wear something once and then chuck it to the back of my wardrobe. Pretty soon my shopaholic tendencies had spiralled into a full-blown addiction.

At least every other week I would book a black taxi to pick me up from our home in Buckinghamshire and drive me into London for a spending binge, landing me with a £60 fare before I'd even started on the shopping. I would nearly always go on my own, as Phill has always been very sensible with money and my over-spending led to huge rows. I'd hide carrier bags and receipts from him, and cut out the designer labels so I could pass off a £600 Dior jacket as £60 from Zara. I was like some desperate alcoholic, bingeing in secret and then hiding the bottles.

I'd usually start my day at Selfridges on Oxford Street, flying round every single concession, from the high street brands to designer, and making mad, impulsive purchases. The problem is I can't just buy one item, I have to buy a whole outfit, complete with shoes and accessories. I am an equal opportunity shopaholic – I'll happily shop in designer and high street stores – but instead of buying a couple of items in Dior, I'll buy twenty in Topman, so I'd still end up spending a fortune.

And it wasn't just clothes, it was furniture and art too. Whenever we moved (and we did so more often than most as Phill supplemented his TV income by renovating houses and selling them on) I would give away all our furniture to friends and family, even if it was only a couple of years old, and start from scratch in the new place.

Once I'd finished in Selfridges I would get the taxi (who I would have kept waiting outside with the meter running) to drop me at Bond Street, where I would work my way down through the designer

stores – Dolce, Gucci, Westwood, Alexander McQueen. Usually I'd meet a friend for lunch, although it obviously couldn't be just a quick sandwich at Pret A Manger, it would have to be black cod and tuna sashimi Nobu. Then the same taxi, now loaded down with carrier bags, would drive me back home again. Before I knew it I was spending two or three thousand in one spree.

I think my problems might have stemmed from the fact that when I was growing up my parents had been extremely careful with their finances. There were no credit cards, no buying things on HP. So as soon as I started earning serious money I was like a kid in a candy store, making up for all those years of sensible frugality. But it was also that most of the people I was socialising with were rich and famous, and my attitude at the time was – if they can spend thousands on designer clothes and stay out all night partying, then why the hell can't I? I was trying my best to keep up with my friends, forgetting that most of my friends were multi-millionaires who didn't have to get up for work first thing in the morning and could pay for someone to make up their faces to hide the damage. Forgetting that I was that someone.

Predictably, my career started to suffer. There were a few particularly heavy nights where I went home from a club at 6 a.m., jumped in the shower and then went straight to work. But because I work so close to people's faces I couldn't blag it. They could see in my eyes and smell my breath. You can't hold a brush steady if you've just finished drinking champagne just an hour or two before. The partying was taking its toll on my appearance too. I looked shocking, really blotchy and puffy, and started to put on weight.

I had watched so many people get carried away by the celebrity whirlwind only to crash and burn, yet I didn't see the warning signs in myself. Luckily after a few months of late nights and increasingly unreliable behaviour Barbara took me to one side and gave me a good talking to. She told me a few home truths, that if I didn't change my ways I would lose all my clients. The prospect of waking

up to my worst nightmare – no job – quickly got me back on the straight and narrow.

Yet how different things could have been if I'd ever got into drugs. I can see just how easy it would be to become an alcoholic or drug addict if you're famous, as everything is available to excess. It sometimes feels that I'm one of the few people in the industry who doesn't take drugs. I've seen some of the most clean-living stars, the ones you would never expect this from, hoovering up cocaine and popping pills – believe me, it's not just the rock stars!

I've been offered coke a million times and I always say no; although once when I first came to London I felt under so much pressure to join in that I ended up pretending to sniff a line and secretly blew it on the floor instead. I guess I've got my neuroses to thank for keeping me off drugs. The thought of being out of control, of taking something and never waking up again, scares the hell out of me. Not only that, I've seen at first-hand the terrible damage that drugs can do.

I was, of course, well aware of Danniella Westbrook before I worked with her. Not only was she famous for her role as *EastEnders'* feisty Sam Mitchell and her gorgeous girl-next-door looks, she had got herself quite a reputation as a party girl. But when she walked into Jeany Savage's studio for the first shoot we did together in 1999 I didn't recognise her. At the time, she was on an extended break from *EastEnders* amid rumours of drug problems and had been keeping a low profile, so I was shocked to see this skinny, frail young woman, her complexion looking far from radiant and her famously long hair cropped into a severe bob. She looked like she needed a decent meal. And she was all over the place – twitchy, chatting away non-stop and constantly munching from this big bag of sweets.

I sat her down and started to apply her foundation and immediately realised something was terribly wrong. My make-up sponge wasn't stopping where it should have done. There was a big hole where her septum should have been. I was completely freaked out:

I'd known she'd been in a serious car accident and obviously I'd read about the cocaine rumours, but I'd had absolutely no idea of the extent of her addiction. I didn't want to make an issue out of it, obviously, so I carried on and did the best I could.

When it came to taking the photos Danniella knew exactly how to work the camera, tilting her head down, posing in a way that the damage was completely hidden. Whenever she met people she would keep her head down and eyes upturned in the way that Lady Di used to in early photos – that same endearingly coy look, only Danniella was doing it to hide the fact that half her nose was missing. In fact, it wasn't until a year after our first shoot, when that famous photo of her sticking her tongue out appeared in the papers, that the story about her coke-damaged septum finally came out.

Danniella is one of the most inspirational people I have ever met. She is an incredible example of how someone can be at absolute rock bottom and then completely turn their life around. After that first shoot I started working with her regularly and she would often seem to be far from herself. It was tragic really – here was this gorgeous, hugely likeable girl who obviously had a very good heart but just got totally and utterly lost along the way. Yet two years after our first meeting I did the make-up for her Christmas wedding to businessman Kevin Jenkins and she was a completely different girl – beautiful, totally clean and completely at peace with herself. In the following years she had two operations to reconstruct her nose and she is now happier than ever with a beautiful family.

Not only is Danniella a wonderful friend, but I have her to thank for one of the most important companions in my life. About eight years ago, Phill was putting in some decking at her house in Kent as part of an occasional home improvement column he was doing for the *News of the World* Sunday magazine, in which he'd make over a room of a celebrity's house.

Phill was working away when he heard the sound of a little dog barking. He went to investigate and when he opened the door this

gorgeous miniature King Charles Cavalier puppy bounded up to him. Apparently Kevin had bought the dog, named Frankie, as a surprise present for Danniella, but as they already had two large guard dogs that roamed the grounds they couldn't let her out as this tiny spaniel could have been eaten alive. So Phill spoke to Danniella and Kevin and they agreed it would be best if he took Frankie home with him.

Well, it was love at first sight. The little puppy bounded into my arms and started frantically licking my face. But something wasn't right. 'She's not a Frankie,' I said to Phill. 'Look at her hair! She's a Dolly.'

And so that was how Dolly Parton came to live with Phill and I, to be joined a few years later by Scarlett O'Hara, a ruby red King Charles Cavalier who arrived on Christmas Day 2007.

* * *

Up until Phill started work on *House Invaders* in 1998 we had rarely had a night apart. If I went on work trips I would usually find a way to get him along too. But once he started filming five days a week – nearly always outside London – things started to change. Overnight we went from living in each other's pockets to barely seeing each other. Then at weekends he'd be so exhausted that having sex would be the last thing he felt like – either that or I'd be off on a work trip somewhere. Our relationship revolved around snatched cuddles and hurried late-night phone calls; we never seemed to spend any quality time together.

And then *House Invaders* decided to get another handyman on the show to appear alongside Phill, a dark-eyed, well-built, handsome Italian by the name of JJ Martinez. Phill went along to the castings and I think he helped pick JJ because he thought he would be a bit of eye candy, which infuriated me. The two of them became really great mates; they even had this special lingo they would use that I didn't understand which made me feel completely left out. It

didn't matter that JJ was straight and had a girlfriend, I started to suspect that he and Phill were having an affair.

Gay men tend to be a lot more open about relationships than heterosexual couples. Some gay men might have a really solid partnership and be close companions, but agree that they are allowed to sleep with other people.

It annoys me when the media implies that gay men are therefore more promiscuous: sex outside the relationship happens a lot in the straight world as well, but it's called an affair and is behind the other person's back – so if anything gay men are just more honest. From day one, however, Phill and I made a firm decision that we didn't want to have an open relationship. We didn't want to risk anything breaking us apart. Besides, we were – and still are – too much in love to consider sharing each other. Even now I'll get jealous if I catch someone eyeing Phill up.

So when he and JJ started getting close – well, my green-eyed monster started running amok. And if it wasn't JJ, it was a researcher or the cute new gay runner. *Look at the way he's talking to Phill, they're definitely having an affair!*

It didn't help that people who work on television tend to be pretty hardcore; they'll work really hard all day and then go out all night to let off steam, so I would ring Phill at 8 p.m. when I got home from work and he'd be in the bar.

'I'm just having a few drinks with everyone,' he'd tell me.

But I'd ring again at midnight and they'd still be out partying. I would hear everyone laughing and joking in the background and be literally eaten up by jealousy, insecurity and loneliness.

To make matters worse, in 1998 my beloved Granddad Joe passed away after a short battle with cancer and his death affected me badly. The last time I saw him was at the Doncaster Royal Infirmary two weeks before he died. He looked terrible, so frail and thin with a grey tinge to his skin. Nevertheless he was perched up on his bed with a big smile, fully engaged in our conversation and ready with a bit of banter.

Shortly after that I flew to America for a job and he died while I was out there, so I missed his cremation service. I wrote a letter to him that my cousin Julie read out at the service:

> Granddad, I'm so sorry I can't be with you today, but I know you'll understand. You have always been there for me, encouraging me to be who and what I am and not what other people expect of me. As a child I learnt from you, all your words of wisdom, and as a man I still think back to everything you said. It's hard to accept this is goodbye, I'm so lucky that you were and always will be a part of my life. I love you and miss you, Granddad.

I made it home in time for the ceremony to inter his ashes, but Mum was terribly upset with me, telling me I'd let everyone down by not coming back for the funeral. For the next few months I'd wake up every night, convinced he was in the room; I felt like I needed to apologise to him. I'm ashamed to admit that when Auntie Mo passed away a few years ago I missed her funeral too because I was abroad for work again – and the worst part of it is that all my family automatically expected I wouldn't be there. I guess I have to face up to the fact that I'll always be worried about my career. It was just like Nell McAndrew said to me when I missed her wedding:

'Surely it's not all about work, Gary?'

But as I said before, I'm just terrified that if I turn down one job I'll be finished.

Shattered by my grandfather's death, in agonies over Phill, I called up his mum Isabel in floods of tears.

'I've got to know if Phill's having an affair,' I sobbed down the phone. 'Am I going mad? Do I need to see someone? You've got to help me!'

She tried her best to reassure me, to tell me that I was worrying unnecessarily, but nothing would convince me.

I even gave Phill an ultimatum – 'Either you stop working on *House Invaders* or I'm going to leave you' – although obviously I didn't go through with my threats.

And then one night I hit rock bottom. I got myself dressed up, called a taxi and went to Soho with the sole intention of having sex with another man. I marched into the first gay bar I came across and sat there with a vodka and cranberry (the first of many that night) working myself up into a fury.

I've had one cock in my life, I fumed, *if Phill is having an affair then* I'm *bloody well going to see what it's like with someone else.*

I must have had fifteen guys come up and blatantly proposition me that night, but in the end I didn't get off with any of them – although I admit I came pretty close. I had needed to feel special, to know that someone else found me attractive, but I went home feeling absolutely disgusted with myself. It was the thought of Phill that stopped me – and the knowledge that if I slept with someone else that would be the beginning of the end.

At 2 a.m. I climbed into a cab on my own, sickened with vodka and shame, and cried myself to sleep.

In the end, we sorted things out; we always do. Phill sat me down one day and basically told me to stop being such an idiot.

'If I wanted to be with someone else I would leave you,' he said to me. 'But I don't and I won't. I love you Gary – I always will do. Now can't we just get on with enjoying our lives together?'

* * *

Autumn 2003, and out of the blue I got a phone call from an old friend – Katie Price. She had just written her first autobiography and wanted me to do her make-up for the book's cover photo. I hadn't seen Kate in a while, and the moment she walked into that studio in West London I could tell there was something different about her. It wasn't just physical, although she had just gone a fresh shade of blonde and looked really healthy and natural; there was an air of

expectation about her, a feeling that she was ready for something new. There was about to be a big change in her life, you could just feel it.

Kate was late, as usual. But when she arrives she's always a total pro and you forgive the lateness because she puts in a 100 per cent. I think that the photographer, the legendary Terry O'Neill, was totally blown away by her. At the start of the shoot I sat her down to talk about what sort of look she wanted for the pictures and Kate said something totally unexpected.

'I'm going to trust you, Gary,' she said to me. 'Do whatever you want.'

You have to remember that up until this point Kate – or rather Jordan – had a very clear way of how she wanted to look. Really black eyes, masses of lashes, caked eyeliner, strong lip-line. But now she was giving me a totally free rein. I decided to lose the drag queen slap and went to the opposite end of the scale: minimal foundation, shimmering cheekbones and eyelids and soft clear gloss on her lips (with no lip liner) to give a sun-kissed, beachy look. Instead of big, over-the-top hair, we went for soft, natural waves. Well, I thought she looked beautiful. The title of the book might have been *Being Jordan*, but the picture on the front cover was as far removed from that as possible.

That was the day I got Kate's trust back – and a million shoots later I think she has realised that she can look just as beautiful without make-up as she can with it on. It was also, for me, the day that the Katie Price phenomenon was born.

* * *

The first time I met Peter Andre properly was in late 2003 when I was booked to do his grooming for a series of publicity photos to be released to the press before he went into the jungle for the ITV reality show *I'm A Celebrity … Get Me Out of Here!* I got the call from his long-time manager, Claire Powell, who had become a close

friend after years of working together, and we did the shoot at a studio in Battersea.

I clicked with Pete instantly. I found him hugely attractive – not so much because of his looks, but because he was such a sweet, genuine guy. I thought he was far more handsome than when I first saw him in his 'Mysterious Girl' days, even if he had lost that famous six-pack.

Pete had been living in Cyprus for the previous few years, where he had been running a gym with his brother, and was really excited about appearing on the show. There had been intense speculation in the papers that Kate was going on the show and, while I knew by this point that she was definitely going into the jungle, I had been sworn to secrecy. Pete was asking me what she was like and I just told him she was a really great girl and that they'd get on really well. What I didn't tell him was that I thought Pete was exactly Kate's type, he was bound to fancy her and – if the chemistry was right – there would be major fireworks between them …

The rest, of course, is history. In January 2004 Kate and Pete went on the show and fell madly in love. Like the rest of the nation, I sat at home glued to the telly, enjoying watching their love story unfold night-by-night. I was thrilled: Pete was just what Kate needed – a really decent, genuine guy who would care for her and Harvey. He was very clean-living, he barely touched alcohol and was raised as a Jehovah's Witness. He wasn't a party animal at all. But Kate was so ready for that change. Her circle of friends changed overnight. All she wanted to do was get pregnant and have babies. Pete became her all.

Things moved incredibly quickly once the two of them came out of the jungle. Kate ditched her old publicist and signed with Pete's manager Claire Powell and her team. They were handed a golden ticket really – the jungle had given Kate the opportunity to show the public the sweet, normal girl behind the lurid headlines and attention-seeking antics. Kate was advised to transform her image, which up

until then had been overly sexy and brash – great for the lad's mags market but not so appealing to other women. Guided by strong management and fuelled by Kate's own readiness for a change, wild, party-loving Jordan changed into sweet, home-loving Katie Price.

People have constantly accused Kate and Pete's relationship of being a publicity stunt, but I can honestly say the pair of them fell very deeply in love. It was an all-consuming love, almost verging on obsession. They were the loves of each other's lives, no question. The public's appetite for Katie and Peter seemed insatiable, and as it snowballed their relationship was steered in a certain direction to capitalise on that overwhelming interest. Posh and Becks had moved on to different things and Britain was ready for a new celebrity super-couple – and Kate and Peter (or Dosh and Pecs!) fitted the bill perfectly.

It's easy to forget, given everything that's gone on since, but I have so many wonderful memories of being with Kate and Pete. Despite the fabulous trips abroad and incredible holidays, some of their happiest times were probably just hanging out at home, ordering a takeaway curry and watching a movie from the big squashy leather chairs in their cinema room.

Kate would always say, 'You guys pick what film you want to watch,' so Pete might go for a romantic comedy or Phill and I would choose an action flick, but somehow we would always end up watching exactly what Kate wanted to – and that would be the sickest slasher flick you could possibly imagine. She's got this weird obsession with true crime and serial killers.

One of my happiest memories of that time was working with Kate and Pete while they were recording their charity single and album together, *A Whole New World*. Kate's always loved to sing; when she was little she always said she wanted to be a pop star – and being with Pete gave her the opportunity to realise that dream.

We filmed the video and did the shoot for the album cover in Rome. For me it was especially exciting because when we got out

there I instantly recognised the video director – a really hot Italian guy named Luca – as being one of Madonna's backing dancers on her Girlie Show Tour. (Yes, my Madonna obsession is such that I know these things!) The *Whole New World* video was based on the classic Sixties film *La Dolce Vita*, so the hair and make-up was a completely different look than Kate was used to: bright red lipstick, eyeliner in a tick, arched brows. She had a real problem with it.

'I'm not Kelly Brook,' she grumbled, as Kelly was working that whole look at that time.

'Don't be silly, trust me – it's going to work,' I told her.

And it did. I think those are some of the most beautiful pictures of Kate and Pete we ever did.

Throughout those first years, Kate and Pete were being guided by a very close-knit team. It was virtually impossible for anyone else to penetrate that inner circle because the control was so tight. At the beginning, it seemed like a good thing. An element of guidance is necessary with any artist.

But the extent to which Kate's personality was being moulded to fit a certain image worried me; maybe we were all just trying too hard. The gap between what was real and what wasn't in the media suddenly became a very fine line. Obviously they got days off, but they were so hot at the time that everybody wanted something from them. The magazines couldn't get enough of them, so whatever went on in their life there was always an opportunity to make money from it – and, like anyone else would do, why not go for it? It was just a question of how far to go.

Kate is very ambitious and always wants to be the best, so when it was pointed out to her what she had the potential to achieve she listened. But at what price fame?

Tantrums and Tiaras

'I'm sorry, Gary, it's her or me.'

I can't tell you how many times, with a sinking heart, I've heard those words throughout my career. While my job certainly isn't brain surgery, what I do is so integral to a woman's self-confidence, sense of identity and self-esteem that some of my clients get possessive and issue me with ultimatums. If I do so-and-so's make-up, then I can no longer work with her – that sort of thing. I'm freelance and have never been on a retainer or contracted to a single person, but people seem to forget that. I can often be working on an event, such as a premiere or an awards ceremony, where I have several clients appearing on the same bill, and that can lead to problems too.

'Don't make her look better than me,' they might joke. Yet although this kind of attitude makes my life difficult (and has lost me clients) at the end of the day it all stems from insecurities and so I do understand. Besides, at times I admit I've been a bit of a diva myself.

Although I hate turning down jobs, there are a few people I have passed on the opportunity to work with throughout my career, including Jade Goody. So many people have told me what a lovely girl Jade was, it would have been great to have met her. I was approached to do her make-up shortly after she appeared on *Big Brother* when the whole reality television phenomenon was kicking off.

A new generation of weekly magazines that blurred the distinction between celebrity and real-life stories had sprang up in its wake, in which instead of running a photo of one of my clients looking her most beautiful, they'd choose the one where her false eyelash was coming unstuck or her lip gloss was smudged and stick a great big circle around it. At the time I kept myself as far removed from this new generation of reality 'stars' as I could. And yes, I do realise this is a bit rich seeing as how people now recognise me on the street because I appeared on Kate's reality show!

But at the time (and we're talking a good eight years ago now) I feared that if I chose to go down that route it would mean I wouldn't be able to work with my other clients – the actresses, pop stars and TV presenters. It all comes back to that industry snobbery that I mentioned earlier.

* * *

While there is undoubtedly a certain amount of bitchiness and backstabbing that goes on in the celebrity world, the media loves nothing more than pitting famous women against each other and stirring up feuds. A prime example of this is the endless column inches devoted to the supposed spat between Kate and Victoria Beckham. I can honestly say that Kate has not got a problem with Victoria. If anything she really admires her as a great mum and fashion icon. And let's face it – they really are a million miles apart.

When Kate and Pete attended the Oscars while they were based in America filming their *Stateside* series Pete had a chat with Victoria

and when he mentioned her relationship with Kate she just shrugged and said: 'There's nothing we can do about the situation, Pete, it is what it is.' And that pretty much sums up the whole thing.

I found myself at the centre of another celebrity feud (or so the papers portrayed it) when Rachel Hunter took over from Penny Lancaster as the face – and body – of Ultimo lingerie, the brand that became famous after Julia Roberts wore its push-up gel bras for the movie *Erin Brockovich*. It was certainly a controversial move: leggy blonde Penny, who had recently started dating rocker Rod Stewart, was replaced by leggy blonde Rachel, who had recently split from rocker Rod Stewart. No doubt Ultimo's boss Michelle Mone, who I like and respect enormously, knew that her choice of models would generate huge amounts of publicity. But there was no problem between the girls – certainly not from Rachel's side.

I had started working with Rachel in 2001, a year or so after she separated from Rod, and we became very good friends. I had also worked with Penny, who I thought seemed a very sweet girl, although just the once on a shoot with the photographer Clive Arrowsmith. Rod had turned up to the shoot too and we chatted for a while; he was a lovely guy and I remember being very jealous of his incredibly thick head of hair.

Of course, Rachel knew that she was walking into a minefield when she accepted the Ultimo job, but I know for a fact that she didn't take it as some kind of personal vendetta or snub to Penny. That girl hasn't got a bad bone in her body – in the ten years I've known her, I've never heard her say a bitchy word about anybody. She reminds me of my sister, Lynne, in that respect.

Even though she lives in Los Angeles, Rachel is totally unaffected by the business. She will get up in the morning, doesn't bother with make-up, sticks on her flipflops and goes to the shops, without a single thought about the paparazzi. Believe me, that down-to-earth attitude and lack of pretension is pretty rare in this industry. I can

honestly say that Rachel is one of the sweetest people I have ever met.

Once I was booked to do a shoot with her at home in LA and fell ill soon after I'd arrived. It was at the height of the swine flu epidemic and I was convinced that I'd caught it on the plane on the flight over and was going to die. I arrived at her house and felt so terrible I couldn't even get her ready, but instead of throwing a diva strop, Rachel just tucked me up in her spare bedroom and made me cups of tea and Lemsip and listened to me moaning while she did her own make-up, bless her. (I didn't have swine flu, by the way. I woke up the following morning and felt absolutely fine. It had probably just been a bit of jetlag.)

I had been booked to do Rachel's make-up for the Ultimo campaign, which we were shooting at the National Hotel on Miami's South Beach. I remember she was looking in absolutely fantastic shape. Like everybody, Rachel has a tendency to fluctuate a little with her weight, although it's never really bothered her. Part of her appeal is that she's got this really healthy, womanly figure; she certainly isn't one of those models who advocates being skinny. At the time, however, there was all sorts of fuss about the pictures from that campaign being overly airbrushed and yes, perhaps the retouching had been slightly overdone, but even in the flesh Rachel looked amazing.

If the furore over Rachel replacing Penny wasn't bad enough, Rachel wore exactly the same black swimsuit as Penny in the campaign. That was the image that was used in all the publicity material and brochures. It was impossible not to compare the two images to see who looked better – which is exactly what the press did, endlessly. It became this massive media shit-storm that wouldn't blow over. Obviously from Michelle's point of view, however, it was all fabulous PR.

* * *

I've travelled all over the world for work with Rachel, including the Laureus World Sports Awards in Monaco in 2001 where she was presenting an award. When I found out that I would be going on that trip I immediately thought back to the family holiday we went on all those years ago and what a fabulous time we'd had, so I arranged for Lynne to come out with me. And the hotel I booked for us? The Hôtel de Paris, the very place we'd briefly visited for a gawp and a citron pressé on that long-ago family holiday. When the taxi rolled up outside this beautiful building Lynne just burst into tears.

'I told you we'd come back and stay here one day,' I smiled.

I later took my parents back there too to celebrate their wedding anniversary and then on to the Martinez in Cannes. I don't do things by half, do I ...?

I also did Rachel's make-up for a show called *Make Me a Supermodel*, which was a big hit for Channel 5 but a complete nightmare for me. The problem was that the lighting was bloody terrible. When you do TV in America they use every lighting trick in the book to flatter the participants. They light from every angle, use gauze over the camera to soften lines, they'll even build all sorts of secret lighting into a desk if you're sitting being interviewed. Everything is done to make you look as fantastic as possible.

Not so much in this country though, and certainly not on reality shows – which is essentially what *Make Me A Supermodel* was. But this was a show about modelling, beauty and glamour, and the lighting on that show was quite harsh and so unflattering that it did nobody any favours. Rachel was the show's host and needed to look like a supermodel, which of course she was.

Over the years I've had the pleasure of getting many brides ready for their big day, both famous and non-famous. It's a real pleasure being involved in weddings, although I do find it quite stressful because timing is usually such an issue – even more so when a magazine has bought up the wedding pictures.

I had been booked to do the make-up for the Emma Noble and James Major nuptials, which were being covered by *Hello!* magazine. The ceremony was taking place in the House of Commons crypt chapel at the Palace of Westminster, courtesy of James's former-PM father John Major. They had hoped to do the wedding pictures in the grounds of the Houses of Parliament, but there were too many paparazzi around trying to steal a picture so although there was this amazing backdrop of Big Ben, the Thames and all these historic, beautiful buildings just yards away, the photos were done in a gloomy covered courtyard. Cue frantic last-minute scrambling around, wrestling with the lighting and make-up …

Of course, working at weddings is particularly special for me when the bride is a close personal friend such as Ulrika Jonsson, who I made up for her 2008 wedding to Brian Monet. She was heavily pregnant with their son Malcolm at the time and seemed perfectly content with her life and blissfully happy.

I had first met Ulrika in 1998 on a cover shoot for *Loaded* magazine. At the time she was the hottest female presenter on TV and (like Kate) her life was starting to become as famous as her job. Up until this point Ulrika's image had been pretty wholesome, but *Loaded* really wanted to push the boundaries and tie her up in chains, manacles and handcuffs for the cover shot. It was shockingly sexy stuff. Ulrika's agent, the fabulous Melanie Cantor who has since become one of my dearest friends, had words with the photographer over the bondage element, but eventually they reached a compromise: Ulrika would wear the handcuffs but not the manacles – and the resulting pictures caused a real stir.

I admit I was a little bit intimidated by Ulrika at first: she was so cool, witty and quick-tongued, and had a very dry Swedish sense of humour, but after that first shoot I quickly developed a lovely relationship with both her and Melanie and we worked together non-stop. Later that year I got Ulrika ready when she hosted the Eurovision Song Contest alongside Terry Wogan (an ultra-camp

extravaganza which, being a gay man, was a particular treat for me!), made her up for a zillion photoshoots and worked with her on a series called *Men for Sale*, on which Ulrika was thrilled to meet her idol, Michael Bolton.

It was while working with her on another TV series, *Dog Eat Dog*, that she confided in me about her affair with Sven-Goran Eriksson. Ulrika was obviously smitten, spending most of her time in make-up replying to gushing texts from Sven in which he told her how much he idolised her. I know that she was totally convinced that they would ultimately be together and was so upset when it didn't happen.

Nowadays, I'm lucky enough to count Ulrika among my closest friends. She is a real laugh, fantastically generous, a super-talented presenter and a brilliant mother too. One year she invited Phill and me to her house in Sweden to celebrate Midsummer Night. I'll never forget dancing round the maypole next to this idyllic lake where she had her holiday home, then enjoying an al fresco dinner of the local delicacy, eels, that went on till late into the night. Then for her 40th birthday she hired a house in Cornwall and 40 of her friends came down to celebrate. That girl really knows how to throw a party, I can tell you …

Ulrika also has a brilliant sense of humour, which has come in handy after a few embarrassing make-up moments over the years. While working on *Men for Sale* she was pregnant with her daughter Bo, and her already big boobs just ballooned. One day she was wearing a low-cut dress and I dusted her cleavage with shimmer powder, but instead of giving a flattering glow as I'd intended, under the TV lights it just looked like she was sweating profusely. The papers had a field day with those pictures. Another time she was presenting Sports Relief with Gary Lineker and I suggested we try something different with her hair, so I styled it into a mass of tight ringlets. Well, she ended up looking like Bette Davis in *Whatever Happened to Baby Jane*. Hardly her – or my – finest hour!

* * *

Another wonderful wedding memory was when I got Barbara ready to tie the knot with her long-time love Scott Mitchell in 2000 – not that I knew anything about it at the time. I arrived at their house that morning and all Barbara told me was that they had a luncheon to go to.

'Just make me look really beautiful today, Gary,' she said, smiling enigmatically.

Scott asked me to do a bit of grooming for him as well, which was unusual.

Hang on a minute, I thought, *I bet they're getting married.*

And sure enough, later that day I got a call from a very giggly Barbara saying, 'Guess what we've been up to this afternoon!'

They had tied the knot at The Dorchester in a very simple cere-mony with just close family.

The news of their wedding broke in a flurry of headlines the following morning, which just so happened to be the day of Gloria Hunniford's 60th birthday party. She was having a lavish masked ball at the Langham Hotel to celebrate and everyone was going: Dale Winton, Cilla and a whole host of showbiz luvvies. As it was being covered by *OK!*, Scott and Barbara had thought it would be better if they didn't attend as they were worried that news of their surprise wedding would overshadow coverage of the party. But Gloria's husband Stephen said he really wanted them to be there, so that day I got a panicked call from Barbara asking if I could come round and get her ready.

Neither she nor Scott had a mask, so I painted the illusion of elaborate silver masks on to their faces, and then I put a really cropped, funky blonde wig on Barbara, who was wearing a skin-tight leather outfit. Honest to God, she looked about 25 – and, as expected, the newlyweds ended up being on the magazine's front cover.

Once, I was actually given as a wedding present – well, my make-up skills were! – to a couple who were close friends of Sir Elton John. Elton had let them use the chapel at his house in Old Windsor for

the ceremony, so that's where I went to get the bride ready on the morning of the wedding.

Well, I've never seen a place like it. Every surface was crowded with priceless treasures, from exquisite antiques to memorabilia from Elton's many tours around the world. As I worked on the bride's make-up in one of the bedrooms I could hear helicopters arriving and kept sneaking a peek as the gardens filled up with the A-List guests, including Jonathan Ross, Bob Geldof and Chris Tarrant. As the time of the ceremony approached, I could hear the clink of crystal champagne flutes and the gentle hum of polite wedding chitchat when the peace was suddenly shattered by a furious banging on one of the downstairs windows.

'Oi!' *Bang bang bang.* 'Get off the FUCKING GRASS!'

It seems that some of the guests had ignored the clearly marked footpath to the chapel and were taking a shortcut across the immaculately manicured lawns. Now I'm not to say whether the grass-proud man in question was the gardener or whoever, but the look on the guests' faces – well, it was priceless.

* * *

I've witnessed some pretty spectacular weddings in my time (of which more in the next chapter) but one of those that I enjoyed the most was the 2007 marriage of Alex Curran to Steven Gerrard. From the white rose and platinum themed decor to Alex's incredible lace Elie Saab dress it was pure class. Not only that, but it took place at Cliveden, a grand country house hotel in the Berkshire countryside which just so happened to be virtually next door to mine and Phill's old house, Grovefield Lodge.

I have so many wonderful memories of that place. Phill had found Grovefield while we were living in that central London flat with Nell and we bought it as a renovation project. It was a beautiful 150-year-old gatehouse but was virtually derelict, so Phill would film *House Invaders* three days a week and then spend the rest of the

time lovingly restoring the Lodge to its former glory. By the time he had finished it was picture-postcard perfect, boasting unique period features and a secret walled garden.

The only problem was that it was situated right next to a busy main road, which was a constant source of worry because of our two cats, Charlie and Arthur. Sure enough, one day poor Charlie got hit by a car just a few months after Arthur had to be put down following a long illness. It was a really hard time for me, as I loved those cats like they were my children. We buried them in the garden, which is one of the reasons I found it so hard when the time came to leave Grovefield and move onto the next project. It will always be a special place for me, and the memories came flooding back when I went to Cliveden for Alex and Steven's wedding about a year after we'd moved out.

I had worked with Alex a few times before the wedding and she was always a joy to make up. At 5 ft 10 with perfect bone structure and the most amazing eyes she could have easily been a fashion model. She's always been a stunning girl – and I think she's one of those lucky women who'll just keep getting better looking as she gets older. But while Alex is a good little model and obviously knows she photographs well, she is very shy. A lot of the WAGs seem to love the attention and make the most of every opportunity, but while Alex has been thrown into the spotlight because she's with Steven (and is very beautiful) she does like to step out of it as much as possible. She's actually a very private person.

I gave Alex a shimmery, sun-kissed look for the wedding, which worked beautifully with the dress and veil. As *OK!* magazine were covering the wedding, I also did Steven's grooming. When I'm getting a guy ready the process will involve giving them a wet shave, tidying up their brows, doing their hair and applying minimal make-up, such as concealer on blemishes and broken veins, foundation to cover red tones and powdering down any shine; in short, sorting out any imperfections that might be picked up on camera.

Steven is not a fan of make-up, but I think he was happy to have me there to deal with any imperfections. You might be surprised to hear that I have worked with a lot sportsmen, from footballers like David Beckham to racing drivers including Michael Schumacher and Jenson Button to the rugby star Johnny Wilkinson, but everyone – no matter how manly and macho they are – needs a little bit of make-up magic when they're in front of the cameras, whether it be a touch of concealer to cover dark shadows, a tweeze of the eyebrow or even a brush of bronzer to add colour.

In fact, sometimes the men can be even more self-conscious than my female clients, especially when it comes to their hair. Most women are happy to experiment with different styles, but men tend to have their signature look and know exactly where each strand of their hair should go and precisely how much wax to use to achieve it.

I have also worked with a lot of great actors, including Willem Dafoe, Jude Law and Mickey Rourke. Years ago I was in Los Angeles and grabbing something to eat at Jerry's Famous Deli in West Hollywood when I noticed this big guy sitting on his own at a table holding a tiny little dog. He lifted his head and I realised with a rush of excitement that it was Mickey Rourke.

Ten years later, in 2009, I was booked to get him ready for the BAFTAs, where he would go on to win an award for his incredible performance in *The Wrestler*. As soon as he sat down in the make-up chair it was obvious that he'd had some work done, although that was primarily because he'd been a professional boxer during a break from acting rather than for reasons of vanity. But he was completely at ease with his appearance – a very attractive quality in itself – and it was a face that could tell a million amazing stories. I thought he was unbelievably sexy.

We got talking and I mentioned to Mickey that I had seen him with his dog at that diner in Hollywood all those years ago and then suddenly this notorious tough guy, this famous movie hard-man,

welled up in front of me. That little dog, who had recently died, had obviously meant the world to him: as he shared his memories with me it was as if he was talking about his best friend. I can think of few things more attractive than a really tough guy who isn't afraid to show his vulnerable side, and by the end of our session I was his biggest fan.

The reception of Alex and Steven's wedding was great fun, a really brilliant party. There were obviously loads of footballers there, including the Redknapps, Michael Owen (who I thought was absolutely gorgeous) and Harry Kewell and his wife Sherrie Murphy. Harry is such a laugh and unbelievably sexy on the dance floor; that guy really knows how to move. Phill was there with me too and of course he did his usual thing of knocking back the champagne and becoming the life and soul of the party. When I decided to call it a night and went up to our room I left him dancing and chatting away, but the next morning when I woke up – no Phill. I called his mobile and, after a couple of attempts, he finally picked up.

'Phill – where the hell are you?' In the background I could hear the twitter of birdsong and the occasional moo of a cow.

He had obviously just woken up. 'Um, I think I'm in a field some-where near our old house,' Phill said sheepishly. 'I guess I must have had a bit to drink last night and I thought we still lived at Grovefield, so when the party finished I set off cross-country to get back there … and I must have got lost along the way.'

I suppose I should be grateful he didn't find his way to Grovefield; I can only imagine what the current owners would have thought if Phill had turned up there at 3 a.m., demanding to be let in …

Having got to know Alex I thought she would really hit it off with Kate, so I introduced the pair of them at my 38th birthday party at Sin nightclub in London. The theme was Divine Decadence and it was a camp extravaganza with gorgeous half-naked men painted gold, drag queens, contortionists and a Marilyn Monroe impersona-

tor. Alex came down from Liverpool with loads of friends and – as I expected – her and Kate got on brilliantly.

* * *

I've worked with a lot of the WAGs over the years. The first footballer's wedding I did was in 1999 when Phil Neville married Julie Killilea in a beautiful winter-wonderland themed ceremony that ended up being quite an inspiration for my own wedding years later. All the big football stars of the day were there, including Terry Sherringham, Dwight Yorke, Ryan Giggs – and Posh and Becks, who had got married only a few months previously. The dress code was red, white and black, which were Gary's team colours but, as the press reported at the time, Victoria seemed to have ignored the theme and turned up wearing a lacy brown dress.

Fast-forward eight years, and I was booked to do the make-up for Coleen Rooney (then McLoughlin) for her 21st birthday party at a hotel near Liverpool. Coleen was incredibly hot at the time and the press interest in the lead up to the event was unbelievable, so it's no surprise that this was no ordinary 21st bash. The circus-themed party featured a giant marquee transformed into a magical big top, stilt-walkers, acrobats, a 5 ft high birthday cake and an entire fairground outside.

Despite the fame and money, however, Coleen is still a very sweet, down-to-earth girl – not your typical brash, blingy WAG at all. When I do her make-up it's all about soft golds and bronzes, a really natural, dewy look rather than the super-glamorous 'babe' face that so many of the girls want. That night Coleen was wearing a Grecian-style Amanda Wakely gown and looked absolutely gorgeous.

I was lucky enough to bring Phill with me as my guest once again, but while it was a wonderful party it ended very strangely – and actually rather terrifyingly. The party was still in full swing at 2 a.m. when we decided to call it a night and we were directed to a fleet of cars that were waiting to take guests back to their hotels. Phill and I

climbed into one of them and we set off, only for me to remember that I'd left my make-up kit back at the coach house where I'd got Coleen ready. I ran back there to find the door was locked, so I had to go back to the venue and find the key. Meanwhile Phill stayed in the car, but after ten minutes of waiting the driver began to behave rather strangely.

'What's going on?' he demanded. 'You told me to take you back to the hotel and now we're just bloody sitting here.'

'Don't worry, mate, we'll pay you waiting time,' said Phill. 'There's no need to be like that.'

'Are you taking the piss out of me?' he said. And then suddenly he fired up the engine and drove off. 'Right, I'm taking you back to the hotel. I'll come back for the other bloke.'

Phill told him to stop, but he just kept driving – and not in the direction of the hotel, but out into the countryside. As he sped down these narrow country lanes he was ranting at Phill: 'Who do you bloody people think you are, ordering me around? I'll show you.'

He was obviously nothing to do with the official party cars. I'm not sure if he thought Phill was a footballer and planned to kidnap him, but Phill was seriously freaked out and called me on his mobile.

'Gary, this guy just drove off with me in the car and he refuses to stop,' he whispered. 'I think he's a nutter.'

Well, you can imagine – I was hysterical. I was convinced Phill had been abducted and called the police. Eventually Phill talked the guy into driving him back to the party venue, where security jumped on him and bundled him off.

We were so shaken up that we didn't want to stay in the hotel that night; instead we paid for another taxi to take us on the four-hour drive back to London.

FOURTEEN

Two Weddings, One Bride,
Three Grooms and a Dog

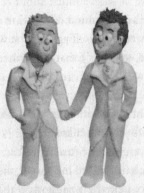

I walked through the winter wonderland with Phill towards an arbour canopied with white roses and silver butterflies, around which stood four semi-naked angels with feathery wings and seriously ripped six-packs. A dozen beautiful princesses clad in long, white gowns stood before us, a shimmering vision of silver sequins, satin and lip-gloss.

As Peter Andre and a gospel choir broke into heavenly song, snow started to fall softly on our upturned faces and everyone around us, all the people we loved most in the world, began to cheer. Was I asleep – was this all some incredible dream …? I had the biggest smile on my face and as Phill and I passed Ulrika she did a double-take and mouthed at me, 'Gary – your teeth!'

Great, I thought happily. Looks like all that money spent on pre-wedding dental work was worth it …

* * *

21 December 2005. It was a special day for many reasons – not just because it was the day that after 13 years together Phill and I finally got married, but because it was the first day that gay couples were legally able to do so in this country. We wanted to make our wedding as big and fabulous as possible to get that message out there: 'Look, at last we can do this!' It was as much about celebrating this landmark day in history as it was about celebrating our relationship.

But I'm getting ahead of myself again. First we need to go back a few months to the September of that year, when there was another wedding, one that was even more over-the-top than mine and Phill's.

When I think about Katie and Peter's wedding day the first thing that comes to mind is … pink blancmange. From that enormous pink dress to the pink pumpkin horsedrawn carriage and the billowing pink marquee with its bright pink carpet, the whole thing is just a haze of Swarovski-studded pinkness. And the second thing that stays with me is a memory of Kate, her tiny frame crushed beneath the weight of all that pink tulle, the colossal hairpieces and huge crown, turning to me and saying sadly: 'This was supposed to be one of the happiest days of my life, Gary, but I'm not enjoying myself at all.'

Regardless of what happened between them later, when Kate and Pete got engaged they were totally and utterly head-over-heels in love. Seriously, they couldn't keep their hands off each other. You could almost see the sparks of electricity flying between them. Their fairytale romance was the tabloid story of the year, perhaps even the decade, and the public were expecting a wedding that lived up to that hype – which in the end of course is what they got. But everyone was trying too hard to create this magical fairytale, so much effort went into planning the perfect wedding.

The day before the day before they got married, Kate and Pete came to stay with us. The wedding was taking place at Highclere Castle in Berkshire, which was just down the road from where Phill

and I were living at the time. That evening we took them out to dinner to our local tandoori restaurant, Malik's, in Cookham, which is famous not only for its incredible food, but for its star-studded clientele. We've taken Kelly and Billy, Barbara and Scott, Ulrika lives round the corner – I think even Angelina and Brad have been spotted in there.

Kate loves it and that night ordered the same thing she always does when we go there: onion bhajee, naan, rice and a chicken korma with extra cream. Peter Jones from Dragon's Den was at one of the neighbouring tables and he sent over several bottles of Dom Perignon to congratulate the nearly-weds, later joining our party for a drink. We were all really excited; it was a fabulous night.

The wedding was being covered by *OK!* magazine, who were devoting an unprecedented two bumper issues of coverage to it, so it was agreed that we would shoot some of the wedding photos the day before the actual wedding. Kate had to put on her dress and veil with her hair and make-up exactly as it would be the following day and so in that respect it took away a bit of the magic of her wedding day itself – although thankfully they left the photographs of her and Pete together until the actual day, so at least he didn't see the dress until she walked down the aisle.

On the morning of the wedding I turned up at Highclere Castle, fought my way through security (it was like trying to get into Fort Knox, what with the armies of guards and helicopters flying overhead all day) and found my way to Kate's suite where she had spent the night with some of her bridesmaids. I remember Kate being really calm, almost weirdly so. There was no sense of excitement, of spontaneity. Even before the ceremony we were doing some photos of Kate with her family – but then of course they were getting paid an awful lot of money and expectations were sky-high. It was only when I started her make-up and Kate put on the CD of the song 'A Whole New World' that she had just recorded as a duet with Pete that she suddenly became alive and began to get excited.

If I'm honest, I didn't particularly like the dress. Pink isn't my favourite colour and there was just so bloody much of it! All that tulle, all those layers of underskirts, the 25-ft-long crystal-studded train – it was completely over the top. Kate wanted her make-up to suit the sugary tones of her dress, so I used pinky purple shadows around her eyes, a few sets of false lashes and some soft pink lip gloss – nothing overly dramatic. But the hair – well, that was another matter.

Kate didn't have any extensions in at the time and her natural hair was only shoulder-length, so that enormous mane of tumbling curls was all courtesy of hairpieces. Kate loves a really catlike, feline look so she tends to scrape her hair back into an eyewateringly tight ponytail to give herself an instant face-lift, fixing hairpieces over the top. She always insists on doing this herself, but on this particular day she pulled it far too tight and by the time the hair stylist, Nick Malenko, had attached all the pieces and that enormous tiara she couldn't get at her own hair to loosen it off. The pain was so bad it was bothering her all day – I think her scalp even started bleeding. But even without that added discomfort, the weight of all those pieces and the crown was just colossal. I tried them myself and was like, 'Kate, how can you keep your head up with all this on top?' Combined with the weight of the dress, the whole thing just drowned her.

Just as I've seen Kate look better, I definitely don't think Pete looked his most handsome that day. Like me, he has always fluctuated a bit with his weight (after all, he does cook the most amazing pasta with tomato and cheese) and he was quite a bit heavier at that time – although obviously he looks fantastic now. But isn't that always the way? Sometimes it takes some grief, trauma or change to reassess your life.

As for Phill and me, the photos of us with Kate on that day look like Cinderella with the Ugly Sisters. Kate had wanted us to wear baby pink and baby blue, but we just couldn't find suits in the right

shade so we decided to get them made for us instead. We had met a tailor when we had gone to Thailand with Jennifer Ellison – and if anyone could help us knock up a couple of pastel silk suits it was sure to be a smiley little Thai gentleman called Mr Lucky! So we sent him our measurements, told him the sort of thing we wanted and kept our fingers crossed.

Well, the colour might have been spot-on, but they were absolutely terrible. They didn't fit properly and looked utterly naff, although the rest of the day was so camp that I think we got away with it. I wouldn't be seen dead in that suit now though.

The day itself was such a huge, extravagant production that most of the time it felt like I was working on a movie rather than celebrating two people's love for each other. Looking back, the whole day is a blur: people getting restless because we were falling behind schedule; Kate getting upset because some of her family were put at the wrong tables; hassles over the endless posing for photos.

It had been such an eagerly anticipated event in the media that it felt like the world's eyes were on Kate – and although she kept telling me to relax and have a drink I wanted to be on hand the whole time to ensure she looked her best. She was exhausted and in agony – and had been struggling with postnatal depression since Junior's birth a few months earlier. I think she had no more than two drinks the whole day. It was such a shame that the wedding turned out the way it did, but it wasn't anyone's fault.

The only moment that captured the true meaning of the day was when Kate and Pete were standing up in front of everyone saying their wedding vows. When the pair of them looked into each other's eyes and pledged to be together forever, that was when you remembered that here were two people who were desperately, crazily in love. And even though the marriage wasn't to last, they truly believed it would, and that look between them was completely genuine.

* * *

194

Kate and Pete were going to be filming their reality show on their honeymoon in the Maldives, so – as well as their management and a film crew – I tagged along. I felt like Kenneth Williams, who ended up going on honeymoon with Barbara Windsor and her first husband Ronnie Knight, except while Williams took his mum as his holiday companion, I took Phill.

For their honeymoon, Kate and Pete had chosen to return to the place where they had celebrated their engagement – the Hilton resort on an island called Rangali. The pair of them had fallen in love with the place on that first visit and it became their favourite haunt. Not only did it guarantee a total escape from the outside world, with no TV or newspapers, it was the most beautiful place I have ever stayed in. I've travelled widely for my job, but I've never seen water that blue or tropical fish so beautiful. It was a total paradise.

I was also lucky enough to join them on that first visit as they were doing a few magazine shoots to celebrate their engagement, as well as more filming for the reality show. It was a magical trip – even though Kate had burnt herself so badly while sunbathing that the pictures in *OK!* had to be extensively retouched to disguise the fact that her skin was coming off in sheets.

At this point I have to be really humble and acknowledge that, if it wasn't for my job and certain people I have worked with, there is no way I'd be able to experience these incredible places. I certainly wouldn't have been able to afford six-star holidays in the Maldives myself. But then Claire, Kate and Pete's manager, was really good like that, making sure that Phill and I were taken care of. It's such a shame the way things have turned out between all of us, because there were a lot of good times – and we all had a blast together in the Maldives.

Phill and I had been going through a bit of a rough patch before that trip and we rediscovered ourselves during those two weeks in the Maldives. We returned to that blissful honeymoon period when

you can't keep your hands off each other, and we had the best sex of our lives! We were staying in these gorgeous villas that stood in the ocean on stilts and were completely private – or at least I'd thought they were. One day I walked out onto our deck totally naked and I must have been standing out there for five minutes doing God knows what before I noticed two of the girls from the crew watching me from the neighbouring villa. They didn't stop teasing me about my willy for the rest of the trip …

After our Californian road trip disaster Phill and I had put the idea of getting married to the back of our minds. It wasn't legal in Britain after all, and it didn't look like it would be any time soon. When the change in the law enabling civil partnerships was finally agreed, Phill and I talked a bit about maybe planning a summer wedding for the following year, but we didn't make any firm plans. We agreed to start saving up a bit of money and think about it again in a few months' time. But then at the end of October 2005 I was working on a shoot with *OK!* when the conversation turned to weddings – and more specifically to mine and Phill's. The writer from the magazine, Emma, suddenly said, 'My God, Gary, wouldn't it be amazing if you married Phill on the first day that gay weddings were legal in this country! We'd love to cover that in the magazine.'

Yes, it would be absolutely amazing, I agreed with her, really special, but the thing was that the day the legislation was to become statute was only six weeks away, and there was absolutely no way we could organise a wedding in that time. It would be impossible. Wouldn't it …?

That evening I went home to Phill and said, 'You know we talked about getting married next year? Well, how about doing it in six weeks' time instead?'

Phill just laughed. 'Don't be ridiculous, babe. It's not enough time and besides, that's just before Christmas.'

Suddenly a song popped into my head: 'Walking in a Winter Wonderland'. And then I remembered Phil and Julie Neville's

incredible winter-themed wedding. True, we had always imagined getting married in the summer, but if we had it in December we could have real snow, an enchanted forest of crystal-encrusted trees, a snow-topped castle-shaped cake, maybe even a real-life fairy on top of the Christmas tree …

I smiled at Phill. 'Let's do it.'

And then of course we found out that Elton John was going to be marrying David Furnish on the same day, which was enough of an incentive to start dreaming up the most lavish, over-the-top winter wonderland-themed extravaganza we could possibly imagine.

* * *

If I do say so myself, Phill and I do throw brilliant parties. People are always telling us we should be professional event planners. Even a simple summer BBQ in our garden can turn into a major event with everyone pissed on cocktails and Ulrika doing karaoke with the guys from Steps. The secret to a fabulous party? Well, apart from the obvious – a great venue, a good mix of people, lots of booze and food – I think it's the entertainment that makes a real difference. It's really important to have a whole variety of things to keep people interested. So we'll have singers, contortionists, dancers, impression-ists – and sometimes a male stripper or two. Willy the Kid has been to our house on several occasions! The bottom line is: the camper the better.

One of our most memorable parties was for my 30th, when we took over the Hempel Hotel in London. All my family came down from Yorkshire, but I was also working with lots of TV personalities at the time and many of my clients were there too: Denise Van Outen, Martine McCutcheon, Melinda, Kate with then boyfriend Dane Bowers, Jane Middlemiss, the *EastEnders* and Corrie girls, Caprice, Nell, Emma Noble (who'd just got married to James Major and caused a major stir) … The list was endless. There must have been about a hundred paparazzi gathered outside the hotel that

night. It was an amazing party – although the wine was flowing slightly too freely and everyone ended up extremely pissed. I remember being in the middle of the dance floor and my friend Jane being sick in her handbag.

Of course, it helps that we've been to some pretty amazing parties thrown by other people as well. Over the years I've been particularly inspired by Jacqueline Gold, the boss of Ann Summers, who is a personal client of mine and one of the loveliest people that it has been my pleasure to meet. She always throws fantastic themed parties in the grounds of her house. Also our friends Nick Malenko and Royston Blythe, a hairdressing couple who have a salon at the Dorchester and are the campest men you'll ever meet. They have an incredibly theatrical house in Wolverhampton and are of the firm belief that no party is complete without some gorgeous semi-naked men handing round some nibbles.

* * *

Looking back, it was a ridiculous thing to do. The madness of organising a wedding in six weeks consumed our lives and turned us both (well, me in particular if I'm honest) into monsters. Phill and I spent the whole time bickering – in fact it got so bad that I'm surprised we're even married! We had signed an exclusive deal for the wedding photos with OK magazine and called in a lot of favours from friends and contacts; nevertheless costs were spiralling out of control.

If you're starting at 100 quid per head for food alone then it quickly mounts up. The biggest challenge, however, was trying to find a suitable venue that not only still had availability so close to Christmas, but was able to cope with the strict security controls we needed to be in place to protect the deal with *OK!*. The Ritz and the Dorchester were all booked up, Claridges was too small, the Savoy was big enough and still had availability, but they couldn't guarantee security. Thankfully the Grosvenor House Hotel on Park Lane met

all our criteria and we booked the grand ballroom, thrilled to have secured such an amazing space.

One thing that wasn't hard to find, however, was bridesmaids. When word got round that Phill and I were getting married the phone didn't stop ringing with friends offering their services. Kate was always going to be chief bridesmaid along with my sister, Lynne, I wanted Barbara to be matron of honour; to represent all my fabulous cousins I chose Julie, and then, of course, there were all those clients who had become close friends such as Melinda Messenger, Emma Noble, Emma B, Francine Lewis …

I called up my stylist friend Bernard Connolly, who I knew would be the only man who could pull this off.

'Bernard, I need some help with the bridesmaid dresses.'

'No problem,' he said. 'How many will there be?'

A long pause. 'Fifteen,' I said. An even longer pause. 'At the very least.'

* * *

Not only did we end up dressing the bridesmaids (we opted for all-white bridal gowns courtesy of Anoushka G, each one custom-made from silk taffeta and duchesse satin) but I dressed everyone else in the wedding party as well: the 11 groomsmen, our parents, the two page boys (my fabulous nephews George and Jason), the three best men (my friends Ricky, Ben and Stan) and two best women (Phill's best friends Jane and Louise) – the whole huge, crazy entourage. No wonder the bill went through the roof!

All the men wore white three-piece suits and the women wore incredibly glamorous full-length gowns. Our nieces Demi, Georgina, Victoria and Bella, wore diamante-covered princess dresses complete with fairy wings embroidered with butterflies, sparkly ballet slippers and little tiaras. As matron of honour, Barbara wore a champagne duchesse satin dress coat with a feathered hat and matching accessories. Everyone looked amazing; on the day there was so much

hand-beaded chiffon and diamante embellishment in the room that you could have been at the Oscars.

Obviously, I wanted to look my best as well, so I had a full set of veneers put on my teeth in the run up to the wedding. I was in agony for days, but it all worked out brilliantly in the end as not only did I have a blindingly white smile, I also lost about a stone in weight because I was in too much pain to eat properly! As for our suits, we had them tailor-made in a matching shade of vanilla; mine was velvet and Phill's was satin, and they both had Swarovski crystal buttons. We wore Dolce e Gabbana ivory patent shoes, and to top it all off I borrowed a stunning diamond crucifix from Boodles and Phill had a diamond tie-pin.

We invited 150 guests for the wedding and another 150 for the after-party. Although it might have looked like it was a big celebrity wedding, we only invited people who were important to us. It certainly wasn't rent-a-crowd! It was huge amounts of work trying to get the invitations out in time. At one stage we were spending every night at our best man Ben's house who had put all the names and addresses into a massive spreadsheet. Without him, there would have been no wedding. We'd make it home in the early hours of the morning and fall into bed, stressing that we might have forgotten to invite someone.

One day a few weeks before the wedding we were having a chat with Nick and Royston (those fabulous hairdressing friends of ours who threw the inspirational parties) when we came up with the idea of the angels. Naturally we had wanted to find a way to work some semi-naked men into the proceedings – although it needed to be tastefully done; after all this was a wedding and there were going to be children present – and this vision of a quartet of gorgeous guys in beautifully tailored white trousers and four-foot-long angel wings fitted perfectly with the Christmas theme.

Later that week Phill and I had gone into Butler & Wilson to buy the bridesmaids' presents, which were beautiful little jewelled bags,

when I spotted the security man on the door. We'd seen him in there before and knew he worked part-time as an actor and model.

I nudged Phill: 'Look at him! He'd be perfect as one of our angels.'

So we went up to talk to him. 'Excuse me, mate, we're getting married in a couple of weeks – it's going to be one of the first gay weddings – and we're looking for some gorgeous half-naked men to take part in the ceremony. Oh, and you'll have to wear this big feathery pair of angel wings …'

I wasn't sure whether he would chase us out of the shop or get straight on the phone to the police, but eventually he just started laughing.

'Are you blokes for real?' he grinned. 'Sounds like a great idea, I'll be up for it. Do you want me to ask my mate too? He's a fireman.'

So we arranged to meet this other guy the following Sunday, which just so happened to be the day after our stag party. We had a mad night out in Soho with a group of our closest gay friends going to all our favourite haunts, including Shadow Lounge, Feedom and Heaven, and then the next day, feeling the very worse for wear, we turned up at Starbucks on South Molton Street to meet the fireman. We had obviously wanted Nick and Royston to come on our angel hunt too, so this poor guy was faced with a whole gang of us. To his credit he seemed totally unfazed, even when Nick told him we'd need to see his body and we all trooped into the toilet to check out his (admittedly very fit) chest while a queue of customers built up outside. God knows what they must have thought when the lot of us piled out.

So we had two of our angels, but we still needed another two, and then through the haze of our hangovers someone came up with the bright idea of trawling round all the gyms in Soho and we spent the rest of that afternoon marching into changing rooms where Royston would go up to all the fit men and go, ''Ere, you've got a good body, do you want to be an angel at their gay wedding?'

Looking back it's a miracle we didn't get punched, but by the end of the day we had dozens of phone numbers. We had planned to call them all up and hold an open audition, but in the end we ran out of time. It was Nick and Royston who came to our rescue (again).

'What about Stallion?' they said.

This guy had been a stripper at one of our birthday parties a couple of years ago and had been memorable for his incredible body – and, of course, for the 12-inch reason behind his nickname. So we called up Stallion and he said yes, he'd be more than happy to help out, and offered to bring a friend of his along too. The angels had landed.

The night before the wedding we stayed at the Grosvenor House Hotel, which had given us the entire seventh floor for the wedding party. Phill and I had the most luxurious suite, overlooking Hyde Park and complete with an enormous four-poster bed. Me being such a control freak, all evening I kept sneaking downstairs to try and catch a glimpse of the preparations, only for our wedding planners – Yvonne and Julie from Revellers World Events, who had also done the Neville wedding – to repeatedly order me back upstairs again, telling me to stop interfering. Nevertheless, I caught tantalising little glimpses of what was going on, including the beautiful fairytale-castle wedding cake, half fruit-cake half chocolate, on top of which were little figures of me and Phill that were perfect replicas right down to my diamond crucifix.

That evening we had to do the interview with Emma from *OK!* (which was all very bizarre, chatting about something that hadn't even happened yet) and then we went out for dinner with Kate and Pete who were staying in the room next door to ours. Pete had been downstairs to do a sound-check in the ballroom, as he was going to sing the Stevie Wonder number 'Love's in Need of Love' with the London Gospel choir while we walked down the aisle, and he was stunned by the scale of the event, which in turn started to make Kate feel nervous.

Meanwhile Phill and I were getting increasingly stressed out because neither our rings – platinum bands with white and blue diamonds – nor our wedding suits had turned up by the time we left for dinner. They eventually arrived at 11 p.m., but not before I had thrown a complete hissy fit and told Phill we'd just have to call the whole thing off. We eventually got to bed at 2 a.m., over-tired and over-excited, only for our alarm to go off just four hours later at 6 a.m. ready for us to start getting ourselves and everyone else ready.

I didn't want to worry about working on my wedding day and so we hired eight make-up artists and eight hairdressers to prepare the wedding party. There were 15 bridesmaids, the fairy flower girls, our mums, the angels, the best women, our dog Dolly – it was a complete conveyor belt. By the time everyone was dressed, styled and groomed we were already running late, and then, as we had to move our whole crazy entourage from the seventh floor to the ballroom without any of the other hotel guests seeing us, we had to take the service lift (which could only carry six people at a time) and find our way through a maze of back corridors and through the kitchens to where the ceremony was taking place. I remember all the chefs staring open-mouthed as these topless guys with fairy wings, various celebrities in wedding dresses, two bridegrooms and Dolly Parton hurried through the kitchen.

The problem was that if we didn't start the ceremony by a certain time the registrar would have to leave because there were so many gay weddings scheduled for that day – and by now we were running seriously behind schedule. Our guests were already ensconced in an antechamber next to the ballroom, drinking champagne and being entertained by a string quartet, blissfully unaware of the drama taking place elsewhere in the hotel. We still had to do some of the photos for *OK!* and we hadn't yet had a chance to do a rehearsal, so nobody had a clue what they were supposed to be doing when it came to the ceremony.

And then, bless her, Barbara came to the rescue. I had noticed she had been stressed that we were running so late and she suddenly took control.

'Right, everyone, move over there!' she shouted. 'Gary and Phill, you need to be standing here. And you – open those doors now!'

If Barbara hadn't stepped in we would probably have taken another half hour and the registrar would have had to leave and we wouldn't have been able to get married.

I gasped when I saw the ballroom. It was like stepping through that magical wardrobe into Narnia. It had been transformed into a magical forest complete with real trees, amongst which all our guests were now sitting. Everything was themed to suit the winter wonderland theme with white feathers, butterflies and diamante sparkles. It was utterly perfect. After the photos we quickly went round the bridesmaids and explained what we wanted them to do, and we were all about to make our grand entrance when someone said: 'Where the hell are the angels?' We finally found them waiting outside and shoved them in the right direction, arriving to much wolf-whistling and cheering from our guests.

There were opposite staircases leading down to the aisle and the bridesmaids started walking down, two at a time, with my sister and Kate leading, while Pete sang absolutely brilliantly and a snow machine churned out a gentle blizzard. After the bridesmaids came the flower girls and page-boys together with Dolly, who looked gorgeous in a crystal collar with a white feathered lead.

Then Phill and I walked to the front of the room to exchange our vows underneath the white rose-covered arbour. When I took Phill's hands he was shaking with nerves and I could feel he had a balled-up bit of tissue in his hand, as he always cries at emotional occasions. Well, for some reason that bloody tissue kept distracting me throughout the ceremony. I was going to mutter to him, 'Phill, throw it on the floor!' but everyone would have noticed.

By the end, though, we were both in tears – as were all the guests – and when we had our first kiss as married men everyone cheered. It felt like we were making history. We – and Elton John and David Furnish and many others that day – *were* actually making history.

* * *

As anyone who's ever organised a wedding will know, one of the hardest things to get right is the seating plan for the reception. I had spent hours trying to make it work, but when you've got so many guests it's virtually impossible to keep everyone happy. Sure enough, a certain celebrity who shall remain nameless decided to swap tables, upsetting another celebrity in the process.

Then there was the issue of Rachel Hunter's sister Jackie. She's a lovely girl and we were thrilled when Rachel said she'd be bringing her as her guest, but the thing was that Jackie once had a relationship with Pete. It was years ago, when he'd been living in Los Angeles, but we knew all too well how jealous Kate could be. In the end we just sat them at opposite tables and (as far as I know!) there was no problem; I do know that Kate wasn't happy about having her there though, but she would never have wanted to spoil our big day.

The food was amazing: a leek and gruyere tartlet to start, followed by a turkey, stuffing and all the trimmings and a chocolate brandy basket with Christmas pudding ice cream for dessert. The only slight downer was that Phill and I never got to try our wedding cake. We did the ceremonial cutting, then I know they must have brought a few slices out because some people told us they'd had some, but after that it vanished without trace. The next morning someone at the hotel told us it had been locked away for safekeeping, but they later admitted that they had lost it. The funny thing is, exactly the same thing happened at Kate and Pete's wedding: the cake just disappeared.

As soon as the ceremony was over the entertainment started – and it didn't stop for the rest of the night. We had opera singers,

tiller girls, hotpant-clad male pole-dancers and a Judy Garland impersonator who sang 'Have Yourself A Very Merry Christmas' for our first dance.

It was a truly wonderful party. Denise Welch and her husband Tim Healy had to leave halfway through to go to Elton and David's wedding, got stuck for three hours in traffic on the way and later sent us a text saying: 'We should have stayed at yours, love!' Talking about *Loose Women*, I also saw a certain newly single star (and one of my favourite ladies) dancing with the Stallion – and later spotted them leave together! It was a blast, although there was a very uncomfortable moment when one of the guests, who was extremely drunk, went up to Pete and slurred, 'Why don't I take you upstairs and show you exactly what a real woman is like in bed?' Kate was standing right next to him; to their credit she and Pete just laughed it off.

My wedding night, however, is not such a happy memory; in fact I'm still pissed off about it today. After the reception we decamped to the hotel bar, but by 2 a.m. I was ready to go back to the suite with Phill. I wanted to make love to my husband, because that's just what you do on your wedding night. Anyway, I got back to the room and Phill turned up with two of his friends from his *House Invader* days, John and Jean, armed with a bottle of champagne. I joined them for a drink, but was dropping pretty heavy hints about wanting to be alone with my husband. I didn't think I could have made it more obvious, but they were completely oblivious because once the champagne was finished one of them whipped out a bottle of vodka and the three of them started to do shots. In the end they stayed until 6 a.m. when Phill and I finally collapsed into bed by ourselves. I was furious, but my darling husband was so drunk he didn't even realise. He was absolutely comatose.

The next morning we were due at the *OK!* office to choose the photos and approve the copy as they only had two days to get the magazine on the newsstand, but when the alarm went off at 8 a.m.

Phill couldn't even move, so I had to go on my own. God, I was so angry! Thankfully we made up for it a few weeks later on our honeymoon in New York (although Phill went mad when I spent ten grand of the money I'd saved towards my tax bill on clothes).

In the end, that issue of *OK!* was one of the biggest-selling of the year. Phill and I were so proud, because we both knew how difficult it was growing up gay and closeted and we felt that anything we could do to inspire people and give them the confidence to come out – well, it had all been worth it.

Heartbreak

We had been living back in London for a year after selling Grovefield Lodge when Phill came home one day bursting with excitement about a potential property development project. While I was busier than ever, since *House Invaders* had finished Phill's TV career had gone quiet. He was being offered lots of reality shows but nothing of interest, so instead he had switched his focus to property development full-time. He had a real flair for it, the market was strong and for shrewd developers the opportunity for profit was huge.

This new project he had found was in Beaconsfield, Buckinghamshire. I loved the area – it was close to London, yet still beautifully green and dotted with pretty picture-postcard villages – but when he showed me a picture of the house I just laughed.

'No way,' I said.

'Please, just come and look at it,' begged Phill. 'I promise you I can make it look fabulous.'

The house, Mersing, was on a quiet private lane, set back from the road amid a tangle of overgrown gardens. It had three small

bedrooms, a kitchen that hadn't been touched since the 1940s, an outside toilet and an old air-raid shelter. As soon as I walked in the door I felt … weird. Although it had been vacant for a while, it smelt as if people were still living there. There were clothes laid out on the bed, a newspaper left open on the sofa. The kitchen table was neatly set for one, as if someone had just popped out and would be back at any moment.

The house unsettled me, but I was so busy with my clients at that time and Phill was so excited about its potential that in the end I agreed we should go for it.

Over the next year Phill worked tirelessly on Mersing. He knocked down nearly all of the old building, but kept two of the original walls because of an unusual round window that made a really lovely feature. As Phill worked the plans became more and more ambitious: he decided to add another floor, then another two bathrooms, a double-garage, electric gates. We ran out of money and had to borrow some from friends, but at that stage it didn't seem like a problem – after all, we were going to make so much money when we sold it. We bought for £490,000 and intended to put it on the market for £1.5 million.

By late 2007 Mersing was finished. It was spectacular, a palatial three floor, seven-bedroom, six-bathroom mansion. It was obviously far too big for just the two of us, Dolly Parton and Scarlett O'Hara, but the idea was to live there for six months and then sell it on for a whopping profit. But then – disaster! Practically the day after we moved in the newspapers were filled with stories about the credit crunch. Financial institutions started collapsing. Overnight, the property market seemed to crash. The last thing anyone wanted to do was spend money on buying houses. We couldn't sell. We couldn't pay anyone back. We were stuck.

For the first time in his life, Phill felt lost. He had always been so in control, so direct, but suddenly his confidence faltered. Selling that house was meant to be his wage. What was he going to do

now? The pressure was suddenly on me to earn more money. For the first time in years, I had to start thinking about my spending habits and put a stop to the ludicrous shopping sprees. It forced me to grow up very quickly. Phill and I were arguing every single day. I feel terrible about it now, but I blamed him for the whole disaster.

'Why did you put that extra floor on? Why did you let the costs get so out of control? We're in such a mess, Phill – *what the hell are we going to do?*'

The stress was destroying our relationship. I remember one day just crying my eyes out to him, telling him I couldn't cope any more and that I was leaving. We hit an absolute low.

Our hopes were briefly raised when Ulrika's parents agreed to buy Mersing but they backed out at the last moment, and then exactly the same thing happened with another buyer. The more we wanted to get away from that house, the more it seemed to want to keep us there …

From day one something wasn't right at Mersing. There were the strange noises for starters. Okay, so it was a new-build house and there were bound to be the odd creaks and murmurs, but these were unexplained loud crashes and thuds. The dogs started behaving strangely, all of a sudden going berserk and dashing upstairs to the top floor, barking furiously at that old round window. We would leave doors open and come back to find them locked and bolted. Keys went missing. On several occasions Phill woke up feeling stiflingly hot, as if something was wrapped around his chest. Honest to God, it was bizarre.

My sister Lynne had always enjoyed staying with me and Phill, usually coming down from Armthorpe by herself every couple of months to get a bit of a break from her two teenage sons and running the business. It was really special for us to spend time together and gave her a rare chance to chill out. But after her first two visits to Mersing she always found an excuse not to come; either that or she'd

stay in a nearby hotel. And it wasn't until after we had sold the house that Lynne told me why.

On her first visit I had put Lynne in the nicest guest bedroom, which was the one that was made up of part of the old house. In the middle of the night she woke up in a sweat, feeling weirdly hot, and opened her eyes to see a little old lady at the end of the bed, just staring at her. But although it was a horrible shock, she doesn't remember feeling threatened and the next morning she convinced herself that she had imagined it.

On her next visit I remember her asking if she could sleep in one of the other bedrooms, but I was adamant she should stay in the best room, and once again she woke in the night – this time to see the old woman walking around the bed. Badly shaken, Lynne got up and spent the rest of the night on the sofa downstairs and next morning made up some story about falling asleep watching TV. She didn't want to tell us what she had seen because she knew how much stress we were already under about the house, but she told her husband Simon and my parents – which explained why they never wanted to come to stay either.

But although all these strange and unexplained things went on, I never felt scared in that house. We later found out that an elderly woman, who lived on her own, had died at Mersing. Now I'm not blaming a ghost for our problems with that place, but it was almost as if that little old lady didn't want us to leave.

* * *

I was hugely lucky to be involved in Pete and Kate's lives for five years. It gave me the chance to see some fabulous places and enjoy so many incredible experiences. But what started out as a fairytale gradually started to lose its sparkle.

By this time, Katie Price was the most famous woman in Britain. Everything she touched turned to Swarovski crystal-covered gold. She had brought out her books, perfume, jewellery line, bedding

range – it seemed that people couldn't get enough of her. Every publication in the land wanted to speak to her – and not just the tabloids. The world was her oyster. Meanwhile Pete was busy working on his music, but Kate was so big and whatever she did was so successful that no matter how talented Pete was he was always going to be stuck in her shadow. It was like Madonna and Guy Ritchie. And I really felt for Pete about that.

But while Kate's career was hotter than ever, she wasn't getting fulfilment from her downtime. If Kate wanted to go to a club or dinner – or even just hang out with Phill and me – there was always so much effort and planning involved. Would Pete want to go there? Would there be enough security? Even though Pete can be just as much of an exhibitionist as Kate, there is a very introverted side to him. He didn't like clubs because crowds made him panicky. He didn't drink much, so having dinner out at a restaurant was never that relaxing. Most of his close friends were in Cyprus and Australia and so he wasn't really comfortable about venturing out of the security of our circle. Occasionally we might go to Movida for a couple of drinks, but you could hardly call it a mad night out. We were so aware of camera phones and of people selling stories.

The problem was that I don't think the press ever quite believed the whole Katie and Peter fairytale. We were all too aware that they were gunning for that one night when Kate went out without Pete and got drunk, so it was made very clear to her that this wasn't ever going to happen – and on the rare occasions it did, she got a firm slap on the wrist. It's really not healthy to constantly curb your appetite for fun and so every few months Phill and I would sneak Kate out for a night at a gay bar in Brighton or London. We could have some drinks and a dance and a laugh and no one would bother her or tip off the press. She knew 'the gays' would protect her – and believe me, they always did!

Kate increasingly wanted to do her own thing and rediscovered her first great love, horseriding. It became her release, her way to

relax. In fact I sometimes think it is horses that are the great love of her life. She befriended Andrew Gould, who became her trainer, and was soon going to the stables most days.

Meanwhile in public, cracks were beginning to appear. Leaks were starting to get outside the camp. Every week there were fresh rumours of Price–Andre marital problems splashed across the magazines and tabloids. There were paparazzi outside their gate 24/7. I knew how important it was for Kate to be in a stable relationship, and she still loved Pete. But at the same time Kate told me that she felt she was no longer in control of her life. Over that last year of their relationship, her confidence just vanished; I saw this strong, confident woman crumble before my eyes. Kate started riding more regularly, spending more time with her equestrian friends, and I hoped this would help.

In early 2009 Kate and Pete decamped to California for three months to film *Katie and Peter: Stateside*, the sixth series of their reality show. I would go out there for a week or so to get Kate ready for a magazine shoot or TV appearance, then come back to Britain for a while before flying back out again. They were staying at a sprawling villa in the furthest reaches of Malibu from Los Angeles and one of my abiding memories of that time is the interminable 90-minute drives to and from the airport.

On one of my trips to LA during this period I accompanied Kate on a trip to a hair salon in Malibu. We had gone to Nobu for dinner one night and had spotted this place, which was just a few doors down from the restaurant. Although I would usually do her hair if I was there, Kate didn't want me to have to work as I had just got off the plane (she's always been really considerate like that) but I went along with her so we could have a chat and catch up.

The salon was extremely basic, one of those little family-run, four-seater places that was about as far from your average glitzy Hollywood hair palace as you can possibly imagine. Kate and I were flicking through magazines and having a cup of tea and a

gossip when suddenly the door flew open and this woman bustled in. She was wearing huge sunglasses, a hat and a raincoat, and was carrying a dripping wet umbrella; the weather was awful during that trip to LA, but then it always seems to rain whenever Kate goes abroad!

The staff immediately wheeled out a rickety screen and positioned it in front of the basins and the woman went behind it to get her hair washed, but it was such a small room that you couldn't help but overhear snatches of the conversation above the sound of the running water.

'So I gotta get ready for the Oscars,' she was saying. 'You can tint my lashes, do my brows …' *God, where do I know that voice from?* 'Yeah, I was talking to Barbra about that just the other day …' It sounded so familiar, yet I just couldn't place it.

I subtly moved my head so I could just about peek behind the screen and at that very moment the woman lifted her head out of the basin and I was suddenly transported into that scene from *Steel Magnolias* where the fabulous, fiery Southern dame Ouiser Boudreaux is in the salon getting ready for the wedding. She spotted me watching her, glared back with a '*What the hell are you looking at?*' frown on her face and then put her head back again.

'Oh my God, Kate, that's Shirley MacLaine!' I muttered, nudging her furiously.

Kate looked up from her magazine. 'Shirley who?'

'Shirley *MacLaine*,' I whispered. 'You know, *Steel Magnolias?*'

'Nah, not seen it,' she said, going back to her magazine.

'Come on, Kate,' I persisted, determined she was going to share in my starstruck enthusiasm. '*Terms of Endearment*? *Sweet Charity*? She's an absolute Hollywood legend!'

I couldn't take my eyes (or ears) off the divine Miss MacLaine. She was deep in conversation with her stylist – the usual hair salon chitchat like what she was enjoying on TV and picking up her groceries – when suddenly a pack of paps, who had obviously been

following Kate, appeared at the salon window and started snapping away.

'Oh my gaad!' screeched Shirley, as the screen was hurriedly wheeled in front of her. 'I've been coming to this place for twenty years and I've never seen a single photographer outside! How the hell do they know I'm here?'

One of the staff then quietly told her that the photographers were probably there for 'that English lady' – they gestured towards Kate – who was very famous in the UK.

Shirley looked over towards us and fixed Kate with that famous beady expression. 'So this is all your fault, young lady?' she said.

I could have died.

Kate's blow dries always take ages because her extensions are so thick, so Shirley actually left the salon before we did. And I will never forget the image of this feisty little woman in huge dark glasses fighting her way through the paparazzi, shoving them with her umbrella and handbag while shouting, 'Get outta my way!' It was absolutely hysterical.

Pete was in LA to record his album and he did a brilliant job. I think he has always been underestimated as a performer. Yes, he did bring out some cheesy stuff – and he'd be the first to admit it – but the guy is bloody talented. Not only is he a fantastic singer, he is a natural in front of the TV camera and he can act too. He's amazing at mimicking accents; he was always doing spot-on impressions of Phill and me, right down to the facial expressions.

But while Pete worked with some fantastic people on that album and came home happy, for Kate the whole experience was decidedly disappointing. She thought this would be her big chance to break America.

I was horrified when I tuned into the *Stateside* show one night to see them having the most explosive, vicious row on camera. I couldn't believe it – how the hell had *that* made the edit? The row didn't do either of them any favours: Kate implied that she was the

one making all the money, while Pete ranted at her, calling her a 'stupid, arrogant little fucking cow'. I guess it's a reality show – and you couldn't get more real than that – but the rumours of relationship problems were rife and this just added fuel to an already blazing fire. The *Stateside* programme highlighted the cracks in their relationship to the worst possible effect. Every couple has arguments, but theirs were in the spotlight to such an extent – how could anyone's relationship survive that?

* * *

In May 2009 I accompanied Kate to the Badminton Horse Trials where she was promoting her range of equestrian clothing. It had been a really lovely day, and I remember trying to persuade Kate to make a night of it.

'Let's go and have dinner and a drink,' I said to her. 'Come on – it'll be fabulous!'

We did, indeed, have a fabulous night and Kate danced her heart out. A group of us including Kate's book publicist Diana, her trainer Andrew and wife Polly and his best friend, a dressage rider called Spencer Wilton and his partner went on a gay-bar crawl around Bristol, and started the fun at a big club called Syndicate. But as soon as we got there, I realised it was a mistake. There were camera phones everywhere and we didn't have any security with us because Kate wanted to feel 'normal', still refusing to acknowledge that in her position that is pretty much impossible. We had a couple of drinks there and moved on, but sure enough, it turned out that a photo of her leaning over Spencer was sold to the newspapers.

That was on the Friday night and the next day Kate and Pete were presenting one of the prizes at the Comedy Awards. I got them both ready for the ceremony; Kate looked absolutely gorgeous in a silver dress and Pete was very smart in a black suit. After the ceremony the four of us went to Nobu for dinner and we had a lovely evening. I

could never have imagined that it would be the last time I would see Kate and Pete together.

The following day Kate and I went back to Badminton again to continue her promotional work and that evening we went back to our respective homes. And then, on Monday morning, I woke to the *thud* of the papers coming through the letterbox and went downstairs to find a picture of Kate with Spencer on our night out in Bristol splashed across the front pages. Funnily enough the papers failed to mention that Spencer was actually gay and that the only straight man in our party, Andrew, had been there with his wife. I called Kate immediately and the first words she said were: 'That's it, Gary. It's over.'

After the statement was issued confirming their split Kate flew straight to the Maldives with her friend Julie, but I spoke to her on the phone. I kept telling her, 'It's not over, Kate, don't be stupid, I'll get on the phone to Pete and we'll try and sort things out.'

I honestly thought they would work it out. I kept ringing Pete, but he wasn't picking up his phone. In the end I just left him a message saying: 'Mate, just to let you know we're thinking about you and whatever happens in the future you know we'll all be friends and we think a lot of you.'

Pete eventually rang back a few days later. He spoke to Phill and told him he'd like to buy our house, Mersing – him and Kate had always loved that place. But Phill laughed off the idea. 'Don't be silly, Pete, you and Kate will sort things out, it will be fine.' We really did think that they would have a few weeks of cooling off and then get back together.

The worst thing Kate could have done in those first six weeks after the split was to stay silent. In my opinion, that had a knock-on effect to all the crap that happened in the following months. Everyone was so used to her always giving her opinions and sharing her thoughts that when she was advised to do the opposite, she left herself wide

open. Because she refused to comment, there was no one to put the record straight or stick up for her.

I was desperate to speak out because what was being reported was so wrong, but it wasn't my place to do so – and when Kate finally did start talking about what happened, two months later in an interview with Piers Morgan, it was all too late. The public had already made up their minds about what happened – and had decided that she was the baddy. But the inescapable fact is that Pete left Kate!

* * *

Kate was devastated by the split. She might put on this brave front in public, but she really is just a vulnerable little girl at heart, and I know she was very hurt by what was being said about her in the press. Overnight, everything she had known for the past five years (apart from her family and close friends) seemed to vanish.

Shortly after she returned from the Maldives, Kate kept a date to appear at *The Clothes Show Live* to promote her equestrian clothing. I was terribly concerned about her because she was looking far too thin and her confidence had been knocked for six, but when she hit the catwalk that afternoon the crowd gave her a standing ovation and it really gave her a much-needed boost. Also that day she met a guy called Anthony Lowther, one of the models. He was very sweet – and very gorgeous! – and when we mentioned that we had been planning a week in Ibiza he invited us to come along to a club night he ran out there called Candy Pants.

The Ibiza holiday had been planned long before the split and was always intended to be a working trip to shoot Kate's calendar. However, as it became increasingly obvious that the press were gunning for her we all tried to talk her out of it; we even made her cancel it a week beforehand. But Pete was going to be in Cyprus with the kids, and Kate hated being in that huge house all by herself, so in the end we agreed to go. Big mistake.

We had begged Kate to stay in a private villa, but again she was adamant that after the last five years she wanted to be like any other normal girl, and so she booked a hotel online, unaware that it was the biggest party hotel in Ibiza. The morning after we arrived we went straight down to the pool for a swim. I dived into the blissfully cool water and as I surfaced I glanced around at the other hotel guests on the sun-loungers.

Oh my God. To my horror, I realised that I recognised every single face around that pool; it was wall-to-wall journalists. I marched straight up to the nearest familiar face and asked what they were doing there.

'Um, I'm working on a tourist guide to Ibiza,' came the reply.

'I'm just here on holiday,' another said. 'What an amazing coincidence!'

I told Kate we would have to check out, but she was adamant we were staying put. Big mistake number two.

I can honestly say I have never read so much bullshit as what was written in the press during our time there. The fabrications started as soon as we got on the plane: the papers reported that Kate was boozing on the 6 a.m. flight out there, whereas in reality she didn't have a single drink. Every day the headlines were getting more and more ludicrous. As the hotel was besieged by journalists we spent most of the time in our room – in fact we only had about four nights out – so because the press weren't getting anything they started making up the most ridiculous stories. Things got so bad that one day I suggested to Kate that she *really* give the press something to write about and shave all her hair off, à la Britney Spears. We spent a day trailing around the town trying to find a skull cap from a joke shop but unfortunately we didn't manage to.

On one of the rare occasions we left the room, we were sitting on the hotel terrace one night when this gorgeous guy in a little pair of tight shorts positioned himself near our group. I wolf-whistled, and he came straight over.

'Oi, which one of you whistled at me then?' he grinned, all flirty.

We started chatting and when we mentioned Kate was doing her calendar shoot he immediately offered to help.

'I've got a boat,' he said. 'I'd be happy to take you to this deserted island I know so you can get some privacy.'

Great, we said, let's do it. Big mistake number three …

So there we were, out in the middle of the ocean, heading to this island when suddenly a speedboat appeared on the horizon. And then another, and another, until there were a dozen boats speeding towards us and helicopters hovering overhead. In the end we had to call it a day, as there were just too many paparazzi.

Our new friend seemed genuinely confused. 'What the hell? They must have followed us …'

He offered to be our guide for the rest of our stay, but for the next few nights wherever we went the press always seemed to be waiting, whereas before we'd done quite a good job of evading them.

It wasn't until the end of our trip that we discovered why. This guy finally admitted that he made his living befriending celebrities and then tipping off the press.

'I'm really sorry,' he said sheepishly. 'You guys have been so lovely I thought I should be honest with you.'

What can you do? No wonder Kate doesn't trust anyone …

When Kate told me she wanted to shoot some of the calendar on a beach one morning, I imagined we'd be going to some secluded bay. Instead, we ended up on Bora Bora, the busiest beach on the island. It was the height of the season and was packed with tourists, but Kate marched down to the water's edge, slipped off her robe, Andy the photographer started shooting and she just worked it. There were hundreds of people surrounding us, taking photos, cheering and shouting,

'We love you, Katie!'

After a few minutes it all got too crazy – Phill was doing his bouncer thing but was struggling to control the crowds – so we

moved to a quieter location, much to my relief. At the time I couldn't understand why Kate had done it, but with hindsight it all makes sense. Apparently whenever Marilyn Monroe felt a bit down she would put on a headscarf, dark glasses and a coat, walk out of her New York apartment and go to a busy street where she would take off the disguise and just stand there, waiting for the tidal wave of recognition and adoration to wash over her. And perhaps it was the same thing with Kate. She was feeling so low at the time, perhaps she just needed to know that she was still loved.

* * *

For me, one of the most upsetting parts of the trip to Ibiza was when Kate got her 'Pete' tattoo covered up with a big cross. We had gone into a tattoo parlour in the Old Town as she had wanted to get a new design on her back, but it was a pretty dramatic tattoo and I urged her to sleep on it. The next day we went back again and while she decided against the design on her back, she asked the guy if he could do something to cover up Pete's name. It was the tattoo artist who suggested putting two lines through it, almost like dagger cuts.

'This guy is always going to be part of your life,' he said, 'so why get rid of his name totally?'

It made sense to Kate, and she agreed to go through with it. I was desperate for her to think about it, to not rush into something she might regret, but it's not in Kate's personality to do that. Once she's got it in her mind to act she'll go for it and deal with the consequences later.

Phill and I were so upset. That was the moment we realised it really was over. Even though things had gone so badly wrong, at the back of my mind I still clung on to the hope that they would sort things out. Although things had become terribly hard latterly, we'd had such a wonderful time with Pete. It felt like the end of an era.

* * *

For the six months following the split, most of what was written about Kate in the press was lies. Whoever said all publicity is good publicity got it badly wrong on this occasion. It was unfolding in front of my eyes, getting worse and worse every day, and there seemed to be nothing we could do to stop it. I felt completely helpless. The headlines were brutal. We started trying to hide all the newspapers and magazines from her. Kate was being absolutely crucified – and for what? For wearing a skimpy gold outfit to a fancy dress party, where everyone else was wearing similar stuff – or even more extreme. For letting her hair down and having a few drinks. For having a kiss and a cuddle with a boy she met. For anyone who wasn't in the public eye this kind of thing would be totally normal for a young woman who'd just been dumped, but when it's Kate – *she's losing the plot!*

It was a horrendous period. For the first three months I barely slept. Kate was in such a state, so either Phill or I would stay with her, or her friends Julie or Melody or her family. Her mum Amy was an absolute rock. It was almost like we did shifts. If I wasn't at the house, I'd text her first thing in the morning and last thing at night: how are you, what's going on, what have you got planned for the day? I'd panic if she didn't answer her phone. I had no idea what frame of mind she'd be in. I put my work on hold for weeks, because I had to be there for her. Every little moment of my life seemed to be consumed by Kate. But I didn't resent it – she's my best friend, and she needed me.

* * *

I had phoned Claire Powell directly after Kate and Pete's split. I'd had a great working relationship with her for many years, so wanted to stay friends and told her that I would be more than happy to work with her other clients as long as it wasn't anything that would conflict with Kate. Claire was enthusiastic and told me she had some exciting projects coming up. We ended the chat on great terms. The

next time I saw her, however, was unfortunately a very different story.

Phill and I had been invited to dinner by an interior designer friend of ours, Dawn Ward, to discuss working on a project. She was staying at the Mayfair Hotel in London and had booked a table for us in the restaurant. As we were walking in we bumped into a journalist friend, Dean Piper.

'You do know that Peter Andre's has just had a press day here?' Dean told us. 'He's in the restaurant now with Claire, Chantelle Houghton, Nicola McLean and a TV crew.'

It had been four months since the split and the negative press was at its height. There had been all this shit about 'Team Price' and 'Team Andre' in the papers, but for me it was never, ever a matter of picking sides. I'd known Kate since she was 16 years old, so of course my loyalties would lie with her. Nevertheless, I had really hoped I could still stay on good terms with Pete and when I saw Claire, part of me still wanted to give her a big hug and say, 'This is all so stupid, can't we just all be friends?' But so much had happened since our last conversation that I admit my attitude towards her had hardened. Suddenly I felt uncomfortable about dining in the same restaurant.

We explained the situation to Dawn and suggested changing the venue, but she told us not to be so silly and that everything would be fine, and so we took a deep breath and walked in. Pete and his party were sitting just near the entrance in a booth so we went for a table at the furthest end of the restaurant. We hurried by their table without looking in their direction, but once we were settled at our table we ordered our food, had a few drinks and a very nice evening – until Phill decided he needed to go to the toilet. By this time someone must have tipped off the paparazzi, as there were about twenty of them outside with their lenses pressed up against the glass.

Just as Phill was walking out of the restaurant, who should be walking back in but Pete. They were directly in each other's paths; for Phill, the natural thing to do was to say hello.

'Hi, mate, how are you?' Phill said to him.

Pete stopped in his tracks and turned to face Phill. 'Don't you "hi mate" me,' he said. 'You chose your side.'

Phill was completely shocked. 'Hang on a minute, Pete, what are you going on about?'

I watched in horror as Phill followed Pete back to the table. Outside, the camera flashes intensified. I'm not sure what was said, but suddenly Phill snapped; that fiery Scorpio temper was unleashed. He stood there and told them exactly what he thought of them. By now, everyone in the restaurant was looking round at the escalating row.

Oh God, I've got to do something, I thought, so I walked over. Sensible old me.

'Come on now, Phill,' I said, trying to diffuse the situation. 'Let's not do this.'

Suddenly Claire turned to me. 'You were supposed to be my friend too, Gary,' she said. 'Where were you when I needed you?'

Well, that was it. I'm the last person to get involved in an argument, I hate confrontation, but all I could think of was Kate, crying her eyes out every day at the stories in the press. I couldn't stop myself giving Claire a piece of my mind.

After the row I grabbed Phill and stalked off, feeling angry and terribly upset that things had come to this; I think everyone was left shaken by the whole sorry episode. And the next day the story was all over the papers. Well, at least we kept Kate out of the headlines for once …

SIXTEEN

A Midsummer Night's Scream

Over the years Phill and I have often been asked to appear on TV shows together, including the celebrity couples' special of *The Weakest Link*. Then in summer 2009 Living TV approached us to take part in their new flagship show, *Four Weddings*. It seemed like an interesting concept: four celebrity couples would attend each others' weddings – or vow renewal ceremonies – and then mark each other out of ten on the outfits, venue, food and the overall experience, with the winner getting £10,000 for the charity of their choice.

We thought it would be the perfect opportunity to throw another brilliant party – and if Seal and Heidi Klum can renew their wedding vows every single year, we could certainly do it five years after our first big day! Not only that, but we hadn't managed to get our first wedding videoed because the guy we had booked dropped out the night before, so the fact it would all be filmed was an added bonus.

The other celebrities taking part were the veteran comedy actress Sandra Dickinson, East 17's Terry Coldwell and the model Nicola McLean. I'd always loved Sandra's work, I'd met Terry years ago

working on TOTP and I had done Nicola's make-up once or twice, so I thought it would be a fun show. The producers needed one half of each couple to volunteer to attend all the other contestants' weddings and Phill stepped in.

I admit I was a bit concerned when he headed off for the first wedding. I'm a firm believer in karma, and knowing my husband's tendency to say exactly what he thinks I was worried that he'd end up slagging someone off. Not only that, but I had been to enough weddings with Phill to know that he would probably get blind drunk and would either end up having a row or falling asleep on a park bench – not a good look when you're being trailed around by TV cameras. I needn't have worried as he was utterly charming through-out, nevertheless before every wedding I'd phone his mobile and nag him: 'Now make sure don't you drink too much …'

The theme we came up with for our vow renewal ceremony was A Midsummer Night's Dream. I'd always loved the play, and I'm a sucker for anything to do with fairytales. As the date was in August, we thought it was bound to be gorgeous weather so we wanted to hold the ceremony outside. My dear friend Christina Vaughan helped us find an amazing location, Syon Park in West London, a grand house set in parkland complete with beautiful walled gardens and a stunning Grand Conservatory. When I saw it for the first time I could instantly visualise fairies and pixies skipping through the undergrowth – it was perfect. We wanted to create the illusion of an enchanted garden, to make our guests feel like they were stepping into a movie, so we enlisted the help of events organiser Chris Fitchew of Beau Production and florists Toby and Manny. We'd worked with them before and knew they would make our wildest dreams a reality.

We hadn't planned to have any bridesmaids, but even though Kate was going through such a terrible time in the wake of the split she really wanted to be part of the ceremony. And so I took her to Doly, the Bond Street shop where she found the gown for her vow

renewals with Pete, to look for a bridesmaid dress. She had barely begun to browse through the racks of fabulous couture creations when suddenly she stopped in her tracks.

'That's the one,' Kate smiled.

I looked at the white dress she had pulled out. It was certainly stunning, with a highly embellished strapless bodice and a full skirt of dozens of layers of tulle, but it was unmistakably a wedding dress. I mean, it literally *screamed* bride.

'Um, are you quite sure you want to wear that, Kate?' A million thoughts were going through my head. She had met Alex Reid by this time so he was going to attend the ceremony with her and I could only imagine what it would look like in the pictures if she was wearing the full bridal get-up.

But Kate was determined. 'I'm going to wear this dress, a tiara – the full works,' she said. 'I want to look fantastic for you boys.'

* * *

A month or so earlier Kate and I had been flying back to London after a very successful five-day work trip to Los Angeles. As well as a new management team in Britain, Kate had landed an agent in LA and I had accompanied her to the States for a series of work meetings, including a casting for *Sex and the City 2* in which she had been up for the role of Charlotte's big-boobed Irish lesbian nanny.

Just the two of us had gone to LA and it turned out to be one of the happiest times we've had together, a really fun trip and a rare chance for us to spend time alone. By now, Kate was finally beginning to feel a bit more positive about the future and was starting to move on, in her head at least. She wasn't seeing anyone, but during our time in LA she kept showing me YouTube clips of this guy she thought was really sexy, a cage fighter who was a friend of her personal trainer.

The thing with Kate is that if her love life isn't right then nothing else in her life is either. She is at her happiest when she's in a stable

relationship – and if she hasn't got that one special person in her life then everything else is out of balance while she desperately tries to find them. When she's searching for that missing piece, she surrounds herself with a lot of people, wants to go out loads to keep her mind occupied. But when she's in love, she's happy staying at home and can focus on other things. So she needed to find someone – and I needed her to find someone too. I needed to get my life back. But a *cage fighter*? The very idea sent the alarm bells in my head into a frenzy.

We got on the plane and settled ourselves in First Class. Now I'm the first person to begrudge paying six grand for an aeroplane ticket, but First Class really is the way to travel. My fear of flying simply vanishes in a haze of comfort and champagne; after all, nothing could possibly go wrong in First Class, darling!

Kate's seat was right at the front nearest the toilets, but she is almost phobic about smells so she was just asking the flight attendant if she could move when a voice behind her said, 'Don't worry, Kate, I'll swap seats with you.'

She turned round to see Kelly Osbourne, and we were all soon chatting like old friends. On flights Kate usually slips straight into her pyjamas, orders everything off the menu (honestly, that girl really can eat!) and then sleeps for the whole journey, but she was still so stressed over the furore at home that she was having real trouble dropping off. She mentioned this to Kelly, who offered her a sleeping tablet. 'They're great,' she said, 'they really knock you out.' So Kate took one and sure enough she quickly dropped off.

About two hours into the flight I was sitting watching a movie when Kelly came running down the aisle towards me.

'Gary, I can't wake Kate!' she said. 'I was trying to see if she wanted anything to eat, but she's completely dead to the world! Oh my God, do you think she's okay?'

I rushed over and grabbed Kate's hand and started rubbing it.

'Kate! Kate!' I started shaking her. 'Kate, wake up!'

Well, I tried everything, but I could have smacked her round the face and it wouldn't have made any difference. By now we were both starting to panic.

'Is she even … breathing?' whispered Kelly. 'Check her pulse! Oh God, what if she's allergic to the pills! Has she taken any other medication? We've got to wake her!'

But for the rest of the 11-hour flight, Kate slept on and on while Kelly and I stressed. We landed, everyone got out and still she slept. And then Kate suddenly opened her eyes.

'Are we there yet?' she yawned. 'God, I had such a good sleep!'

The week after we got back I accompanied Kate to Michelle Heaton's birthday party – and who should be there, but that cage fighter from the YouTube clips. My first impressions of Alex Reid were that he was rugged and attractive with this really raw sexual quality to him. Not only that, but it was immediately clear to me that Kate liked Alex.

I'm ashamed to admit it now, but for the first few months of their relationship I was pretty rude to Alex, as was Phill. I have since apologised to him on numerous occasions, but in those early days we just felt that it was too much too soon. I had wanted her to meet a normal guy with a normal job who would look after her, and to me a cross-dressing cage-fighter was about as far from that as I can imagine!

Bloody hell, I thought, *Kate doesn't make it easy for herself …* But at the end of the day, I was just happy that he was making her happy.

* * *

August arrived, and turned out to be one of the wettest since records began. Every single morning we woke up to rain; it looked like our Midsummer Night's Dream was in danger of becoming a very damp nightmare. On the Friday before our big day – a Sunday – we had to make the decision whether to hold the ceremony in a marquee or gamble and stick to our original al fresco plan. The weather forecast

for the day itself was an ambiguous mixture of clouds, showers and sunshine. To make matters worse, we had visited the venue to check on preparations on several occasions and discovered that the Grand Conservatory, where we were holding the reception, was leaking badly. But it seemed such a shame not to make use of the gardens, so eventually we decided against the marquee and just pray that the sunshine outweighed the showers.

Well, someone up there obviously likes us because the day of the ceremony dawned blue and cloudless. We had stayed at the May Fair Hotel in London with our family the night before and Kate and Alex arrived with the kids and nannies in tow on the Sunday morning. We planned to change at the venue so the paparazzi didn't get any pictures of us in our outfits, but I did Kate's make-up at the hotel before we left. Meanwhile Nick and Royston kindly gave up their salon at The Dorchester to do a conveyor belt of hair and make-up for the rest of the wedding party.

By the time we were finally ready to leave for Syon House we were already running half an hour late. Phill, who was waiting in the hotel lobby, was getting more and more anxious. He kept phoning her mobile saying, 'Can you please get yourself downstairs NOW!'

Eventually she appeared and Phill helped her through the scrum of paparazzi that was by now gathered outside and into the people carrier that had been booked to take us all to the venue. But as soon as Phill shut the door on Kate, the driver zoomed off. We were left standing on the pavement, the groom and groom, already late for our own wedding and with no car to get there! There was nothing else to do but hail a passing cab.

We arrived at Syon Park, bundled out of the taxi with all our bags and legged it round the back of the house to get changed in one of the outbuildings, where the cast of fairies and magical creatures were putting the finishing touches to their costumes. It was very surreal to be getting dressed in our suits while a giant stilt-walking peacock fluffed up its feathers. I wore a cream silk suit with a lilac

floral shirt, while Phill's suit was lilac with a cream shirt. We were even happier with our outfits than we were for the wedding – and as we'd just got back from a holiday to Marbella with Kate and Alex, we both had deep golden tans. Meanwhile our guests had arrived and were enjoying champagne on the lawn while being serenaded by a harpist. As usual it was all a bit of a last minute panic, but when we finally caught our first glimpse of the gardens – well, all the stresses just vanished.

The grounds had been filled with candles and there were fairies hiding in the bushes and playing on flower-draped swings, while winged unicorns, fauns and pixies wandered around the lawns. Inside the Great Conservatory we had thousands of pounds' worth of flowers sprinkled with diamante that sparkled in the candlelight. It was utterly magical.

Kate looked absolutely beautiful, like a Hollywood goddess, but she was so nervous before walking us down the aisle because we'd had no time for a rehearsal (again). It didn't help that she could barely move in the dress because the hooped skirt was so wide that she had to kick it up with every step. We were preceded down the aisle by a procession of all the magical creatures, including the stilt-walking peacocks, giant swans, fauns and winged unicorns. Kate and I walked down hand-in-hand, then Phill joined us halfway and we went the rest of the way together with Kate in front. If people hadn't known what was going on they'd have probably thought that I was giving Kate away to marry Phill!

The reception was amazing with non-stop entertainment and delicious food courtesy of Rhubarb, who have catered for the Beckhams and Elton John. We started with an amazing selection of canapés presented in elaborate birdcages and mini chaise longues, then sat down to a gruyere soufflé, sea bass and a trio of puddings. Although I was having a wonderful time, I was painfully aware that Kate – who was sitting on the top table with us – was getting more and more upset. It must have been so hard for her, putting on a

wedding dress and walking down the aisle to watch us renew our vows, when she had done exactly the same thing with Pete just months before. As a present for Phill and me, she had recorded a version of one of her favourite songs, 'Show Me Heaven', and had planned to sing it live for our first dance, but as the time approached she suddenly broke down. Kate went to sit with her family and I could see her literally shaking with sobs.

'Kate,' I said gently, 'you really don't need to sing. We can do our first dance to the recording.'

But she was adamant, and half way through the song it all became too much for her and the tears started flowing. Phill and I grabbed hold of her and gave her a huge cuddle, but she was inconsolable. Everything – the emotions of the day, the split with Pete, the mauling in the press – suddenly hit her. I think she did a lot of her crying on that night.

As the evening wore on, however, Kate started to brighten up. It was almost as if she had needed that release. Alex was fantastic because he'd been thrown into this crazy world but was a total support for her all night. Plus she'd had a few drinks – and when Kate gets merry she always has to have a sing and she loves nothing more than a big 80s ballad. So when one of the singers started the Whitney Houston number 'I Have Nothing', which was the song she walked down the aisle to at her wedding, she got straight up and joined in. It was note-perfect, and by the end everyone was cheering. We all ended up back at the May Fair, in the bar, and then about fifty people crowded into our suite. I don't think we got any sleep that night.

I actually enjoyed the vow renewal more than our wedding day because it was much more relaxed, but there was one thing that did put a dampener on our memories. Once again, *OK!* magazine had been covering the ceremony and took some beautiful pictures. When I went to approve the photos, they showed me the ones they were planning to use; however, you never get cover approval in these

situations. But by the time it hit the newsstands, I had been airbrushed out of the photo completely and Alex put in my place, so it looked like he was standing next to Kate.

Of course, I totally understand why they did it – the pair of them were such hot news that the magazine wanted to imply that they were the ones who'd got married. But I was absolutely gutted; in fact I was beside myself. I had expected that they'd want to put Kate on the cover, but to take me out of the main photo? When it was my vow renewal? It felt very personal at the time, although I know better than anyone how the game works.

* * *

Two and a half years after our house was completed Phill and I finally sold Mersing. We didn't make quite as much money as we'd hoped, but it was more than enough to pay everyone back and invest in a new project. We moved to a fabulous garden flat on a square near Hyde Park and all our problems just seemed to vanish, both financial and emotional. With the pressure of selling Mersing no longer hanging over us we stopped arguing and fell in love all over again. Phill got offered some interesting TV projects. Things were finally looking up.

Over the years Phill and I have often talked about how much we would love to have kids, but as a gay couple you put it to the back of your minds. You just assume it's not going to happen. Besides, our lives have always been so busy we would have to get a full-time nanny – and I would want to be in a position where I could do the majority of the parenting myself. But Kate has often said that if we were ever in a position to have children, then she would be a surrogate mother for us. We'll be at a big family barbecue at her house, watching all the kids running around in the garden, and she always brings it up.

'If you ever want to do it, Gary,' she'll say, 'you know I'll happily help you out …'

At first I used to laugh, but she really means it. I'm not sure how it would work – perhaps we could give her a cocktail and just see what happens! It's something we often think about. In the meantime we have so many wonderful children in our lives, including Junior, Harvey and Princess, who is our unofficial goddaughter; Kate calls us her Fairy Godfathers! Her name totally suits her: she *is* a little Princess. We adore her and spoil her rotten – in fact the other day I bought her a Girls World, the very present I'd so desperately wanted when I was little. Princess has watched her mum being made up from the minute she was born and loves playing dress-up and putting on make-up. Like most little girls she is fascinated by lip-gloss and nail varnish, often taking mine and putting them on herself.

* * *

By the time my 40th birthday came round in September last year I was in the mood to celebrate, so I threw a fabulous party at Blakes Hotel. As usual the champagne was flowing all night and everyone got pissed. My dear friend Denise Welch was among the guests. I've worked with all the Loose Women and they're a brilliant laugh – and even more outrageous in real-life than they are on the show. At the end of the night Denise had been standing outside the party in front of the assembled paparazzi giving everyone a tipsy kiss goodbye, and the following day a huge picture of her was splashed across the *Daily Mail* engaged in what looked like a full-on lesbian romp with a 'mystery woman'.

And the woman in question?

My mum.

Well, you can imagine she was horrified! She had all these people ringing her up to tell her they'd seen the photo of her snogging Denise Welch in the papers. I thought it was hysterical, but I don't think Mum left the house for days after that …

A month later, on Halloween, Phill and I, together with Kate, Alex and a group of our friends, were invited to the Bloodlust Ball, a big

horror-themed party at Hampton Court. But on the same night my trainer Lucas mentioned he was going to a fetish club called Torture Garden – and would we like to come along? I'd heard this place talked about for years and admit I had been intrigued. As well as a dancefloor and DJs like a normal club, there were also lots of private rooms catering to every fetish you can possibly imagine.

Everyone got dressed up and lots of celebrities attended in disguise. I mentioned it to Kate, who was instantly dubious. She'd had such a rough time with the press lately, the last thing she wanted was to give them more ammunition. But Lucas assured me that the location was secret and that there wouldn't be any paparazzi there, so she promised me she'd think about it.

That night our little group spent four hours getting ready at Kate's house. Kate wore red leopard-print stockings with a matching eye mask and a black rubber corset, while Alex wore a bra, stockings and suspenders with kinky boots, a choker and a hat – he was a sight to behold, I can tell you. Phill was Dr Death in a full surgeon's outfit complete with fake blood and severed limbs attached and for the first time ever, perhaps inspired by Alex, I decided to get dragged up in knee-length boots, black leather hotpants and a corset. I had never put a full face of make-up on myself before and was shocked at how well I made up. With trashy red lips and three sets of eyelashes I looked like a young Boy George.

We arrived at the Ball three hours late to find the place swarming with so many photographers we had to stay in the VIP room, but it was too small to dance and there was hardly anyone in there anyway so after an hour we decided to go to Torture Garden.

Well, we had the most amazing night. It felt so decadent, so outrageous – kind of like a kinky Studio 54. True, in some areas it was rather sleazy, but our group stuck to the dance floor and Kate relaxed, danced and partied the whole night – and no one ever found out she had gone there.

* * *

It was around this time that we were having dinner at The Ivy one night when we bumped into Stephen Gately, who was at a neighbouring table. I'd known the Boyzone singer for years and had worked with him on the odd occasion, but we'd become close through Ulrika when they were doing *Dancing on Ice* together in 2007.

Stephen was the most amazing person. Honest to God, he would walk into a room and just light it up. No matter who he was talking to, he was so warm and friendly that he would always make you feel fabulous about yourself. And he was so incredibly talented! Ronan got a lot of the glory, but Stephen was a truly accomplished all-round performer. Phill and I would often meet up for dinner or a night clubbing with him and his husband Andrew. I've never seen two people so in love; they were the perfect match and obviously worshipped each other.

That night at The Ivy, Stephen told us he and Andrew were going on holiday the following week to their apartment in Majorca but he was planning on getting back in time for a mutual friend's birthday party, where we agreed we would properly catch up.

'See you in two weeks' time,' he smiled when we left. 'Can't wait!'

Well, we did keep our date with Stephen two weeks later, but it wasn't at the birthday party – it was at his funeral.

I was woken on the morning that news of his death broke by my phone's text message alert. To start with I lay in bed, not bothering to check it, but a minute or so later another text arrived – and then another. I finally picked it up to discover the shocking news that Stephen was dead. *What?* It couldn't be true … I immediately turned on the TV, desperately hoping the whole thing was a sick hoax, but it was all over the news. I was in bits. We spoke to Andrew and needless to say he was utterly devastated and in deep shock.

The funeral mass took place in Dublin. The streets surrounding the church came to a complete standstill as there were so many people wanting to pay their respects. It was a deeply moving service.

Surrounded by photos of Stephen at all the different stages of his life, Ronan sang and all the Boyzone guys did readings. Everyone was in tears. It was so hard to understand, how this young, talented, wonderful guy's life had so brutally been cut short.

To make matters worse, a journalist called Jan Moir wrote a terrible, poisonous piece in the *Daily Mail* a few days after he died linking his death to his homosexual lifestyle. God, I was angry. It was blatantly homophobic. Stephen and Andrew were two consenting adults, they weren't hurting anyone or breaking the law and what they choose to do in private is their business. The only slight consolation was the massive public backlash that followed Moir's comments.

* * *

When Kate was asked to go back on *I'm a Celebrity* in late 2010 she agonised over the decision for a very long time. She had been such a hit on the show the first time round, but so much had happened since then and it felt like a huge gamble. In the end, she decided to take part in the show primarily as a way of getting closure from Pete. That might sound weird, but they met in the jungle on camera, it felt right for her to end it the same way.

Kate did a fantastic job in the show, but I was sorry that she ended up walking after a week and didn't stick it out for a bit longer. I do understand that seven days of back-to-back Bushtucker Trials had worn her down, but she was only being voted to take part because she was the most interesting person in there and besides, Phill and I had only just arrived in Australia and had been looking forward to enjoying a few days off in the sun! As I joked to her when she got out, 'I can't believe you, Kate, you've ruined my holiday ...'

Kate only told two people that she and Alex were going to get married in Las Vegas – her mum and me. Both Amy and I had the same concerns: isn't this too soon? Is this right for Kate? But at the

end of the day it was her life, and by then we'd got to know Alex and had realised he was a really decent guy. I liked his honesty, the fact that he wanted to protect Kate and that she obviously felt so safe with him. He was fantastic with the kids and had given her the stability that she so needs.

I won't talk much about the wedding as it was private, but suffice to say Kate looked the most beautiful, the most natural I've ever seen her. It was all very simple. Phill and I walked her down the aisle and Alex had a best man there, so there were five of us present for the short, but highly emotional ceremony. The hotel photographer took a few pictures of her outside and I think they were some of the best pictures I've ever seen of Kate. She was literally glowing with happiness.

Later that year on 3 July, Kate and Alex celebrated their marriage by having a blessing in Surrey. I guess they felt that they wanted to share their joy with family and friends and, in contrast to Vegas, they would have a church service and reception in the grounds of Kate's house. Kate looked stunning in a full white corseted satin dress and Alex in a dove-blue suit. The day was full of emotion and fun but was very nearly destroyed by the brutal behaviour of the paparazzi.

Kate arrived at the small church in Woldingham in a replica of the A-Team van, a total contrast to the Cinderella pink pumpkin carriage that she had arrived in to marry Peter. What should have seemed like a fortress might as well have been made of paper. When we reached the church, the clash between the paps and security reached an all-time high. A huge scuffle broke out as Katie tried to get out of the van. She was pushed, pulled and subjected to the worst verbal abuse from the paps that I have ever heard – far from the good wishes that one normally hears at a wedding. The genuine fans and well-wishers were trampled on and crushed by the frenzy of paparazzi trying to get their big money shot. Kate was really shaken and upset when she finally managed to get into the church 20 minutes later. It took a good 10 minutes to calm her before she was

able to walk down the aisle to meet Alex. It was probably one of the most terrifying moments that I have ever witnessed. Luckily the police arrived. Kate and Alex exchanged vows and the rest of the day's celebrations were finally allowed to continue.

* * *

The early summer of 2010 was such a manic time for me. I had the opportunity to co-host a new TV show called *Promzillas* – a make-over show with a big difference! The American prom craze had taken the UK by storm and the show explored the extreme and colourful world of prom life, as well as providing a snapshot of the modern British teenager at this crucial time in their life. I loved making the show; not only did I get to travel around the country in a pink double-decker bus – not camp at all! – and wear clothes that would have made Oscar Wilde look straight, but I met such a range of characters, from the demanding prom diva who would stop at nothing to be the belle of the ball to the quiet shy girls in desperate need of finding their confidence and themselves. It was more than just a makeover show – it took everyone on an emotional journey. My chance to become Cinderella's fairy godmother had finally arrived and I got to wave my magic wand and sprinkle some stardust to make dreams come true! It took two months to record the show that sent me on a whirlwind tour of the UK.

Half way through recording *Promzillas*, I was invited by MAC to the BAFTAs. I decided to take Kate as my guest – she wore a fabulous couture strapless, long black dress, complete with a dramatic train that fanned out behind her. I scraped her hair back into a tight clas-sic chignon and gave her smoky eyes and soft beige glossy lips. She looked beautiful and the way I had wanted her to look for the Oscars the year before. I had picked out a suit for myself from one of my favourite designers, Terence Trout, the day before, expecting it to be delivered that morning to the hotel where we were getting ready. It did arrive but it was not until the very last minute that I checked and

discovered it was not my suit! Now I don't pull a diva strop very often in my life (although some might disagree!) but at that moment every diva I have ever worshipped entered that room – Liza, Madonna, Bassey, Streisand all turned up shouting, 'Where the f*** is my f****** suit?' It was Sunday so the shop was closed – what was I going to do? The BAFTAs were due to start in 45 minutes and Cinders had no dress for the ball! Prince Charming to the rescue! With no time to spare and a ticking BAFTA clock, Phill contacted the designer, got him to open the shop to find my suit and, after Kate and I raced over to meet Phill in Hyde Park on the way to the Palladium, I changed in the car and got there just as the curtain rose! Cinderella would go to the ball after all!

Shortly after filming *Promzillas*, Phill and I were asked to participate in another TV show – *Ghosthunting* – with Kate and Alex. For one night, we were to delve into the deep abyss of the unknown in three truly horrifying locations and take part in a paranormal investigation. Looking back, I cannot believe I agreed to do it – having only recently left a haunted house to move to London, the last thing I wanted was to open a portal to let the little old lady from Beaconsfield find me again! While Kate and Phill found the whole experience hilarious, I was reduced to a nervous wreck. Even though we never actually saw a ghost or my little old lady, it was a truly scary experience!

Autumn continued to be very busy for me. There were lots of new clients, as well as trips stateside to New York and LA. On one of these trips, Kate decided it was time to change her hair colour. She had been dark for four years and there was a blonde dying to get out. The timing was right and, besides, blondes have more fun! Maybe this was an unconscious message that it was time for change on all fronts – including her marriage!

I often felt that Kate's dark hair made her look harder and it also reminded me of a difficult two years. A new year, a new hair colour – and who knows what else new?!

Christmas arrived and with it came a very special present from Santa Paws himself! Over the last few months, Phill and I had been thinking of adding to our family so, when Kate announced that she wanted to help us in our mission, how could we refuse? Now it's not what you're thinking – surrogacy might come later! – but when we saw a Cavalier King Charles puppy, we couldn't resist! Lola Ferrari was born in October 2010 and we had the pleasure of her joining our family on Boxing Day. Dolly Parton and Scarlett O'Hara adore her and now our not so little family is complete – at least for now !

Unfortunately, while I celebrated nearly 20 years of togetherness and 5 years of marriage to Phill, I was saddened that Kate's marriage to Alex was not having such a happy ending. I so wanted it to work out for them both and hoped that they could resolve any problems. However, it was not to be. I never really got to know Alex well but, as I have said before, he seemed like a decent guy and, as a fighter, he certainly proved himself when he fought Tom 'Kong' Watson!

February 2011 and it was Oscar time again. This year I was accompanying Kate to the famous Elton John AIDS Foundation Academy Awards party. Terence Trout (again) designed a black crystal collared suit for me and, unlike the previous year, Kate was fully prepared with six dresses on standby and a stylist to hand in LA. She didn't actually wear any of these and opted instead for a sexy black cocktail number by an LA-based designer, setting off her new blonde look. We had such a fun night and, in usual Pricey fashion, she stole the show!

* * *

I am so excited about the next few months. It feels like my life has fallen into place. I feel content, complete and happy – maybe at the age of 40 I have finally grown up! I have been with Phill for nearly 20 years, the bad times have been totally outweighed by the good and we are still together and strong. My family are healthy and

happy, Dolly Parton, Scarlett O'Hara and Lola Ferrari adore their Sunday afternoon walks in Hyde Park and my best friend may be single but is having lots of fun with the dark clouds of the last two years finally lifting. I have got myself a fabulous new agent and my new primetime TV show *Promzillas* is launching.

My make-up range is almost complete – and I won't just be catering for women, I'm going to be bringing out products for the guys too! Old clients have fabulous new projects and new clients inspire me. But although my career has taken a slightly different turn, I am still spending most of my days working as a session make-up artist and loving every single moment.

I've had such a varied career, from working with the hottest new pop band, to an actress who's suddenly the latest thing, or the next big catwalk star. I have watched a million egos come and go, seen the good, the bad and the downright ugly, but at the end of the day I'm still here and I imagine you'll still see me round London with my make-up kit well into my sixties. I certainly can't wait to write my next autobiography!

I mentioned earlier about my first ever trip to Los Angeles when I spotted that billboard poster of the actress Melanie Griffith and prayed that one day I might work with her. Well, four years ago those prayers were finally answered when I was booked to do her make-up for a magazine shoot. When Melanie walked into the room and I heard that famously breathy, girlish voice I was instantly transported back almost 20 years to that magical moment on Sunset Boulevard.

Even though I had worked with many Hollywood stars by then, it seemed particularly special for me because of that memory; I didn't stop smiling for the rest of the day. I had used beautiful smoky bronzes and soft browns for her make-up, but just as I was finishing Melanie asked if I could give her red lips. I wasn't that keen on the idea as it didn't really go with the rest of the look, but as a make-up artist your job is to listen to the client and besides, there was a good

reason for the request: 'Antonio just loves me with red lips,' she smiled coyly.

Sure enough, when her husband (Antonio Banderas) walked in later that day you could almost feel the electricity between them. My God, the sparks flew! I don't think I've ever seen two people more in love.

I bumped into Melanie again two years after that shoot on a trip to LA. I was in the lobby bar of the Beverly Wiltshire, just a few miles from Sunset Boulevard, when I noticed her sitting at one of the neighbouring tables. I would never have approached her as she was obviously in a business meeting, but at that very moment she turned her head in my direction, caught my eye and her face lit up into a huge smile.

'Hi, how are you?' she said, beckoning me over for a chat. I guess the Hollywood gods were smiling on me again that day …

* * *

One thing I didn't tell you about my trip to that psychic all those years ago was that she told me I had a gift: that I was a healer. I don't know about that – as I said before, what I do is hardly brain surgery. But thinking about it, my job is about creating beauty. And if that makes people feel better about themselves, if it lifts their mood and spirit, and leaves them feeling more confident, secure and happy, well – I'd say that's a very precious gift to be able to share.

ILLUSTRATION CREDITS

All photographs not credited below have kindly been supplied by the author. The author and publisher are grateful to the following for permission to reproduce their copyright material. While every effort has been made to trace the owners of copyright material reproduced herein, the publishers would like to apologise for any omissions and will be pleased to incorporate missing acknowledgements in any future editions.

Pages 14–15: With special thanks to Clive Arrowsmith, Alan Strutt, Alvin Coates, Andy Neale and Elizabeth Hoff.
Page 17: © Dan Kennedy / OK! Magazine
Pages 18–19: bigpicturesphoto.com and Getty Images
Pages 20–21: © Dan Kennedy / OK! Magazine

ACKNOWLEDGEMENTS

I would like to thank the lovely Clare Reihill for asking me to write this book. And thank you to everyone at HarperCollins for their enthusiasm and support. Thank you to Maggie Hanbury, my wonderful literary agent, for striving on until we got there! And also to Catherine Woods for working so hard with me to help me tell my story and also for her endless patience, I could never have done it without her. Thank you once again to my husband Phill, to all my family and friends for their help, and of course to the wonderful clients whose faces I've been painting for so many years. To the photographers, art directors, agents and everyone behind the scenes, who help to make my working life so exciting, thank you. And finally a big thank you to my Katie for always being there for me.